Monet on the Normandy Coast

Tourism and Painting, 1867-1886

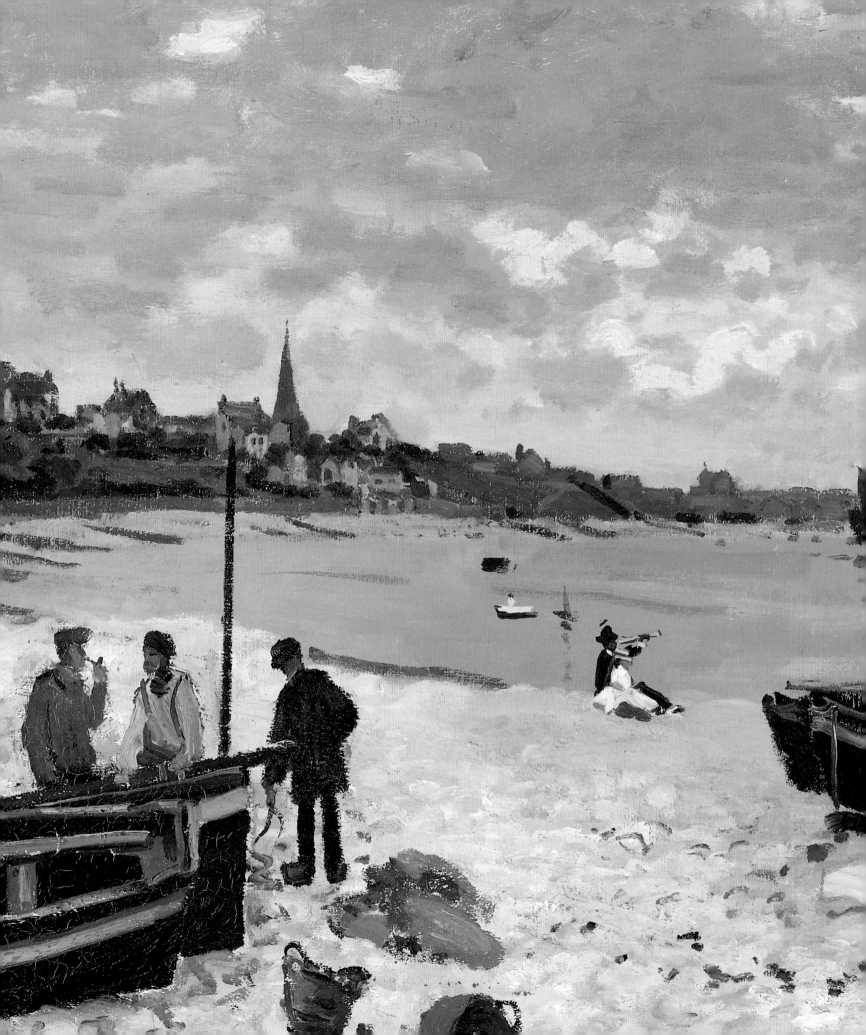

Monet on the Normandy Coast

Tourism and Painting, 1867-1886

Robert L. Herbert

Yale University Press

New Haven and London

Designed by Gillian Malpass
Set in Linotron Bembo by Best-set Typesetter Ltd, Hong Kong
Printed in Singapore by C.S. Graphics PTE Ltd

Library of Congress Cataloging-in-Publication Data

Herbert, Robert L., 1929–
 Monet on the Normandy coast : tourism and painting, 1867–1886 /
Robert L. Herbert.
 168 pp. 275 cm.
 Includes bibliographical references and index.
 ISBN 0-300-05973-6
 1. Monet, Claude, 1840–1926–Criticism and interpretation.
 2. Tourist trade and art–France–Normandy. 3. Normandy (France) in art. I. Title.
ND553.M7H43 1994
759.4—dc20
 94-13913
 CIP

A catalogue record for this book is available from The British Library

Frontispiece: Detail of fig. 13.

To Alexander and Bethany

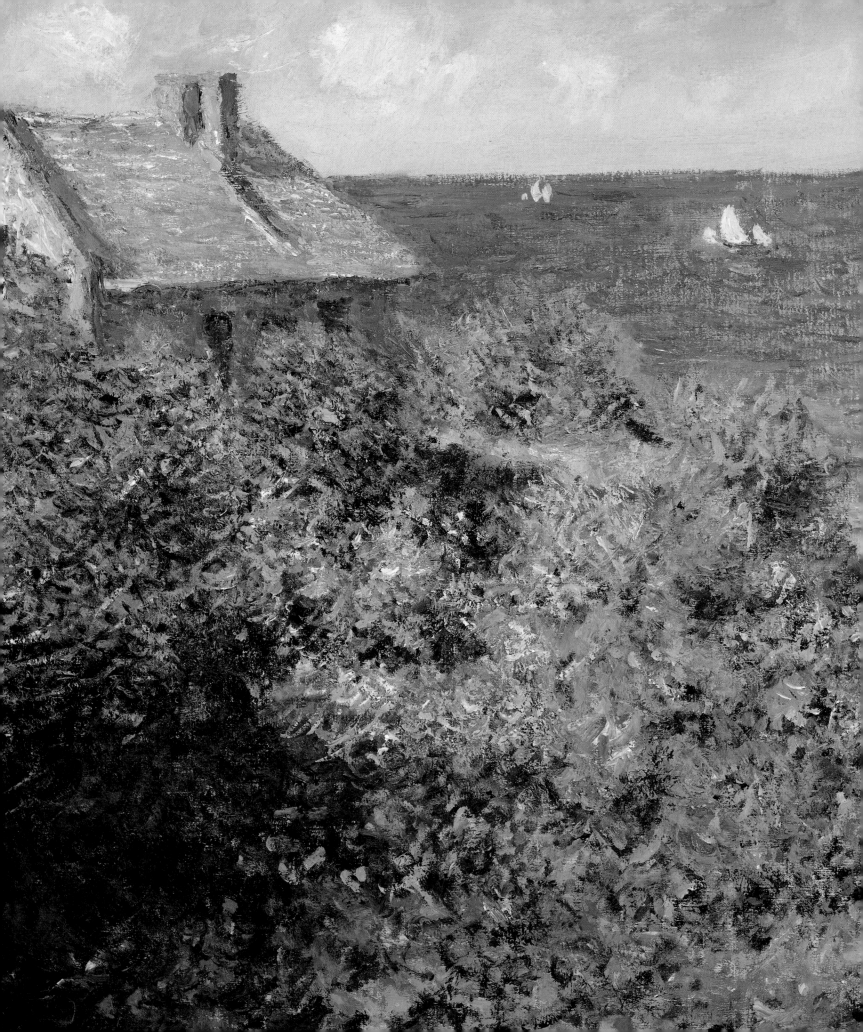

Contents

Acknowledgments		ix
List of Illustrations		xi
Map of Northern France		xvi
A Note on Style		xvii
Introduction: Tourism and Painting		1
1	From Sainte-Adresse to Trouville, 1867–1870	9
2	From Les Petites Dalles to Pourville, 1881–1882	37
3	Etretat's History and Fame	61
4	Etretat, 1883–1884	71
5	Interlude at Bordighera	91
6	Etretat, 1885–1886	97
Conclusion: Illusions and Realities		129
Notes		137
Bibliography		144
Index		147

1. Detail of fig. 57.

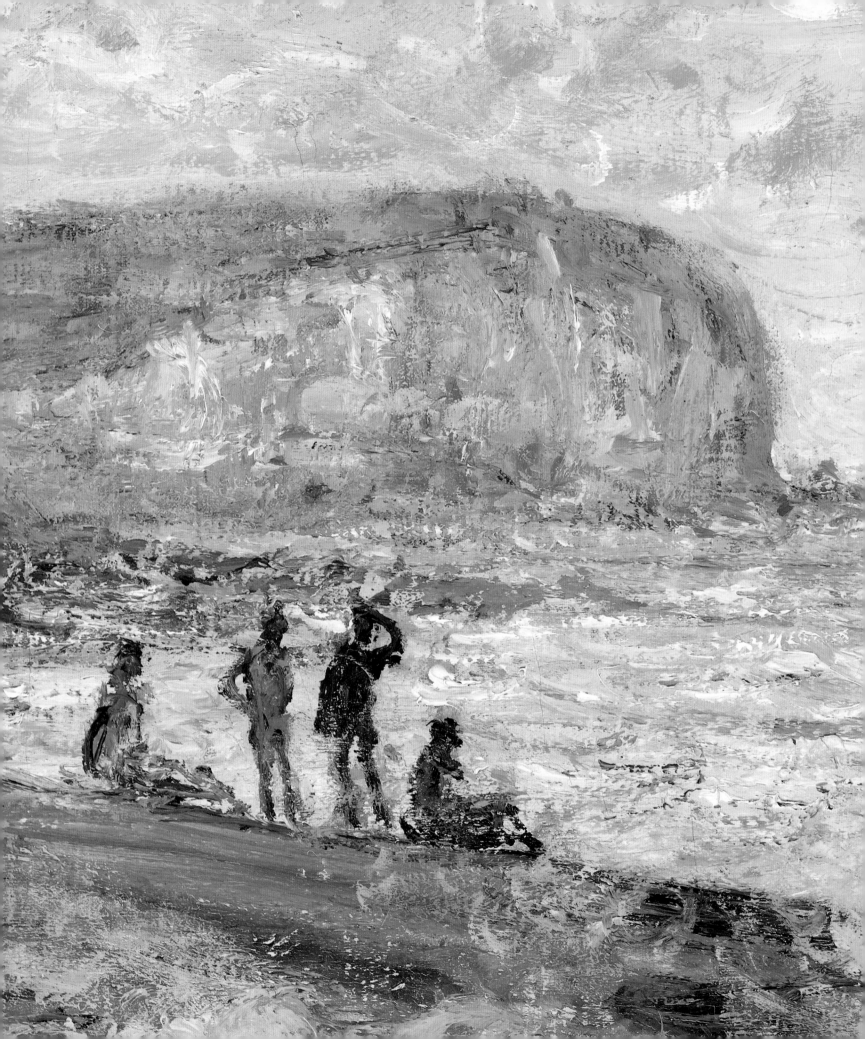

Acknowledgments

While developing the ideas for this book, I benefited from the interchange with students in my seminars at Yale University over a period of two decades. They are too numerous to list here, but I hope they will recall our discussions and not feel slighted by the omission of their names. I learned from their skepticism as well as from their agreements, as I did more recently in seminars at Mount Holyoke College.

My debts to prior publications are numerous, as is evident in my notes and bibliography. I should single out here several that were of particular importance. The Wildenstein catalogue (W) records not only all of Monet's work, but also his letters; it is the essential working instrument for any study of Monet. For their many lessons and refined observations I have often turned to the books on Monet by Joel Isaacson (1978), John House (1986), Paul Tucker (1982, 1989), and Virginia Spate (1992). Dominique Rouillard's admirable study (1984) of English Channel resorts has perceptive analyses of town planning, architecture, topographical illustration, and travel literature. The salient history of Etretat is found in Raymond Lindon's book (1963), which also records alterations to the village and the social habits of its visitors. For tourism, I first profited from Dean MacCannell (1976) when I was writing the last chapter of my *Impressionism: Art, Leisure, and Parisian Society* (1988). It was dissatisfaction with the incompleteness of that chapter that made me turn to the present book, and here the insights of John Urry (1990) and James Buzard (1993) have been especially helpful.

My working manuscript was first read by Eugenia W. Herbert, whose clear-headed observations helped me plug holes in a rather leaky craft. I'm especially indebted to James D. Herbert (no relation!) and Paul Hayes Tucker who steered me out of muddy waters by going over everything from keel to bridge in thoughtful detail. I remain behind the wheel and won't blame them when my text takes the reader through doubtful shoals, but I couldn't have made the voyage alone.

My visits to all the Norman resorts and coasts referred to in this book were often facilitated by the knowledge and friendship of Jacques Caumont, Jennifer Gough-Cooper, Bertrand Dorny, and Anne Walker. My warmest thanks go to them for participating in such generous ways in my researches.

For various courtesies, vital information, and help in obtaining photographs, I want also to thank Joseph Baillio, Anne-Marie Bergeret, Jacques Caumont, Francis Dupuy, Marcia Erickson, Jacques Fischer, Peter Fischer, Katsunori Fukaya, Tokiko Goto, Jennifer Gough-Cooper, Nathan Halpern, Ay-Whang Hsia, Barbara Mirecki, Charles Moffett, Dr. Peter Nathan, Elisabeth Royer, Janet Traeger Salz, Shinichi Segi, Susan Alyson Stein, Charles Stuckey, Carol Forman Tabler, Martine Thomas, Gary Tinterow, and Paul Tucker.

Gillian Malpass has encouraged this book from the beginning, and has closely supervised its design and production with a combination of tact and skill that I've seldom encountered. I'm also grateful to Sheila Lee for her talent and persistence in scouting out photographs.

South Hadley, Massachusetts, February 1994

2. Detail of fig. 39.

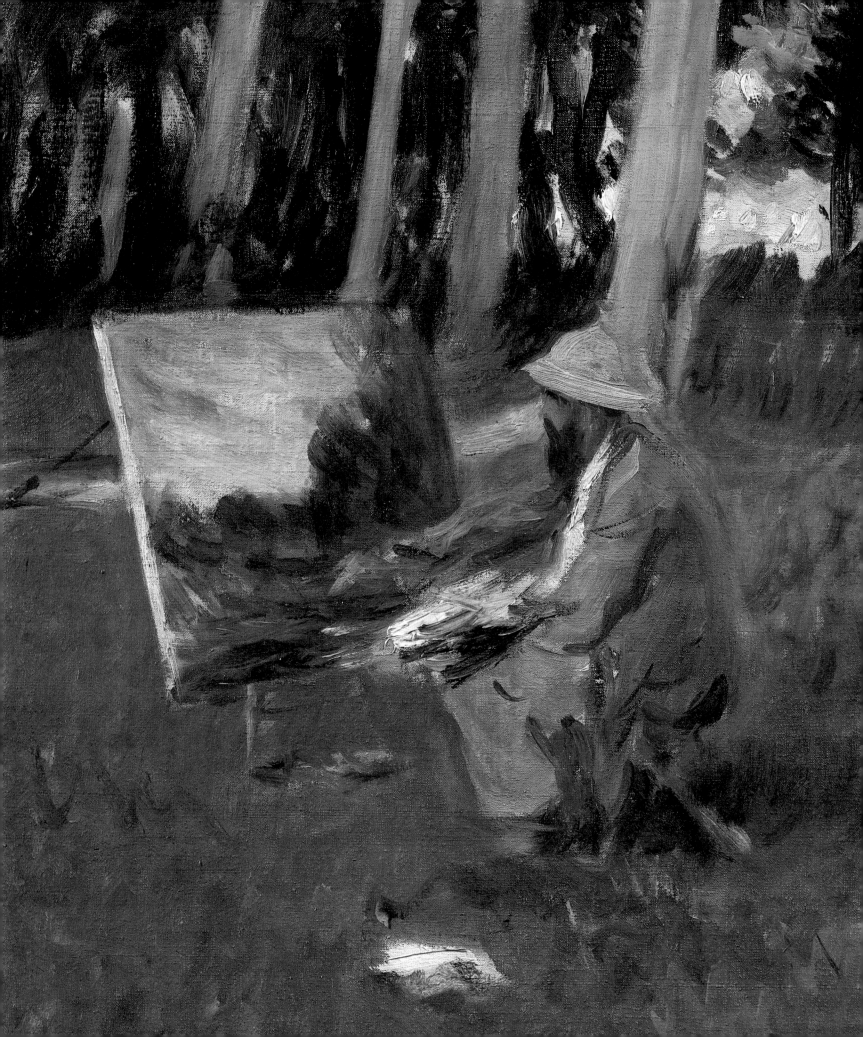

Illustrations

Works are by Monet and are oil on canvas, unless otherwise indicated. Dimensions are in centimeters and height precedes width.

1. Detail of fig. 57.
2. Detail of fig. 39.
3. Detail of fig. 105.
4. Detail of fig. 62.
4a. Detail of fig. 27.
5. Northern France, showing Monet's sites.
6. Detail of fig. 31.
7. Detail of fig. 93.
8. Detail of fig. 17.
9. Detail of fig. 16.
10. *La Pointe de la Hève at Low Tide*, 1865. 90 × 150. W 52. The Kimbell Art Museum, Fort Worth, Texas.
11. *The Port of Honfleur*, 1868. 148 × 226. W 77. Collection unknown, presumed destroyed. Photo © document Archives Durand-Ruel.
12. Willem van de Velde, *Sea with Bathers*, 1653. 42 × 48. Hermitage, Leningrad.
13. *The Beach at Sainte-Adresse*, 1867. 75 × 101. W 92. The Art Institute of Chicago, Mr. and Mrs. Lewis Larned Coburn Memorial Collection, 1933. 439.
14. *Regatta at Sainte-Adresse*, 1867. 75.5 × 101.5. W 91. The Metropolitan Museum of Art, New York, Bequest of William Church Osborn, 1951.
15. Adriaen van de Velde. *The Beach at Scheveningen*, 1658. 50 × 74. Kassel, Staatliche Gemäldegalerie.
16. *Sainte-Adresse, Fishing Boats on the Shore*, 1867. 57 × 80. W 93. Gift (partial and promised) of Catherine Gamble Curran and Family, in Honor of the 50th Anniversary of the National Gallery of Art, © 1994 Board of Trustees, National Gallery of Art, Washington, D.C.
17. *Terrace at Sainte-Adresse*, 1867. 98 × 130. W 95. The Metropolitan Museum of Art, New York, Purchased with special contributions and purchase funds given or bequeathed by friends of the Museum, 1967.
18. Jules Després, *Sainte-Adresse towards the Cap de la Hève*, from Constant De Tours, *Du Havre à Cherbourg* (Paris, c.1890), p. 59.
19. *Garden of the Princess*, 1867. 91 × 62. W 85. Allen Memorial Art Museum, Oberlin College, Ohio, R.T. Miller, Jr. Fund, 1948.
20. Joseph Vernet, *A Sea-Shore*, 1776. Oil on copper, 62.2 × 85.1. National Gallery, London.
21. Eugène Boudin, *Approaching Storm*, 1864. Panel, 36.6 × 57.9. The Art Institute of Chicago, Mr. and Mrs. Lewis Larned Coburn Memorial Collection, 1938. 1276.
22. J.B. Jongkind, *Shore at Sainte-Adresse*, 1866. 33.5 × 56. Private collection.
23. Frederik H. Kaemmerer, *The Beach at Scheveningen, Holland*, 1874. 69.9 × 139.7. © 1994 Sotheby's Inc. The Masco Collection.
24. *Luncheon*, 1868–9. 230 × 150. W 132. Städelsches Kunstinstitut, Frankfurt.
25. *Stormy Sea at Etretat*, 1868. 66 × 131. W 127. Musée d'Orsay, Paris. Photo © RMN, Paris.
26. Detail of fig. 25.
27. *The Jetty at Le Havre*, 1868–9. 147 × 226. W 109. Private collection.
28. *The Porte d'Amont, Etretat*, c.1868. 81 × 100. W 258. Harvard University Art Museums, Cambridge, Mass., Gift of Mr. and Mrs. Joseph Pulitzer, Jr.
29. Etretat, the Cauldron at high tide. Postcard, c.1905–10, from J.-P. Thomas, *Etretat autour des années 1900* (Fécamp 1985), pl. 28. Photo Thomas Jacob.
30. Detail of fig. 34.
31. *The Beach at Trouville*, 1870. 38 × 46. W 158. National Gallery, London.
32. *Camille on the Beach at Trouville*, 1870. 38 × 47. W 160. Collection of Mrs. John Hay Whitney.
33. *The Boardwalk at Trouville*, 1870. 52.1 × 59.1. W 156. Wadsworth Atheneum, Hartford, The Ella Gallup Sumner and Mary Catlin Sumner Collection.
34. *Hôtel des Roches Noires*, Trouville, 1870. 80 × 55. W 155. Musée d'Orsay, Paris. Photo © RMN, Paris.
35. Detail of fig. 33.
36. Detail of fig. 14.
37. Eugène Boudin, *The Beach at Trouville*, 1865. Panel, 34.5 × 57.5. Toledo Museum of Art, Purchased with funds from the Libbey Endowment, gift of Edward Drummond Libbey.
38. Detail of fig. 39.
39. *Cliffs of Les Petites Dalles*, 1880. 59 × 75. W 621. Museum of Fine Art, Boston, Denman Waldo Ross Collection.
40. *Ships Careened in the Harbor of Fécamp*, 1881. 80 × 66. W 645. Collection unknown. Photo © document Archives Durand-Ruel.
41. *The Sea Viewed from the Cliffs at Grainval*, 1881. 60 × 75. W 648. Private collection, Japan. Photo Isetan, Tokyo.
42. *The Cliff at Grainval, near Fécamp*, 1881. 61 × 80. W 653. Private collection, Japan. Photo Muromachi Fine Art Inc.
43. J. Gauchard, *View from Grainval towards Le Tréport*, from Adolphe Joanne, *Géographie du Département de la Seine-Inférieure* (Paris, 1881).
44. Tony Johannot, *Two Women on the Edge of a Cliff*, c.1835–45. Watercolor and gouache, 42.5 × 35.5. Collection unknown.
45. J.-F.Millet, *The Cliffs at Gréville*, 1867. Pastel, 43.5 × 54. Ohara Museum, Kurashiki.
46. Edgar Degas, *The Tub*, c.1886. Pastel, 70 × 70. Hill-Stead Museum, Farmington, Conn.
47. Edgar Degas, *Landscape*, c.1890–2. Pastel, 46 × 54.6. Courtesy Galerie Jan Krugier, Geneva.
48. *The Pointe de l'Ailly, Low Tide*. 1882. 60 × 100. W 778. Mr. and Mrs. Nathan L. Halpern.
49. *Cliff Walk at Pourville*, 1882. 65 × 81. W 758. The Art Institute of Chicago, Mr. and Mrs. Lewis Larned Coburn Memorial Collection, 1933. 443.
50. *Rocks at Pourville, Low Tide*, 1882. 63 × 77. W 767. Memorial Art Gallery of the University of Rochester, New York, Gift of Mrs. James Sibley Watson.
51. *The Cliffs at Pourville*, 1882. 65 × 81. W 755. Nationalmuseum, Stockholm.
52. Fernand Fau, engraved by Rougeron Vigneret, *Gathering Mussels at the Roches Noires*, from Constant De Tours, *Du Havre à Cherbourg* (Paris, c.1890), p. 83. Photo Thomas Jacob.
53. Detail of fig. 49.
54. *Pourville, Flood Tide*, 1882. 65 × 81. W 740. The Brooklyn Museum, Gift of Mrs. Horace Havemeyer.
55. Detail of fig. 54.
56. Detail of fig. 57.

3. Detail of fig. 105.

57. *The Coastguard's Cottage at Pourville*, 1882. 61 × 88.3. W 805. Courtesy of the Museum of Fine Arts, Boston, Bequest of Anna Perkins Rogers.

58. Detail of fig. 59.

59. *Cliffs at Varengeville*, 1882. 65 × 81. W 806. Photo courtesy Lefèvre Gallery, London.

60. *Gorge of the Petit Ailly, Varengeville*, 1897. 65.4 × 92.1. W. 1452. Harvard University Art Museums, Cambridge, Mass., Gift of Ella Milbank Foshay.

61. Detail of fig. 60.

62. *The Church of Varengeville, Setting Sun*, 1882. 65 × 81. W 727. Barber Institute of Fine Arts, University of Birmingham.

63. *The Church of Varengeville, Effect of Morning*, 1882. 60 × 73. W 794. Private collection. Photo courtesy Christie's, New York.

64. Detail of fig. 63.

65. J.M.W. Turner, *Lake Avernus: Aeneas and the Cumaean Sibyl*, 1814–15.

66. Detail of fig. 86.

67. Etretat, looking northwest. (Color postcard.)

68. Etretat, looking southwest. (Color postcard.)

69. Etretat, looking toward the Manneporte. (Color postcard.)

70. Maurice Davanne, *Etretat from the "Chambre des demoiselles,"* 1851. Photograph, 23.2 × 29.9. Yale University Art Gallery, New Haven, Conn.

71. Alexandre-Jean Noël, *Etretat*, c.1787, from Prosper Dorbec, *L'art du paysage en France* (Paris, 1925), pl. 2. Photo Thomas Jacob.

72. Clarkson Stanfield, engraved by R. Brandard, *Rocks of Etretat*, originally for Leitch Ritchie, *Travelling Sketches on the Sea-coasts of France*, London 1834, foll. p. 54, sold currently as postcard in Etretat.

73. D. Lancelot, engraved by August Trichon, *The Porte d'Aval and the Needle of Etretat*, from Eugène Chapus, *De Paris au Havre*, Paris 1885, p. 235. Photo Thomas Jacob.

74. Eugène Le Poittevin, *Bathing at Etretat*, 1865–6. Panel, 21 × 48.5. Private collection. Variant of the painting exhibited in the Salon of 1866 (Musée de Troyes). Photo courtesy of Elisabeth Royer.

75. Maurice Davanne, *Eugène Le Poittevin's Studio-House "La Chaufferette" at Etretat*, 1851. Postcard processed in 1923, from J.-P. Thomas, *Etretat autour des années 1900* (Fécamp 1985), pl. 249. Photo Thomas Jacob.

76. Maurice Davanne, *Fishermen's Workshop, Etretat*, 1851. Postcard processed in 1923, from J.-P. Thomas, *Etretat autour des années 1900* (Fécamp 1985), pl. 248. Photo Thomas Jacob.

77. Detail of fig. 94.

78. Gustave Courbet, *The Wave*, 1870. 117 × 160.5. Fernier 747. Musée d'Orsay, Paris. Photo © RMN, Paris.

79. Gustave Courbet, *Cliff at Etretat after a Storm*, 1870. 133 × 162. Fernier 745. Musée d'Orsay, Paris. Photo © RMN, Paris.

80. Detail of fig. 79.

81. Laundresses at Etretat. Postcard from J.-P. Thomas, *Etretat autour des années 1900* (Fécamp 1985), pl. 145. Photo Thomas Jacob.

82. *Etretat, Rough Seas*, 1883. 81 × 100. W 821. Musée des Beaux-Arts, Lyon.

83. *The Cliff and the Porte d'Aval*, 1883. 60 × 81. W 819. Private collection.

84. Detail of fig. 83.

85. Detail of fig. 82.

86. *Etretat, Setting Sun*, 1883. 60.5 × 81.8. W 817. North Carolina Museum of Art, Raleigh, Purchased with funds from the State of North Carolina.

87. *Fishing Boats and the Porte d'Aval*, 1883. 73 × 100. W 822. Wallraf-Richartz-Museum, Cologne. Photo Rheinisches Bildarchiv.

88. The Hôtel Blanquet at Etretat, from Compagnie des chemins de fer de l'ouest, *Album-Guide illustré des voyages circulaires, Côtes des Normandie* (Paris 1881), p. 39.

89. *Fishing Boats*, 1883. 65 × 92. W 823. Collection unknown. Photo © document Archives Durand-Ruel.

90. *The Beach at Etretat*, 1883. 65 × 81. W 828. Musée d'Orsay, Paris. Photo © RMN, Paris.

91. Detail of fig. 90.

92. Eugène Isabey, *The Beach at Granville*, 1863. 83 × 124. Musée de Laval, Laval. Photo courtesy Musée du Vieux Granville.

93. *Rough Weather at Etretat*, 1883. 65 × 81. W 826. The National Gallery of Victoria, Melbourne, Felton Bequest, 1913.

94. *Etretat, the Beach and the Porte d'Aval*, 1884. 60 × 73. W 907. Marauchi Art Museum, Tokyo.

95. Gustave Courbet, *Cliff at Etretat*, 1869. 76.2 × 123.1. Fernier 719. Birmingham University, Barber Institute of Fine Arts.

96. *The Manneporte, Etretat*, 1883. 65 × 81. W 832. The Metropolitan Museum of Art, New York, Bequest of William Church Osborn, 1951.

97. Detail of fig. 96.

98. *The Needle at Etretat, Low Tide*, 1883. 60 × 81. W 831. Collection unknown. Photo © document Archives Durand-Ruel.

99. Detail of fig. 101.

100. Auguste Renoir, *Field of Bananas*, 1881. 51.5 × 63.5. Musée d'Orsay, Paris. Photo © RMN, Paris.

101. *The Moreno Garden at Bordighera*, 1884. 73 × 92. W 865. Collection of the Norton Gallery of Art, West Palm Beach, Florida.

102. *Villas at Bordighera*, 1884. 73 × 92. W 856. Santa Barbara Museum of Art, Bequest of Katherine Dexter McCormick in memory of her husband, Stanley McCormick.

103. Detail of fig. 102.

104. Detail of fig. 127.

105. John Singer Sargent, *Claude Monet Painting at the Edge of a Wood*, c.1885. 54 × 64.5. Tate Gallery, London.

106. *Meadow with Haystacks near Giverny*, 1885. 73.6 × 93.4. W 995. Museum of Fine Arts, Boston.

107. *Wintry Landscape, Etretat*, 1885. 65 × 81. W 1020. Collection unknown. Photo © document Archives Durand-Ruel.

108. *Etretat, the Beach, and the Porte d'Amont*, 1885. 60 × 81. W 1009. Collection unknown. Photo © document Archives Durand-Ruel.

109. *The Beach and the Porte d'Amont*, 1883. 67.5 × 64.5. W 1012. The Art Institute of Chicago, Gift of Mrs. John H. Winterbotham in memory of John H. Winterbotham; the Joseph Winterbotham Collection, 1964. 204.

110. Joseph Pennell, *Falaise d'Amont, Etretat*, from Percy Dearmer, *Highways and Byways in Normandy* (London, 1900), p. 331. Photo Thomas Jacob.

111. Eugène Boudin, *Etretat, the Porte d'Amont*, 1887. 47 × 65. Collection unknown. Photo courtesy Christie's, London.

112. *Fishing Boats*, 1885. 73 × 92. W 1028. The Seattle Art Museum, 25% fractional interest gift of a private collection, Seattle.

113. Etretat, the beach and the Porte d'Amont, 1888. Photo Roger-Viollet.

114. Detail of fig. 109.

115. *Boats in Winter Quarters*, 1885. 65.5 × 81.3. W 1024. The Art Institute of Chicago, Charles H. and Mary F.S. Worcester Collection.

116. *The Departure of the Fleet*, 1885. 73 × 92. W 1025. The Art Institute of Chicago, Mr. and Mrs. Potter Palmer Collection.

117. Etretat, winching a boat. Postcard, from J.-P. Thomas, *Etretat autour des années 1900* (Fécamp 1985), pl. 127. Photo Thomas Jacob.

118. Théodore Rousseau, *The Jetty at Granville*, 1831. Panel, 17.8 × 42.9. Wadsworth Atheneum, Hartford, The Ella Gallup Sumner and Mary Catlin Sumner Collection.

119. Camille Corot, *Port de la Rochelle*, 1851. 50 × 71. Yale University Art Gallery, New Haven, Conn., Bequest of Stephen Carlton Clark.

120. Detail of fig. 115.

121. *The Cliff of the Porte d'Aval*, 1885. 65 × 81. W 1018. Collection unknown. Photo courtesy Sotheby's, London.

122. George Inness, *Etretat*, 1875. 76.2 × 114.3. Wadsworth Atheneum, Hartford, The Ella Gallup Sumner and Mary Catlin Sumner Collection.

123. Etretat, the beach and the Porte d'Aval, c.1888. Photo Roger-Viollet.

124. *Etretat, Rainy Weather*, 1885–6. 60.5 × 73.5. W 1044. National Gallery, Oslo.

125. Detail of fig. 124.

126. *Fishing Boats Leaving the Port, Etretat*, 1885–6. 60 × 81. W 1047. Musée des Beaux-Arts, Dijon, legs Robin.

127. *The Needle and the Porte d'Aval*, 1885. 65 × 81. W 1034. Sterling and Francine Clark Art Institute, Williamstown, Mass.

128. *The Manneporte, Viewed from the West*, 1885. 65.5 × 81.3. W 1037. Museum of Art, Philadelphia, The John G. Johnson Collection.

4. Detail of fig. 62.

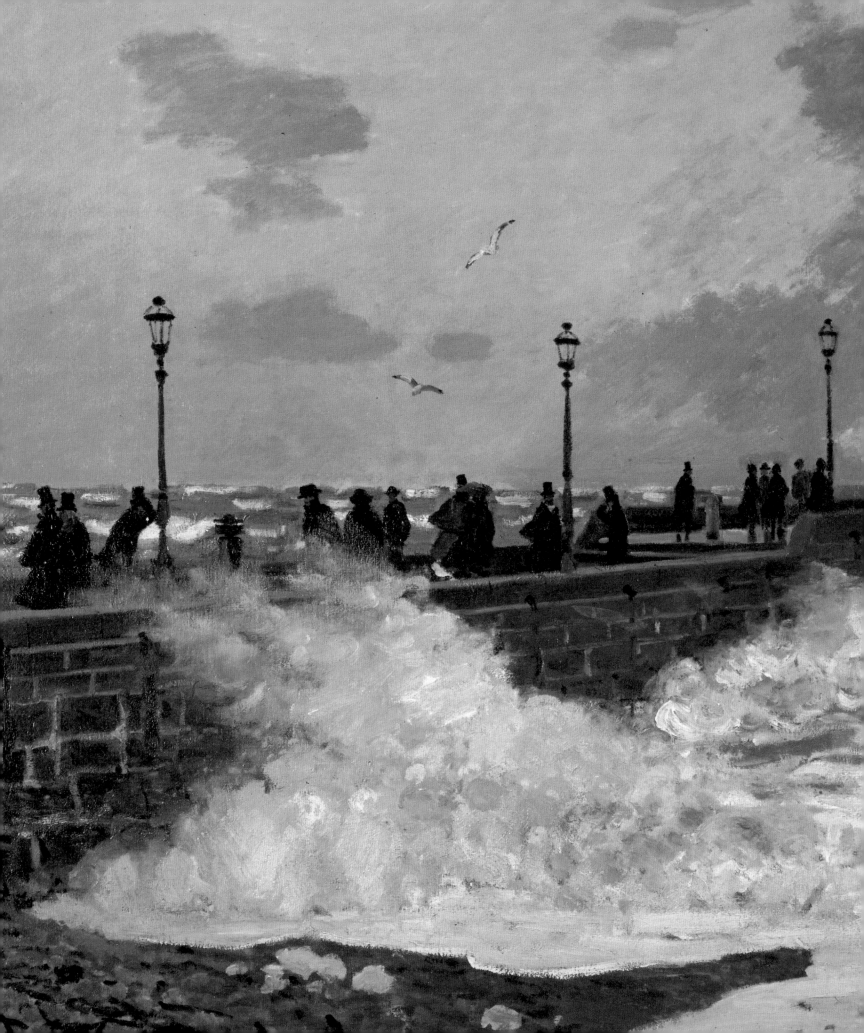

129. *The Manneporte, Etretat,* 1885–6. 81.3 × 65.4. W 1052. The Metropolitan Museum of Art, New York, Bequest of Lizzie P. Bliss, 1931.

130. *The Manneporte at High Tide,* 1885–6. 65 × 81. W 1035. Mrs. A.N. Pritzker, Chicago.

131. Detail of fig. 130.

132. Claude Lorrain, *Landscape with Perseus, or The Origins of Coral,* 1674. 100 × 127. By kind permission of Viscount Coke and the Trustees of Holkham Estate.

133. Joseph Wright, *Grotto at Salerno, c.*1774–80. 101.5 × 127. Yale Center for British Art, New Haven, Conn., Paul Mellon Collection.

134. *The Manneporte, Etretat,* 1885–86. 92 × 73. W 1053. Collection unknown.

135. *The Needle Seen through the Porte d'Amont,* 1885–6. 73 × 60. W 1040. Collection unknown. Photo © document Archives Durand-Ruel.

136. Detail of fig. 28,

137. Detail of fig. 138.

138. *The Needle Seen through the Porte d'Aval,* 1885–6. 73 × 92. W 1050. Mr. and Mrs. Nathan L. Halpern, New York.

139. Three successive views of the Porte d'Aval. Photographs by the author, 1991.

140. Gustave Courbet, *Beach at Etretat, Sunset,* 1869. 54 × 65. Fernier 722. Private collection.

141. Detail of fig. 143.

142. The "Fort de Fréfossé," built *c.*1887, destroyed in 1911. Postcard, 1903.

143. *Banks of the Seine at Jeufosse, Autumn,* 1884. 54.6 × 73.6. W 913. Mr. and Mrs. Nathan L. Halpern, New York.

144. *Under the Poplars, Sunlight Effect,* 1887. 74.3 × 93. W 1135. Staatsgalerie, Stuttgart.

145. Pierre Outin, *The Look-Out Point,* 1878. 59 × 98.5. Collection unknown.

4a. Detail of fig. 27.

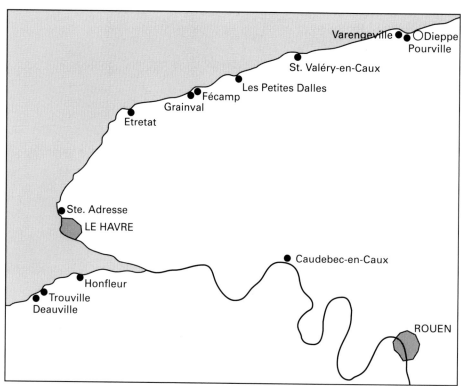

Varengeville ● ○Dieppe
Pourville
St. Valéry-en-Caux
Les Petites Dalles
●Fécamp
Grainval
●Etretat
●Ste. Adresse
LE HAVRE
●Caudebec-en-Caux
●Honfleur
●Trouville
Deauville
ROUEN

5. Northern France, showing Monet's sites.

A Note on Style

Short titles are used to refer to all publications in the Bibliography, which consists of a single alphabetical list, preceded by annotations.

Well-known artists are usually referred to by their surnames only, but artists' full names and dates where known will be found in the Index.

I have made constant use of the catalogue by Daniel Wildenstein and his collaborators, *Claude Monet, biographie et catalogue raisonné* (Lausanne, 5 vols., 1974–91), abbreviated simply as "W," followed by suitable indications for volume, page, or letter. "W" followed by an arabic numeral refers to a catalogue entry. Where known, present locations are provided, except for groups of paintings which I list usually only by their "W" numbers.

Dimensions of pictures are given in centimeters, height preceding width. Oil on canvas is assumed, unless otherwise described. English titles are used unless the original French has special significance.

I have made my own translations from the French except where otherwise credited.

Romantic and Romanticism are capitalized when the early nineteenth-century movement is understood, and in lower case when a broader, more timeless use is meant.

To counter the assumption that a genderless person is male, I occasionally introduce "she" or "her" instead of "he" or "his." However, for contexts in which male artists are consistently the issue, I use the masculine.

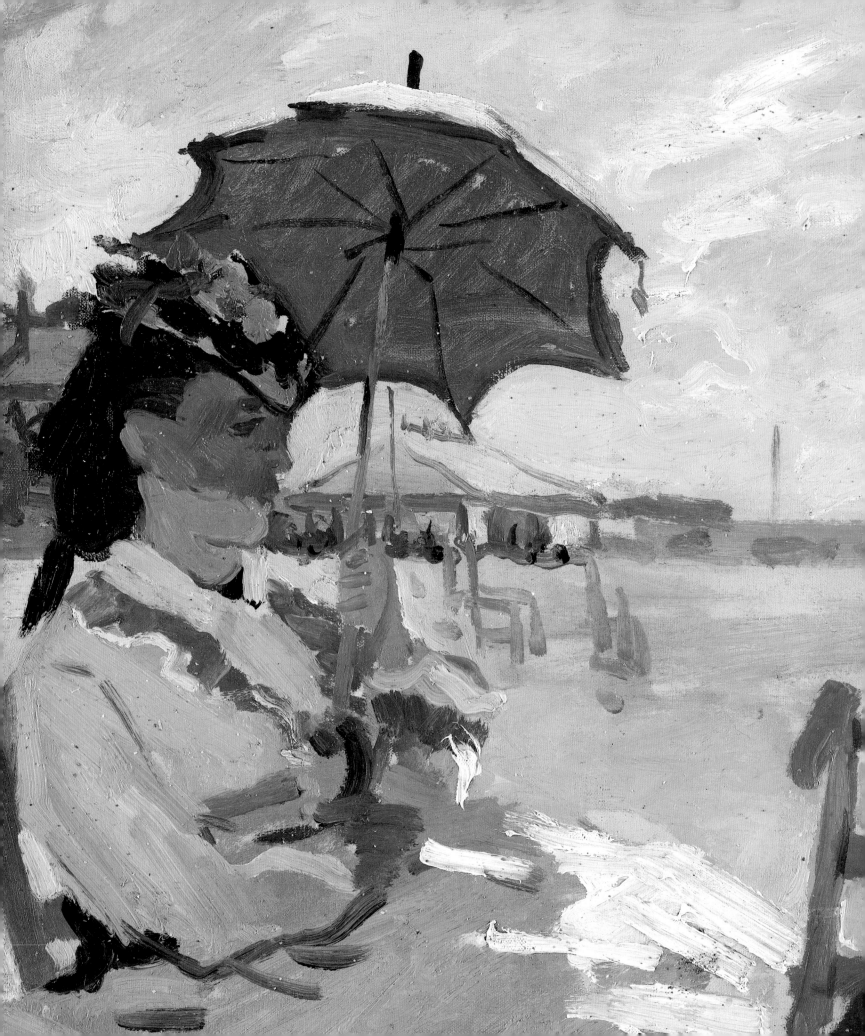

Introduction: Tourism and Painting

This book began with a simple observation I made when I first visited Etretat. I was there to see if I might learn something by standing on the same spots from which Monet made his pictures. I was familiar with old prints, paintings, and photographs of the resort that give a rather complete idea of what it looked like to visitors in the 1880s, and with texts that showed what was omitted in those pictures. Although there have been many changes since then, the main outlines of the landscape have not changed, and most of Monet's viewpoints can easily be found. My biggest surprise was to see just how carefully he edited his field of vision so as to exclude nearly all signs of the village. He began many pictures of seemingly isolated promontories while standing on the resort's beach or on pathways just above. In either case the slightest shift of the visual frames he employed would have disclosed portions of buildings. From other spots he did indeed paint the beachfront and the bay, but he usually omitted Etretat's buildings entirely by angling his frame towards the sea. When, finally, I realized that he did many pictures from hotel windows, it became apparent that he was painting only one aspect of the vacationer's experience: the famous cliffs, the seafront, and the bay as they could have appeared decades earlier. He was deliberately shutting out of his compositions the tourist hotels, the bathers, and other obvious signs of the fishing port's transformation into a popular resort. I wondered why, since he was supposedly a naturalist who painted what he saw. Why did he "see" only certain features of the landscape?

I hope to answer that question in the chapters that follow, but I should first make some observations about the way Monet painted his views of Etretat. The word "view," after all, implies both what is being seen in nature, and the subjective act of seeing. The former is more obviously a social construction, and more susceptible to the historian's work. Monet brought with him foreknowledge of the famous views, foreknowledge whose large features we can reconstruct with reasonable clarity. The subjectivity of seeing is much more resistant to analysis, but although we cannot look into Monet's mind, at least we have the paintings and can make reasonable deductions about their genesis. Monet was determined to make the views his own, and he stared closely at nature. He developed a technique in which brushwork, color, and composition could register his responses to nature, apparently instinctual responses that marked out his originality.[1]

To a certain extent, then, Monet seems dependent upon nature, as though he were freshly copying its particular aspects or effects without the intervention of artistic conventions. "Aspects" and "effects," however, like "views," involve the perceiving mind as well as nature, and so we know that Monet could not really copy nature, he *constructed* his pictures. (An obvious proof of this is that he finished most of his pictures in his studio, away from the sites, although he hid this practice from his interviewers.) In the analyses that follow I shall write about his sites usually in terms of an exterior reality, and about his pictures as conscious constructions. Both have social elements, and both involve the artist's subjectivity, but for the sake of expository clarity I shall take the risks involved in separating them. When I write "construction," I shall be emphasizing the painter's artful procedures born of the experience of his craft, but I hope not to deny that such procedures involved intensive looking at nature. I shall pay special attention to Monet's way of framing Etretat, particularly to the way he excluded much that lay in front of him.

In studying Monet's exclusions I have found that he recapitulated some of the practices of tourism. Visitors to Etretat went there in order to see its famous archways vaulting over the sea, to walk up on the cliffs and look out over the sea, and to observe the comings and goings of the local fisherfolk. But to see was to exclude. Like Monet, visitors used newly improved roads and transport to reach the resort, stayed in local hotels, and frequented village restaurants, but for the most part this is not what they "saw." Although they participated in the social organization of vacationing and were surrounded by other visitors and by the institutions of the leisure industry, many of them sought the solitary views that Monet painted. Eventually, like Monet, they carried away images of the pre-modern landscape. In

6. Detail of fig. 31.

effect, however, both painter and vacationer arrived with such images already formed in their minds. No matter how personal an encounter with nature, it had been socially constructed by the written and visual texts that guided the visitors' steps. When examining this assortment of texts, the historian of Monet becomes to a certain extent the historian of tourism.

We shall see in coming chapters that Monet's vantage points at Etretat and at other Channel sites had been well established earlier in the century. Travel books told vacationers where the pathways were, the precise spots from which to have the favored views, and what they would see when they arrived there. They often told them what they would feel! Thus like the tourist, when Monet went along the Channel coast, he chose pre-established vantage points, even though he made the views his own by transposing portions of them into art. Travelers also could make these views their own by solitary contemplation from the same spots. Modern writers on tourism have stressed that such viewings constituted an active social force, that they were not merely passive sightings but agents in a whole set of changes in the land and its people. Access to such views actually altered the landscape, for pathways were beaten down, literally mapping out the viewpoints. Prior knowledge guided vacationer and painter, who were therefore not at all independent of society although in search of a unique experience. In fact, each was deliberately recapitulating a social experience in order to savor it alone, much as we do when looking at a Monet in a museum.

A singular proof of the active force of the sought-after views is found in the transformation of Etretat and similar ports from fishing villages to resorts. Between the 1830s, the decade of most so-called discoveries of these sites by a few artists and writers, and the 1860s, when resort activity was thoroughly established, fisherfolk sold out to entrepreneurs who built hotels, casinos, inns, and villas. Some fishermen became bathing attendants, their wives and daughters, laundresses and servants to vacationers. Chambers of commerce encouraged the retention of traditional costume and rituals; these constituted performances for visitors. Monet's paintings unwittingly paralleled these performances, for, by eliminating nearly all the changes in Etretat, he presented the landscape and village as it had been a generation earlier. He avoided the gregarious half of tourism, its hotels, casinos, and bathers, and limited his compositions to the other half, the individual responses to a spectacular natural setting uncontaminated by obvious marks of tourism.

Before proceeding further, I should discuss the rather unclear terms "tourism" and "tourist," "vacationing" and "vacationer." The two pairs cannot always be separated, although I shall attempt to take account of their differences when I use the terms. "Tourism" is the generic term and nearly the only one used by modern writers when discussing all the circumstances attached to vacation resorts and pleasurable travel away from home.[2] I shall therefore employ it for the general phenomenon of visiting the coast of the English Channel. However, much as I value the stimulating writing about tourism that has appeared in recent decades (coinciding with the rise of the tourist industry to first place in international commerce), I regret that "vacationing" is not often enough shaken out of this multi-branched phenomenon for separate examination.

Let us consider the types of visitors to Etretat in a summer of the 1880s, not in refined discrimination, but in large categories. Some would be tourists from abroad generally unfamiliar with the site but aware of it from travel accounts. They would be the furthest removed from assimilation and the ones most likely to treat the resort as a short-lived performance on a foreign stage. Others would be tourists from elsewhere in France, more familiar with a resort village of this kind, and yet, mainly from Paris and other large cities, they would, like foreigners, be of a class and a culture apart from the locals and from regional visitors (themselves distinguishable from locals, but classed with them by more distant visitors). Both foreign and French visitors from distant places are properly called tourists, even if we can distinguish between them in certain kinds of attitude and experience.

The remaining type of visitor is the French vacationer. Unlike tourists who would typically stay for a few days, vacationers settled into the resort for one or more weeks, some for the whole bathing season. One of their aims was to relax and bathe in a familiar setting, and they therefore lacked the experience of strangeness or quaintness that the tourist sought. Some of them came from a distance and would not be easily distinguished from tourists, but many came from cities and villages in Normandy. A range of villas, hotels, pensions, rentals, and restaurants catered to the differing incomes of vacationers, who represented a rather broad spectrum of the bourgeoisie, from wealthy summer residents who had their own villas to the less well-off who stayed in modest rooms. Whether short-term visitors or seasonal residents, tourists and vacationers shared in what we have to call, for simplicity's sake, the tourist industry. We could distinguish their different interests, but their common actions in Etretat, as in other Channel villages, altered it from fishing port to resort, and therefore we are entitled to consider the impact of tourism as a single large phenomenon. I shall nonetheless use "vacationer" and "visitor" as often as "tourist" to remind the reader that we are not always

7. Detail of fig. 93.

involved with the same responses to Etretat and to the other resorts that figure in this book.

Most modern writers on tourism concentrate on the first of these types, tourists outside their own country, and usually posit a relative lack of familiarity with a given site; they also concentrate upon twentieth-century tourism. The happy exception is Andrew Hemingway's study of the imagery of British seaside resorts of the early nineteenth century in one chapter of his superlative book (Hemingway 1992). However, even if they do not discuss painting, many insights offered by James Buzard, Dean MacCannell, and John Urry (see Bibliography) can be applied to all classes of resort visitors and are of great value in interpreting Monet's pictures and their place in the rise of modernism.

For many people, as Urry and Buzard remind us, there is a slight pejorative in the term "tourist," which is frequently glossed as "mere tourist" or "only a tourist," implying that the speaker is someone else who prefers such epithets as "traveler" or "nature-lover." This is usually a member of a cultured élite, an upper-class traveler called the "anti-tourist" by Buzard. Buzard's term takes its meaning from opposition to the ordinary tourist, who is of a lower class. That is, the self-aware traveler finds her distinction precisely by doing or feeling that which she believes the mere tourist neglects: the solitary climb up the cliff at dawn or sunset, the finer appreciation of the view, that which Urry has dubbed "the romantic gaze."[3] Her cultured position above the heights of Etretat is also one that defines her superior class (or would-be class); it is what allows her to appreciate Monet when she encounters his work in a gallery. This does not mean that Monet's clients of the 1880s and 1890s had necessarily visited Channel resorts, but they were well-to-do people who associated travel with the fine arts, and who were ready to place a soulful rendering of a famous seascape on the walls of their homes in Chicago or Paris. For a few upper-class travelers such an acquisition responded to an experience that merged travel, nature, and fine arts, whereas the less wealthy tourist, participant in Urry's "collective gaze," had to settle for a chromo or a postcard. To own an oil painting was reserved to a few, but to enjoy it on the walls of a gallery or in a reproduction was equally a way of identifying one's superior class, of separating oneself from those unfortunates who could only buy a postcard.

Despite the usefulness of these distinctions, both Buzard and Urry make the élitist nature-lover diverge too much from the tourist of lesser means and culture. The separation must not become a rigid one, even if it confesses a gap (whether real, or wished-for) between social classes. Is it not true that the anti-tourist and the tourist are commonly stances adopted by the same person at different times? Tourists use the social facilities of hotels, restaurants, and transport to permit their solitary walks in nature, so Buzard's anti-tourist is not necessarily a separate person, but often a momentary *persona* during the performance of tourism. To understand both Monet's art and also our reaction to it, we should remember that each of us, like him, can be both tourist and solitary nature-lover in the same day. We will at one time indulge ourselves in Urry's "romantic gaze," but in front of the postcard stand or in the restaurant, we share in his "collective gaze." When I write about Monet in the context of tourism, I shall frequently point out that his pictures seem to embody only the romantic gaze, and that he took his distance from the subjects and activities characterized by the collective gaze. At times this might seem to imply that he was not like a tourist, but I hope the reader will recall that the tourist experience involves both the individual and the collective.

I should also explain why I have limited a study of Monet and tourism to twenty years along the coast of Normandy (my only exception is his excursion to Bordighera in 1884). After his last campaign at Etretat, with which the book ends, Monet occasionally painted at other tourist spots: Belle-Ile in the autumn of 1886, Antibes in 1888, London in 1899, 1900, and 1901, and Venice in 1908. (He also returned to Pourville on the Norman coast in 1896 and 1897, of which more, later.) However, these other campaigns have been well dealt with by Steven Levine (1985), Paul Tucker (1989), James Herbert (1992), and Virginia Spate (1992), and I could add little to their perceptive accounts. The limitation to Normandy gives me the opportunity to study pictures and sites that are unusually well documented in the history of tourism and of painting. They form, as it were, a single story because of their shared culture. Furthermore, these sites and their paintings are saturated in the artist's biography.

Monet, raised in Le Havre, was intimately familiar with the Norman coastline not just as an observer, but as a native. In addition to roaming the cliffs and shores on his own, he was often with family members. He stayed with his aunt at Sainte-Adresse in 1867, where this book begins; he took Camille Doncieux and their child to Etretat in 1868, and to Trouville in 1870. His brother, Léon, vacationed at Les Petites Dalles, and Monet visited him there on several occasions. In the early 1880s the painter went with Alice Hoschedé and their merged families to Pourville and to Etretat (although later he commonly worked away from his family). Therefore, unlike his seasons at Antibes and elsewhere, Monet was at times both painter and family man on the Channel coast, and this links his art

8. Detail of fig. 17.

4

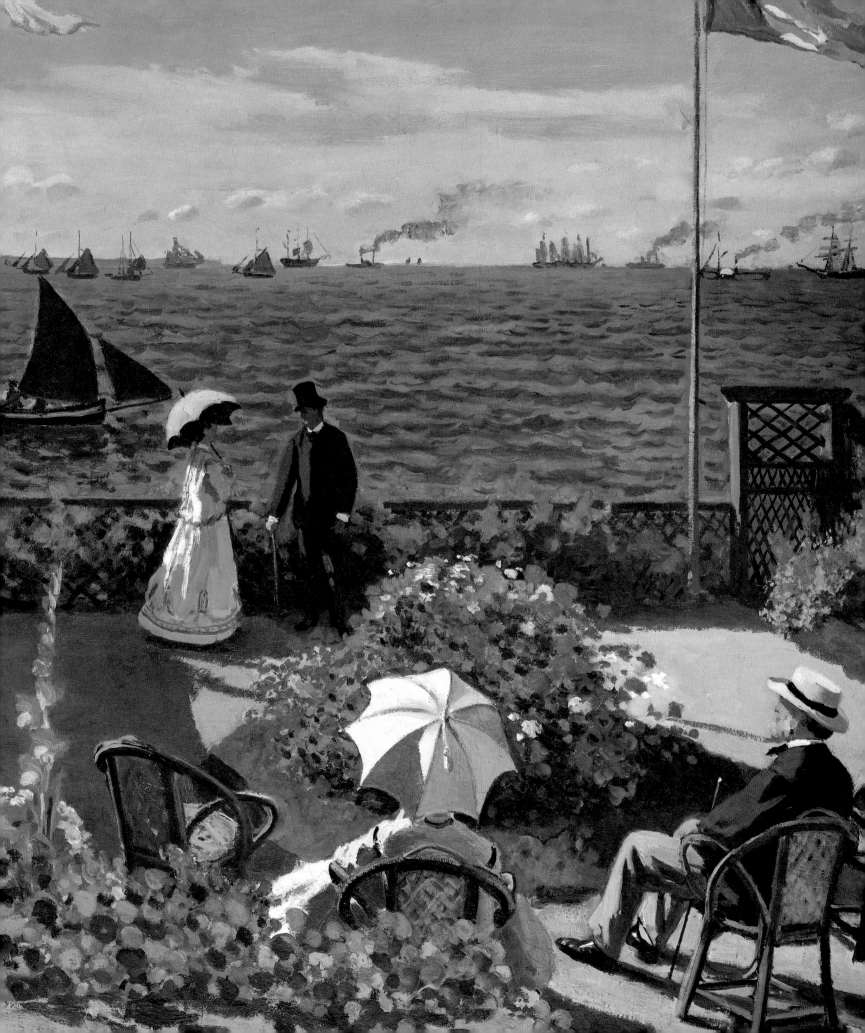

intimately with tourism. His familiarity with the Norman resorts (Belle-Ile, Antibes, London, and Venice were new to him) allows me to assume his knowledge of the sites and their representations, and perhaps to persuade the reader that my analyses do not rely upon mere juxtapositions of paintings with social history, but involve meaningful interrelationships. After all, he could have chosen unfrequented promontories and little-known shores. Instead, he consistently painted well-known resorts which I will take up in order: Sainte-Adresse in 1867, Etretat the following year, Trouville in 1870, Les Petites Dalles in 1880, Fécamp in 1881, Pourville and Varengeville in 1882, and Etretat in successive years from 1883 to 1886.

About one-third of this book is devoted to Monet's work at Etretat in the middle 1880s, because he painted more there than anywhere else away from his home base (eighty-three known paintings). I focus on this resort as a case-history in art and tourism, and for that reason I deal more briefly with his paintings at the other bathing stations. In several dozens of paintings Monet represented the cliffs, the bay, and fishing boats at Etretat, but never the hotels, the villas, the vacationers, nor even the village itself. Years earlier, at Sainte-Adresse in 1867, and at Trouville in 1870, he had painted vacationers as well as the seashore, and hotels and villas as well as the Channel waters. What made him renounce these rather sociable views for the pierced headlands of Etretat, the boats on its foreshore, or views across the bay that all but eliminate the village itself? Some of the answers might be found in Monet's inner self which we cannot know, but there are areas that we can probe: the dialogue between his "motifs," as he called them, and the site itself; the dialogue between his pictures and prior representations; and that between his art and Parisian financial and cultural markets. These areas are not mere background – anathema to the social historian – but interconnections that root paintings in cultural history.

Some readers will think that devotion to one artist is incompatible with cultural history, but of course I do not. We need only ask why Monet's estate at Giverny is now a major tourist attraction to realize how deeply his life and art have penetrated modern culture. I risk the accusation of committing idolatry, but my interest is not in presenting Monet as a "great" artist, but as a case-study in cultural significance (and some will be offended by my unvarnished treatment of his self-interest). I think that Monet has recently been the subject of many more books and articles than Cézanne because his art suits the constantly expanding vogue for tourism and vacationing in mythologized "nature." Indeed, he is a more accessible artist than Cézanne (but not a greater one) because of these associations. The

kind of nature that Cézanne constructed does not bespeak leisure travel and instead takes his viewers into realms of withdrawal, into nature as a more private experience. Monet's pictures usually lack images of people, but they are in a more obvious dialogue with vacationing as a displacement of urban life. Their expression of an underlying anxiety, owing to this dialogue, perhaps also contributes to his current vogue.

No artist's work can be literally unique or we should fail to understand it, since we would lack a shared visual language. A painter uses a social language, no matter how individually interpreted, and for this reason art is built upon art, not just upon an experience of nature. Many artists had recorded the salient views at Etretat and other resorts well before Monet's visits. Among older artists who painted at Etretat, Sainte-Adresse, Trouville, and Varengeville were Monet's mentors Eugène Boudin and J.B. Jongkind, and other artists he knew personally, including Courbet, Daubigny, and Corot. Delacroix had painted at Etretat (Monet owned a watercolor of Etretat by him, but we do not know when he acquired it), and so had many notable mid-century artists, including Eugène Isabey, Charles Mozin, and Eugène Le Poittevin. More obscure topographical artists had also worked along the coast, and their prints appeared in guidebooks, helping establish the views that tourists and Monet subsequently adopted. Courbet is the only artist mentioned in Monet's letters from Etretat (see Chapter Four), but we can be confident that he was aware of this vast visual record, and that he staked his claim to greatness on his own interpretations of famous views. Although I avoid the concept of "influence" (to approximate features of an earlier picture is to share a social language, not to be detoured or influenced), I juxtapose some prints and paintings by other artists to elucidate Monet's particular qualities, and I do this because his art is amenable to historical analysis. It is not an utterly private and individual creation.

In order to expand the context for Monet's seascapes I discuss the connections between his paintings (both their subjects and their technique) and his market. When we read the hundreds of letters reproduced in the catalogue raisonné edited by Daniel Wildenstein (W), we cannot be in doubt that Monet was making a product that he was bent upon marketing. In the accompanying texts in that catalogue, and in some of the recent literature,[4] we learn that Monet was obsessively and often ruthlessly devoted to making money. The 1880s, on which this book concentrates, was the decade of his rise to great fame and considerable wealth; his letters reveal his close attention to all aspects of his market, and his skill at manipulating dealers. He did not live independently of his clients and his exhibi-

tions, nor can his paintings be isolated from the associations that the port's fame had guaranteed to any rendering of Etretat. He was anxious about the reception of his successive campaigns of painting, and it is no accident that his sites along the Channel were tourists' and vacationers' spots whose fame preceded their appearance in Parisian showrooms. Equally beautiful pictures of utterly unknown seacliffs would have lacked the essential ingredient that made a market possible: a shared set of associations with the sites, with the literature about them, and with other artists' renderings of them.

1 From Sainte-Adresse to Trouville, 1867–1870

Monet's first sustained campaign of painting that involved tourism was at Sainte-Adresse, a resort suburb of nearby Le Havre where he spent the summer of 1867. He knew the resort well, for he had grown up in Ingouville, a district of Le Havre that lay between its center and Sainte-Adresse, and his aunt Marie-Jeanne Lecadre was often his host at her villa in the resort. Sainte-Adresse had already figured among paintings the young artist had been doing for several years in the region of the Seine estuary, but none of these represented vacationers. Indeed, seashore visitors are extremely rare in early Impressionist painting. As we shall learn in coming pages, one must pay attention to the presence or absence of vacationers in order to tease out the meanings of paintings of Europe's premier resort coast in the nineteenth century.

In 1864 Monet had painted a number of coastal views at Honfleur, across the estuary from Le Havre, and at Sainte-Adresse, looking forward to his first major appearance in public. The following spring, the twenty-four year old artist showed two seascapes in Paris at the "Salon," the annual exhibition juried by the official Academy of Fine Arts: *The Estuary of the Seine at Honfleur* (W 51), and *Sainte-Adresse, la Pointe de la Hève at Low Tide* (fig. 10). Both were large studio pictures (nearly five feet wide), and their size, commensurate with officially sanctioned landscapes, was a mark of Monet's ambition to establish himself in the public arena. A few liberal critics praised his two Salon paintings, remarking that they demonstrated more robustness than finesse.[1] In *La Pointe de la Hève at Low Tide*, which shows the curving bay of Sainte-Adresse, Monet's hardiness is found in the way he painted the rocks along the shore and the rising slope above. He used flat tints placed side-by-side, often surrounding them with contrasting tones so that these areas seem like a mosaic or patchwork when examined closely. They lack the subtle modeling that would let one area glide into another, as more conventional painters would have done. In the water, too, Monet rendered both waves and rocks with abbreviated gestures and gave his sky a rather shaggy texture.

The few critics who welcomed Monet's Salon entries did so because in some sense they were familiar. Monet displayed an unromantic directness and a broad manner of applying paint that had marked the work of the older men who then formed the vanguard of landscapists familiar to these critics: J.B. Jongkind (whose work provided the closest model for Monet's two Salon pictures), Eugène Boudin, Gustave Courbet, Charles Daubigny, and J.-F. Millet. All of them shared in the development of mid-century naturalism which since the 1830s had looked less often to the classical Mediterranean tradition represented by Nicolas Poussin and Claude Lorrain, and more frequently to Dutch landscape of the seventeenth century and to British painting of the early nineteenth. Favoring this rival northern tradition, mid-century naturalists eliminated some of the subjects that had characterized French landscape painting in the decades before 1830, such as Italian and Mediterranean sites, historic events, and sea battles, and with them they jettisoned also the often theatrical effects of Romantic art. They more commonly painted French sites and developed ways of

9 (facing page). Detail of fig. 16.

10. *La Pointe de la Hève at Low Tide*, 1865. 90 × 150. W 52. The Kimbell Art Museum, Fort Worth.

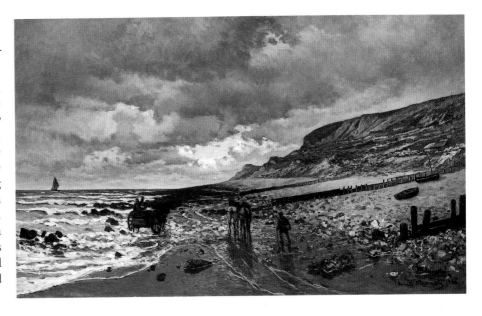

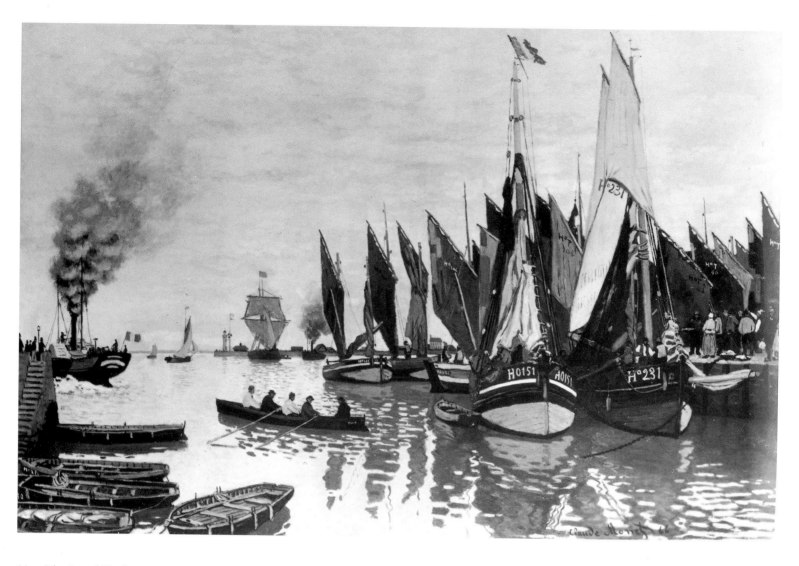

11. *The Port of Honfleur*, 1868. 148 × 226. W 77. Collection unknown, presumed destroyed.

convincing their viewers that they were responding directly to the outdoors more than to the demands of studio practice.

From 1864 to 1867, Monet's seascapes were painted with bold abbreviations that were even more daring than the work of Courbet, Daubigny, or Jongkind, but they also revealed his awareness of Dutch painting. A brash young painter with only a modicum of conventional training behind him, Monet affiliated himself with leading independent artists, but he also sought some support from tradition, particularly from Dutch painting. At Le Havre and Honfleur he represented ships in offshore seas, views along the coast, and commercial ships and fishing boats moving in and out of harbors. His huge *Port of Honfleur* (fig. 11), rejected by the Salon jury in 1867, is one of these. Although lost during World War II, a black-and-white photograph of it shows the two leading aspects of his art: on the one hand, rather flat brushwork and shapes that come forward to the surface and lack the careful transitions of

earlier generations (presumably the reason for rejection); and on the other, a composition and subject that recall Dutch marine painters of the seventeenth century such as Jan van de Cappelle or Willem van de Velde (fig. 12). By then he had come to know Boudin and Jongkind, his real mentors, who were intercessors with the earlier tradition, Jongkind by birthright, Boudin by predilection.

At Sainte-Adresse in 1867, Monet revealed the same mixture of unconventional technique and subject that prompt us to think of Dutch paintings. Both features of his work appear in different proportions in the several seacoast pictures he did that summer. *The Beach at Sainte-Adresse* (fig. 13) and *Sainte-Adresse, Fishing Boats on the Shore* (fig. 16) seem to be fresh responses to the Norman coast, yet they should be linked with a common kind of Dutch seascape that shows fisherfolk along curving shores.[2] Adriaen van de Velde's *Beach at Scheveningen* (fig. 15) is such a picture. Of course, Monet displayed his modernity by altering this basic

10

type. His higher horizons create broad areas of beach that rise upward to form pronounced shapes on the surfaces, whereas in the van de Velde we are so convinced that the beach slopes rapidly away from us that we are unaware of its shape. His more numerous figures, diminishing gradually in size, lead us by stages into depth. Monet's figures and boats do not help form such a clear retreat into space because they are closer to the surface as a result of their flatter rendering. Instead of organizing his illusion of space by prior conventions of modeling in light and dark, he laid his colors down in partly separate areas of light tints. These bespeak the directness, the inventiveness of a technique dedicated to fresh looking, but to anyone anticipating the effect of a van de Velde, they make the picture seem flat and disconnected.

In *The Beach at Sainte-Adresse* we first notice fishing boats and the three local men on the left, but our eye is almost immediately drawn to the seated couple at the edge of the water. Despite their tiny size, we recognize them as tourists or vacationers because of the woman's white and red clothes and her beribboned straw boater, and the man's raised telescope (frontis.). Once we spot them, we are obliged to convert a traditional seacoast scene to one that has been invaded by modern life. The same is true of *Regatta at Sainte-Adresse* (fig. 14) where a dozen vacationers look out at a regatta, leaving only the less prominent beached boat and its cluster of mariners to represent local life.[3] This picture is more frankly about leisure than the other, which suggests an ordinary weekday (its ships are dark-sailed working craft, not pleasure boats); whereas this one has a mood suitable to a regatta, perhaps one of those organized by the local chamber of commerce or yacht club to offer an attraction for visitors. The importance of visitors and residents from across the Channel to the development of tourism in Normandy is indicated by the fact that such regattas, their ships, rules, and terminology, were of British origin.[4]

No outsiders are found in *Sainte-Adresse, Fishing Boats on the Shore* but it, too, can call up the experience of visitors to these shores. The couple seated in *The Beach at Sainte-Adresse* would be among those who hoped to look upon such a slice of local life. And we the viewers, like such vacationers, are psychologically alone in front of this picture and therefore do not think consciously of being a vacationer any more than we do when we stand in front of a traditional marine. Nonetheless, although we see only fisherfolk, there is a hint of our presence as viewers in the position of the standing fisherman (fig. 9). Although talking to the woman and child, he faces us as though posing for our surrogate, the painter. After staring at him for a moment we imagine ourselves standing alongside the artist because

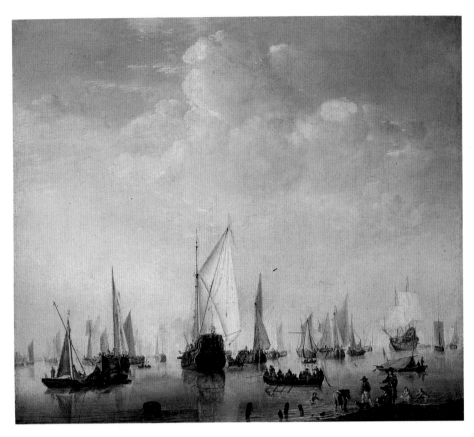

we have recognized the obviousness of his pictorial arrangement. The standing couple are centered in the gap between two boats and are backed symmetrically by a third; the flanking boats have figures near them, marked out against apertures of light tones to form a widening pattern of internal symmetry. This engages us, if only half-consciously, in organizing the scene by virtue of staring at it: a curious echo of the tourist experience.

The famous *Terrace at Sainte-Adresse* (fig. 17) has no working natives at all, only well-to-do people at leisure, so at first we would be tempted to divorce it entirely from *Fishing Boats on the Shore*. It takes its place nevertheless alongside this other picture, for the vacationer's stay at a resort involves not just one view or mood, but several. When vacationing, we hope to be alone at times in order to have an unmediated look at local scenery (John Urry's "romantic gaze"), but at other times we acknowledge the company of fellow visitors (the "collective gaze"). These two pictures are therefore the extreme poles of the tourist's experience, whereas *The Beach at Sainte-Adresse* and *Regatta at Sainte-Adresse*, are somewhere between them, because both visitors and locals are present. Taken together, the four encapsulate the several dialogues a vacationer has with the native scene and with other visitors.

12. Willem van de Velde, *Sea with Bathers*, 1653. 42 × 48. Hermitage, Leningrad.

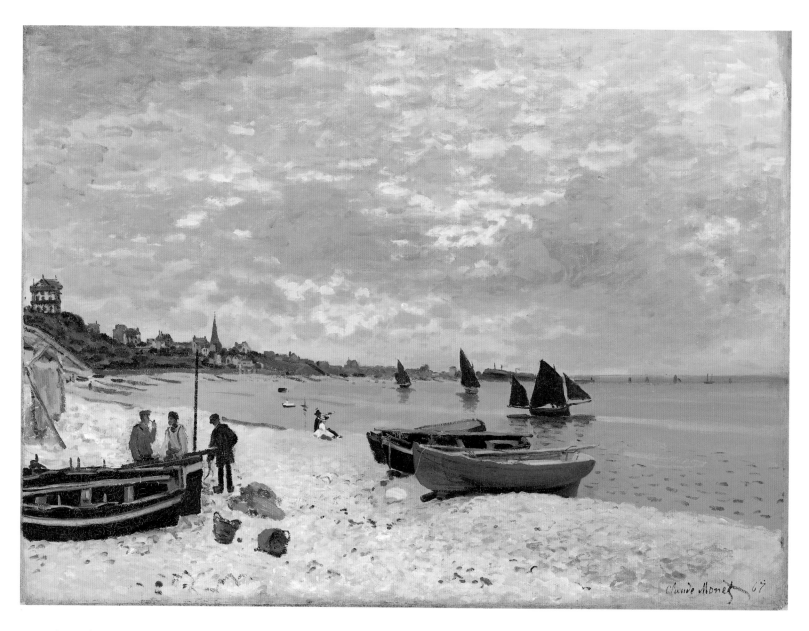

13. *The Beach at Sainte-Adresse*, 1867. 75 × 101. W 92. The Art Institute of Chicago, Mr. and Mrs. Lewis Larned Coburn Memorial Collection.

Terrace at Sainte-Adresse is the most strikingly modern of these pictures because of its abrupt geometry and, like the others, it refuses to give more than a minimum narrative to tie together its four figures. We discover a middle-aged couple and a younger, perhaps courting couple, on the kind of flowered terrace that marks summertime villas, as do the bentwood chairs. Monet's figures perform their rituals in proper dress and pose, on the surface of a flattened, well-ordered garden, separated from the sea – now a backdrop – and from all but one sign of traditional local life: the nearby fishing boat whose bowsprit just touches the young woman's parasol. Toward the horizon there is a medley of ships both old and new that represent this transitional generation of steam and sail. A coastal paddlewheeler in national colors nudges the flagpole bearing the French

flag, a witty instance of the contrived geometry of this composition that flattens out space into horizontal and vertical zones.

Monet's terrace appears more modern than his picture of fisherfolk because, in a manner of speaking, it predicts the boulevard that later supplanted the old shoreline (fig. 18). The painter's flat geometry can be held up to the modernity of a resort like Sainte-Adresse, where proprietors of villas and hotels pushed terraces out toward the water, built new boulevards along the once natural shoreline, and created other artificial spaces.[5] These new planes and spaces, made for visitors, divide them and their class from the natives. That Monet's picture has an urban disposition should not be surprising. Although he knew Sainte-Adresse as a native of the region, he approached it from the

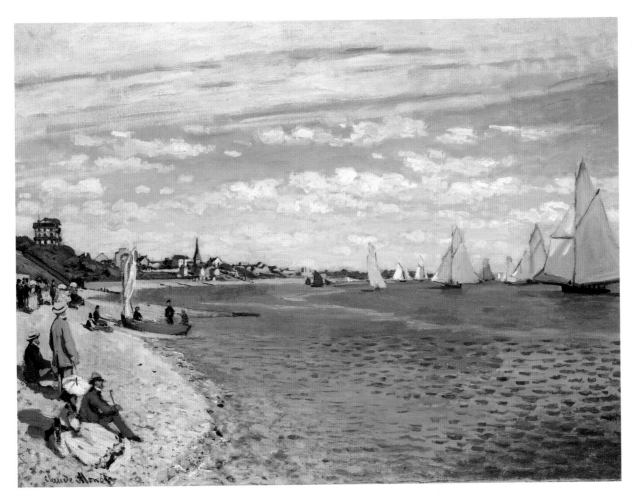

14. *Regatta at Sainte-Adresse*, 1867. 75.5 × 101.5. W 91. The Metropolitan Museum of Art, New York, Bequest of William Church Osborn, 1951.

vantage point of one for whom Paris was the principal cultural market. He not only exhibited in the capital, but also he had lived and painted there and in its suburbs. In the months just before coming to Sainte-Adresse he had painted three views of Paris from the colonnade of the Louvre, and one of them, *Garden of the Princess* (fig. 19), has geometric zones and the high horizon line of the terrace picture.

The extent to which Monet's art speaks for his era becomes clearer if we compare his terrace picture to Joseph Vernet's *Seashore* (fig. 20). Vernet, France's most prominent painter of marines in the late eighteenth century, also represents vacationers. Guided by a *cicerone* in Turkish dress, the tourists look out upon a historied bay and at natives in the water (who embody class distinctions, not just national ones). Faithful to his century, that of the increasingly important grand tour, Vernet took his viewer to the Mediterranean, away from contemporaneous France. By contrast, Monet's naturalism continues the drift of nineteenth-century French painters away from the Mediterranean in favor of northern landscapes. This change was just as much one of style as of subject. In Vernet's picture, for example, the illusions of land and water tip back so successfully that we are not conscious of their shapes as we are in the Monet. Instead of moving up the canvas across Monet's abrupt, flat strips, our eye moves back into depth by zig-zag steps based on alternations of light and dark. Individual elements are so modeled that we sense them as three-dimensional objects more than we do Monet's. Compare any of Monet's figures with Vernet's and his light-struck portions will appear as flat, irregular shapes that Vernet would have reckoned crude in the extreme.

Monet's painting is contemporary in more than one sense. The young woman was modeled on his cousin Jeanne-Marguerite Lecadre, the older man, on his father (who posed also for the standing man in the foreground of the regatta picture, fig. 14), and the older woman, probably on his aunt Lecadre, who had invited the impecunious young man to her resort villa that summer. Had the picture been exhibited then (it was first shown twelve years later), the public need not have known this, but the involvement with Monet's life is something we should take into account. In this vacation picture (even if from nearby Le Havre, the

15. Adriaen van de Velde. *The Beach at Scheveningen*, 1658. 50 × 74. Kassel, Staatliche Gemäldegalerie.

figures he posed were on vacation), his father faces toward Le Havre, unseen off to the left, the place of his and Mme Lecadre's business,[6] and toward the ships that reproduce the busy traffic in and out of Le Havre. By mid-century Le Havre had outdistanced Marseilles in volume of produce, so Monet's preference for north-European naturalism over the classicizing tradition is a meaningful parallel to the shift of France's commerce from the Mediterranean to the English Channel. His biography, in other words, is part of the social history of France, which in turn is linked with the north-oriented naturalism that his older contemporaries had been developing.

At the outset of his career Monet had met Boudin in Le Havre, and the older artist's light-struck pictures of the coast were persuasive models. Other models were provided by Jongkind whom he had met in Sainte-Adresse in 1862. Being Dutch, the latter was in more than one sense an intercessor between Monet and the tradition of Dutch naturalism. Both Boudin and Jongkind had preceded Monet at the sites he undertook in the 1860s, so it was their subjects as well as their styles that proved instructive. Jongkind, for example, had worked at Sainte-Adresse on several occasions and produced a series of watercolors and oils there in 1862. His *Shore at Sainte-Adresse* (fig. 22) shows the bay from about the same spot as Monet's in one of his pictures (fig. 16). This is not to speak of "influence" (Monet need never have seen Jongkind's pictures of Sainte-Adresse; that view had long been established), but in more general terms of precedence. Jongkind is one of

the artists who helped make Sainte-Adresse known. His palette, based more on color than traditional chiaroscuro, was laid down in broad and free strokes that encouraged the younger painter to be daring in his own technique, similarly devoted to the effects of natural light, freshly seen.

Jongkind seldom showed vacationers along Norman beaches, but Boudin had made a specialty of doing so. In a characteristic Boudin (fig. 21), resort guests are out on the beach, facing the water in a frieze-like arrangement that speaks more for their social grouping than for their individuality. Monet's paintings at Sainte-Adresse reflect a different ambition. They are somewhat larger than typical Boudins and, except for the terrace picture, their angled views bring to mind major types of Dutch seascapes of the seventeenth century. The self-effacing Boudin was content with clients for small pictures and carved out a market for himself by specializing in seacoast tourism, but Monet was thinking on a grander scale and hoped to show in the official Salon in Paris. Because paintings of vacationers could not be readily assimilated with the tradition of grand marines, Monet sent huge compositions of the harbor at Le Havre to the Salon of 1868. One was accepted by the Salon jury (W 89, since disappeared), but the other (fig. 27) was rejected, doubtless again because of its technique, since its subject was perfectly traditional. The jury may well have associated its broadly brushed treatment with the work of Edouard Manet, the *enfant terrible* of the decade, who had exhibited several seascapes in his one-artist show in Paris in May, 1867.[7]

What we learn from Monet's Salon entries is that he was not yet as thoroughly committed to the landscapes of modern life as he would be in the next decade. Throughout the later 1860s echoes of conventional marines cohabit with views of contemporary vacationers. By linking up with the grand tradition of marine painting, Monet was emulating older artists whom he knew and admired. Daubigny, Courbet, and Manet painted seascapes during the 1860s, but before 1869 only Courbet had pictured a vacationer, the artist himself in *The Shore at Palavas* (1854, Montpellier, Musée Fabre), and a woman paddling a boat in the surf in the curious *Podoscaphe* (1865, private collection). It was not until 1869, painting in Boulogne, that Manet began to represent resort clients at the seashore, and that same year Berthe Morisot inserted a vacationer in her *Harbor at Lorient* (Washington, D.C., National Gallery of Art). What this tells us is that Monet's paintings of vacationers at Sainte-Adresse in 1867 – few, in relation to all his marines of those years – were forerunners of the more thorough turn to contemporary subjects that marked the next decade in the work of all the Impressionists. (Morisot painted shore visitors

at Fécamp in 1874, and the Isle of Wight in 1875, and Manet, at Arcachon and Boulogne in 1871, and Etaples in 1873.[8])

Why this reluctance among leading painters to represent vacationers at the seashore in the 1860s? In addition to the greater prestige of the tradition of marine painting (no matter how modernized by these artists, it discouraged images of contemporaries), there was also an unwillingness to be associated with the kind of anecdotal painting that flooded the Salon and dealers' shops. The two reasons are of course related: to associate oneself with the grand tradition was to look down upon the richly stuffed narratives of much contemporary painting in order to establish a higher position, to cater to a cultured élite who could thereby distinguish themselves from popular taste.[9] We need only compare Monet's regatta picture (fig. 14) with

one like *The Beach at Scheveningen, Holland* (fig. 23), a somewhat later canvas by his contemporary Frederik H. Kaemmerer (1839–1902), a Dutch artist often resident in France. Kaemmerer's palette reminds us that the Impressionists had no monopoly on high-keyed color, but his detailed description of beach society is just what Monet avoided. We see many women and a few men, including a priest (women sometimes brought their confessors to the shore), conversing with one another, in contrast to Monet's stiffly posed figures who tell us little about themselves except that they are on vacation. Kaemmerer's sample of local life is the young woman on the left who is being patronized by the extravagantly dressed young visitor, whereas Monet's is found in the sailors standing by the beached boat. By comparison with Kaemmerer, Monet lacks narrative because his figures are not doing much and do not react

16. *Sainte-Adresse, Fishing Boats on the Shore*, 1867. 57 × 80. W 93. Gift (partial and promised) of Catherine Gamble Curran and Family, in Honor of the 50th Anniversary of the National Gallery of Art, Washington, D.C.

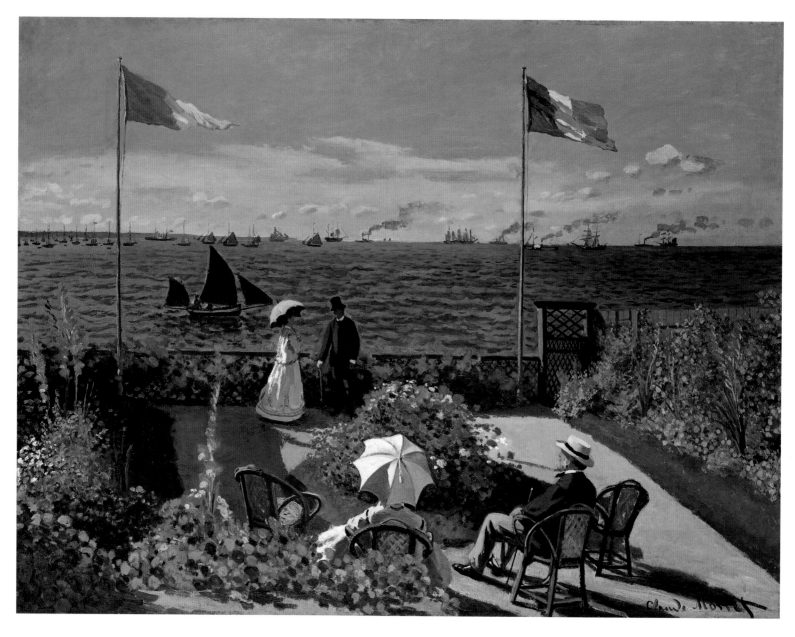

17. *Terrace at Sainte-Adresse*, 1867. 98 × 130. W 95. The Metropolitan Museum of Art, New York.

18. Jules Després, *Sainte-Adresse towards the Cap de la Hève*, from Constant De Tours, *Du Havre à Cherbourg* (Paris, c.1890), p. 59.

to one another, nor are their costumes and features provided with the other's detailed descriptions. This lack, in other terms, is the detachment of naturalism, the ostensibly neutral reconstruction of life-as-it-is-seen without apparent authorial intervention. It is the seemingly inexpressive treatment of contemporary life for which Manet had been the notable pioneer in the early 1860s.[10] His paintings lack Kaemmerer's kind of anecdote and lack also the careful modeling and convincing, deep spaces of traditional art. So, too, Monet's paintings of vacationers at Sainte-Adresse all have these pictorial shortcuts that no longer convey conventional modeling and story-telling.

We must admit that this definition of naturalism has been established by critics and historians to suit artists like Manet and Monet, and not Kaemmerer. In other words, it is a special definition that identifies and props

16

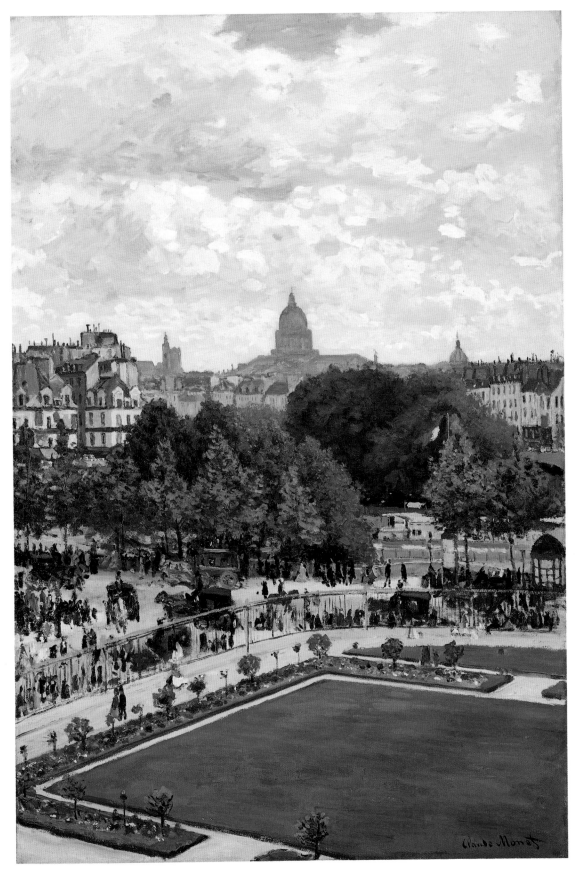

19. *Garden of the Princess*, 1867. 91 × 62. W 85. Allen Memorial Art Museum, Oberlin College, Ohio, R.T. Miller, Jr. Fund.

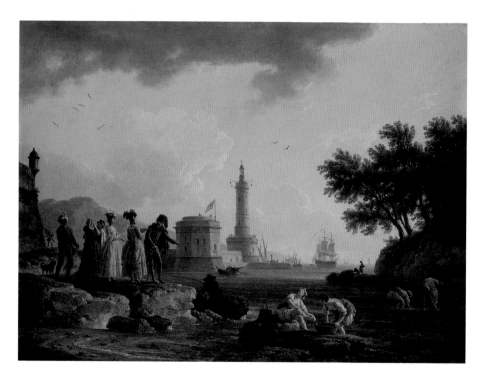

(Monet's are mostly separated), some conversing with one another, and so forth. However, Boudin's costumes are more generalized and his figures less individualized, because his more open and expressive brushwork is far less descriptive. He therefore removes us from the realm of the anecdotal to that of self-conscious art-making. He is a forebear of modernism because his art fits into the genealogy of Impressionism, whereas Kaemmerer's does not. (In the twentieth century, "kitsch" will be used to make such distinctions, a useful but prejudiced term that separates the art of a cultured élite from the "popular.")

One more issue needs to be raised about Monet's beachfront paintings at Sainte-Adresse, and that is the apparent anomaly of a naturalism that is supposedly neutral in relation to the external world and yet one that embraces highly personal elements. Zola's famous formulation, "a work of art is a bit of nature seen through a temperament,"[11] allows for the intervention of the artist's individuality, out of recognition that no two painters would make identical pictures of the same bit of nature because perception is inevitably bound up with one's subjectivity. Monet's naturalism, therefore, involves us with his perceptions, and hence with his actions and his life. His movements are captured in the gestural liberty of his brushwork which, failing to imitate in Kaemmerer's sense, calls attention to itself. In pursuit of a greater naturalism, that is, Monet developed a highly individualized technique that makes the viewer aware of the way his hand moved and of his choice of colors and shapes, as much as of the scene that has been reconstructed. It is true that one was always supposed to admire the artfulness in art (Kaemmerer hoped for such admiration), but from Romanticism

20 (above). Joseph Vernet, *A Sea-Shore*, 1776. Oil on copper, 62.2 × 85.1. National Gallery, London.

21 (below left). Eugène Boudin, *Approaching Storm*, 1864. Panel, 36.6 × 57.9. The Art Institute of Chicago, Mr. and Mrs. Lewis Larned Coburn Memorial Collection.

up painters deemed to be key figures in rising modernism. Many people not conversant with that definition would regard Kaemmerer as more natural, because they can find more interaction among his figures, and more descriptive detail upon which to build social narrative. The distinction between this more popular meaning of naturalism and that of the vanguard can be furthered by comparing Kaemmerer with Boudin (fig. 21). Superficially, Boudin and Kaemmerer have a lot in common: each shows numerous figures in overlapping groups

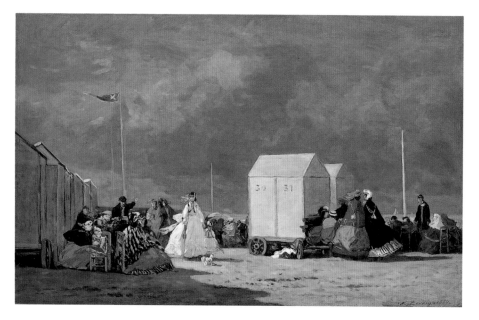

onward, artfulness was redefined by the vanguard, and the self-assertiveness of obvious brushwork took on new importance.

As for Monet's life, it has already been said that he posed family members for his vacationers. Although his

23. Frederik H. Kaemmerer, *The Beach at Scheveningen, Holland*, 1874. 69.9 × 139.7. © 1994 Sotheby's Inc. The Masco Collection.

painted scenes were fictions, and one might think the choice of models unimportant, they added a component of personal knowledge that reinforced the subjectivity of his naturalism. We might look again at his *Terrace at Sainte Adresse*, this time at its bourgeois setting: a young couple whose empty chairs show that when seated, they would be properly chaperoned. Since Monet's father bitterly opposed his liaison with Camille Doncieux (when he learned she was pregnant, he urged his son to abandon her),[12] the picture's social correctness seems to offer an imagined alternative to his actual situation. Camille gave birth to their son in Paris that same summer. Monet had left her alone in the capital in rather dire straits (he threw her on the mercy of friends), because his father and aunt would not accept her; Monet met his child only some time after his birth. Viewed in this light, his terrace painting is, on the one hand, a politic composition vis-à-vis his original family, but on the other, an odd one for his new family. It also gives lessons about his ambition, and his sometimes ruthless use or disregard of family and friends in his determined search for success.[13]

Although Camille's plight and Monet's relations with his family give a particular resonance to this picture, he was not alone in employing family members as models. When Morisot pictured vacationers in Fécamp in 1874 and at the Isle of Wight in 1875, she also used members of her family; so, too, did Manet at Arcachon in 1871 and at Etaples in 1873. Morisot's models include sister, niece, and husband, and Manet's, wife and mother. The close association of personal lives and naturalism is only a paradox if we think that to be

natural in painting is to be so neutral, so dispassionate, that the artist sets aside her or his life. For that matter, Monet was thoroughly familiar with Sainte-Adresse, Le Havre, and Honfleur, where all his seascapes were done until late in 1868 (and then he went only to nearby Etretat and Fécamp). We know that he returned repeatedly to his native region because he could live more cheaply there, but this also meant that he could take up subjects which he knew intimately. Admittedly, we shall never know what went through his mind while painting at Sainte-Adresse, or what distinguished his thoughts there from those he had when working elsewhere, but we can be sure that familiarity with his native region and his use of family models meant that in these early years he infused his art with a greater portion of lived experience when he was near home.

Etretat 1868–9

In the year following his season at Sainte-Adresse, Monet lived and worked in Paris and its environs, and then returned to the coast for the summer of 1868, staying at Le Havre and Sainte-Adresse. While there, he stationed Camille, unwelcome among his family, first in Fécamp, then in Etretat. The few pictures he painted at Sainte-Adresse and at Fécamp show the shore and careened boats; the vacationers of 1867 do not reappear. In the autumn of 1868 he settled for several months in Etretat with Camille and their infant son, Jean. Monet had visited Etretat earlier, but this was his first prolonged stay. He and his family remained

22 (facing page bottom right). J.B. Jongkind, *Shore at Sainte-Adresse*, 1866. 33.5 × 56. Private collection.

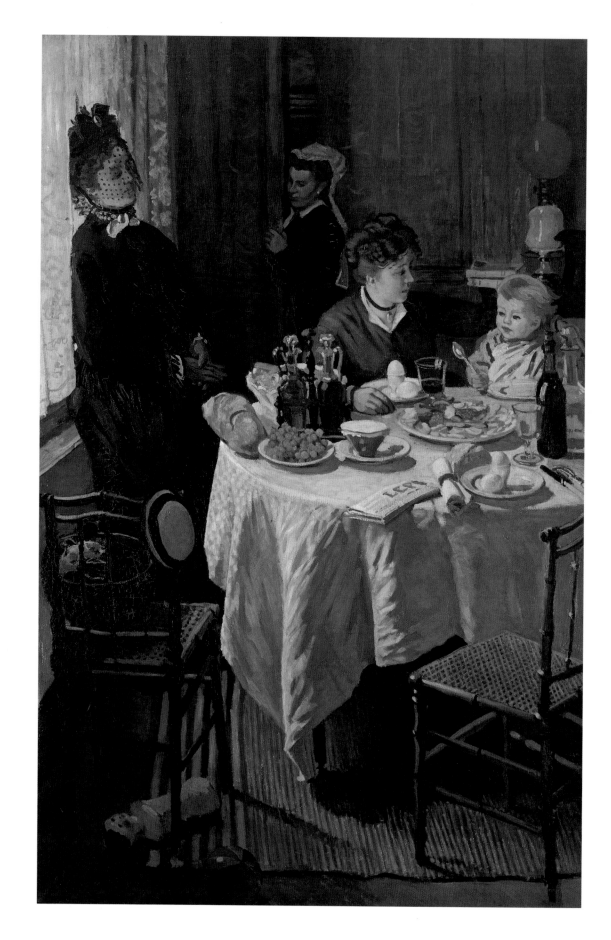

24. *Luncheon*, 1868–9.
230 × 150. W 132.
Städelsches Kunstinstitut,
Frankfurt.

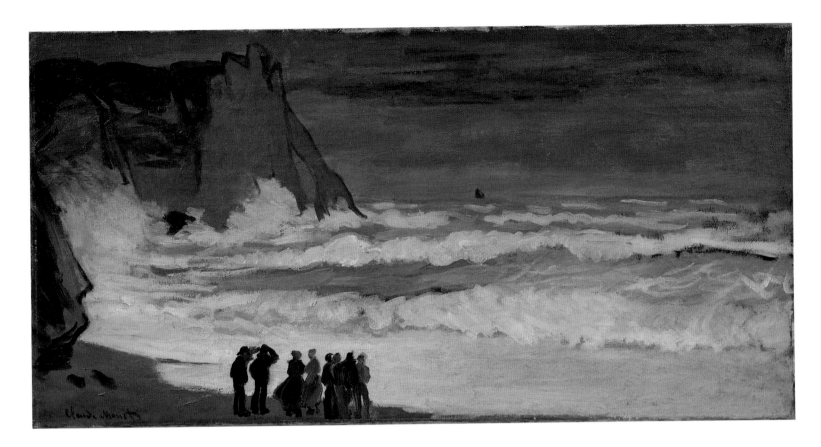

there until the spring of 1869, although he made several visits to Le Havre. Only two seascapes survive from this campaign at Etretat, *Stormy Sea at Etretat* and *The Porte d'Amont, Etretat* (figs. 25 and 28).[14]

Much of Monet's time that winter must have been usurped by his ambitious *Luncheon* (fig. 24), which he destined for the offical Salon (it was refused in 1870). It would have appeared to the public as a genre picture, a simple luncheon scene whose like, as far as subject is concerned, could have been found in many exhibitions in European countries at that time. Its refusal surely was a result of its very broad handling, which would have made the jurors think of the obstreperous Courbet and Manet. To someone used to the smooth modeling of conventional painting, the child, for example, would have seemed like a cartoon, since there are few transitions between shadowed and highlighted areas. Today we readily accept this brushwork as Monet's simulation of spontaneity of vision (although we also recognize its cunning artifice),[15] but at the time it was painted Monet's shorthand would have been conspicuous for what it failed to transmit, not for what it revealed.

Monet's picture of prosperous family life takes on a piquant quality when we realize how brief was his season of relative comfort. Both before and after his winter at Etretat he was constantly on the hunt for

enough money to live, and therefore the interior painted at Etretat seems to be the creation of an ideal that he could offer Camille and their child, and by extension, to his Salon audience. Like any other middle-class father, he could set his family down in the healthy light and air of a seaside resort, even though their actual circumstances were far from those created in the painting. His painting was an assertion of bourgeois respectability belied by actual circumstances: unmarried companion, child out of wedlock, borrowed money, rented quarters.

The wintry outdoors at Etretat shows in *Stormy Sea at Etretat* (fig. 25), a study or sketch[16] whose main elements were drawn in thick, summary outlines and only sparingly modeled. If one did not know the shapes of Etretat's distinctive covered boat hulls (*caloges*, see figs. 82 and 87), the angular lines along the left edge of the canvas would not be decipherable. The cliff above is treated with similar abruptness, but its famous mass is easily read, even to the dark patch at the waterline, the cavern known as the Trou à l'homme (literally, "Manhole"). The agitated sea seems more fully modeled than the cliff because its successive combers recede convincingly, but in fact it was painted with a nearly equal quickness. Streaks of white and off-whites were set down over the darker underpainting in undulating diagonals and swirling

25. *Stormy Sea at Etretat*, 1868. 66 × 131. W 127. Musée d'Orsay, Paris.

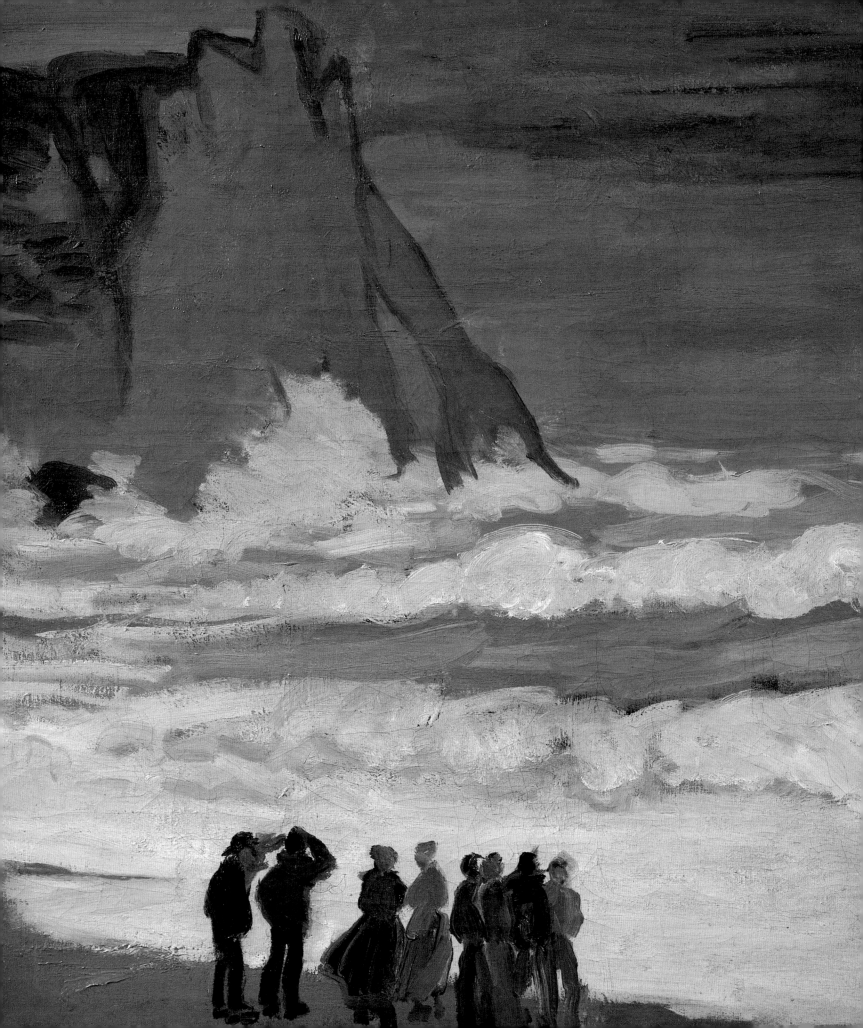

27. *The Jetty at Le Havre*, 1868–9. 147 × 226. W 109. Private collection.

curves that let us equate brushwork with the images of foam and water. This bravura performance – and such panache cries out for applause – was not then considered suitable for exhibited pictures, but by the turn of the century, when the canvas was bought by the famous connoisseur Etienne Moreau-Nélaton, it was accepted as the very proof of painterly genius and associated with qualities of spontaneity that Monet, Morisot, and the other Impressionists did so much to legitimate.

In the foreground of Monet's *Stormy Sea* (fig. 26) eight people look out over the turbulent water. Despite their cursory presentation, we can tell something about them, because Monet, who began as a caricaturist in Le Havre, has learned how to convey salient information in abridged silhouettes. (Boudin and Jongkind provided him with many lessons in this regard.) The two men on the left are in mariners' clothes, apparently looking toward the lone ship on the near horizon; one either points or wields a telescope, the other holds his hat against the wind. Next to them two women, skirts buffeted by the wind, talk to one another (Monet made the customary masculine assumptions: men are actively watching, women, talking). The other four are men, but they are not as easily distinguished although they are differentiated by slight variations in tone and brushwork. The group is essential to the picture, for without

them we would have neither a scale by which to measure the surf, nor a sense of being on the edge of a populated place. They are, moreover, not vacationers but local people who help specify Etretat as a mariners' locale (one that did not have a safe harbor, hence that ship in the distance will remain offshore). They give us a sense of judging the weather, wondering when the sea will subside, and when boats might be launched. Monet puts us in the privileged position of insiders who look out upon a native setting without any hint of other visitors: the ideal tourist's viewpoint.

The sheer size of this sketch (nearly 131 centimeters wide) suggests that Monet intended to work further on it for exhibition. Its spontaneity and tentativeness, which appeal so much to us today, would have been subdued by more work. It would presumably have acquired something of the finish of *The Jetty at Le Havre* (fig. 27), rejected by the official Salon the previous year.[17] Comparison with that picture offers more than one useful lesson. Hoping for acceptance by the Salon, Monet used a traditional composition and subject, with a strongly receding quay and a rainbow. Although roughly painted by the conventional standards of Monet's day (the presumed reason for its rejection), its different elements are clearly modeled and distinguished from one another. Its surf recedes convincingly beneath the sky, which takes up more than half the

26. Detail of fig. 25.

28. *The Porte d'Amont, Etretat, c.1868. 81 × 100. W 258. Harvard University Art Museums, Cambridge, Mass., Gift of Mr. and Mrs. Joseph Pulitzer, Jr.*

surface. Its figures' costumes are sufficiently detailed to let us conclude that we are looking at a mixture of vacationers and local residents, and not at the purely local figures of *Stormy Sea*.

Another seascape that seems to date from Monet's first campaign at Etretat is the dramatic *Porte d'Amont, Etretat* (fig. 28).[18] It is not as finished as the more ambitious *Jetty at Le Havre*, but it is a fully realized canvas and not a sketch. Flat stripes of buttery pigment convey the layers of sedimentary limestone that characterize the cliffs along the Channel, layers pockmarked by congelations of flint. Monet's stripes have an expres-

sive freedom that might let us think they were arbitrary approximations, but John House's photograph of the site[19] shows that the painter was attentive to what he saw. Although he did not engage in painstaking detail, the relative width and placement of his stripes correspond to specific layers in the chalk. To the right, the two jagged pieces that thrust out over the sky are foreshortened strata that still today bulge out there.

Of course, Monet's strokes of paint call attention to themselves and therefore to the artist's gestures, for here at Etretat, half-way through the first decade of his mature activity, Monet was sharing in the development

24

of Impressionism's key feature: exposed brushwork that seems to capture a new spontaneity of vision in front of nature. By deliberately denying traditional modeling carried out in subtle brushwork, and thereby making his painted gestures so evident, he merged a "natural" vision of the exterior world with his individual subjectivity as the perceiving artist.[20] This was not literally new in the history of landscape, for early in the century John Constable had developed an expressive freshness in his handling of paint that was identified with a subjective response to nature.[21] Monet, however, employed a higher-keyed palette (sometimes using new, chemically derived pigments of greater intensity), more contrast, and a flatter application, all of which gave greater separateness to his painted marks than was the case with Constable.

It is true that Monet could exhibit his personal reaction to nature with his technique, but because his procedure constitutes an artistic convention, not really an instinctive way of painting, it is more of a representation of spontaneity than its literal embodiment.[22] Because exposed brushwork now took on great importance, Monet had to vary it in order to transmit different kinds of information. Constable could rely upon the cohesion of an underlying conception of light-and-dark, a matrix that partly absorbed the individuality of his brushstrokes. Monet, refusing that kind of matrix, had to give new vocations to his touch. He rendered light reflections on the water in dashes, streaks, and squiggles whose directions and length have little of the character of the flat stripes above. They are convincing not so much by imagistic imitation as by their gestural character (fig. 136). We empathize with their shapes and gain a sense of rapid and changing motion of light on the water, despite (actually: because of) their obvious appearance as strokes of paint. They work in this way because they are different in hue, tone, and shape from the smoother grey-purples and greens of the areas shaded by the stone.

Color shares in the artificiality of this structure of revealed brushwork. Because there are no careful transitions between areas, Monet took the risk of laying the colors against one another too abruptly. The risk was worth it, because some abruptness, like the gestural freedom of his brushwork, seemed to be proof of spontaneity, a lack of mere convention. (It is, of course, a *new* convention of his making.) In most areas of rock, sky, and water, he avoided overly stark juxtapositions of color by placing closely related values or hues side by side. Different hues, such as the greens and purples in the water, have a similar value (degree of light and dark) which helps integrate them. The strata above have different values, but similar hues. Because we are to imagine the moderate light of a cloudy late after-

noon, and not a strongly lit daytime hour, Monet's palette is rather subdued. Still, the greens and purples in the foreground, responding to seaweeds and tidal stains on the rocks, contrast with the pale orange glow and the pinks in the sky to give essential life to the scene.

To obtain this view Monet had to climb from the village up over the northeast promontory of the Porte d'Amont, down a rugged descent to the shore, and then pick his way across the rocky shallows to a raised shelf exposed only at low tide. (It was low tide that revealed the darkly stained rocks in his picture.) Monet always boasted of his stamina and his willingness to go to lengths to obtain a desired vantage point. Although a temporary visitor, he associated himself with local people and dressed of necessity in suitable clothing and footgear. Like them he clambered over the rocks, followed the tides, exercized a weather eye, and used this experience to develop an insider's sense of the place. Here, from his tidal perch, he looked through the small arch of the Porte d'Amont across other exposed tidal rocks toward the far side of the bay. Framed as it is by the cave-like aperture, the distant Needle takes shape as the veritable symbol of this rugged coastline. Villagers may have taken pleasure in such a view, but it is more surely a painter's visual frame appropriate to the art of composing a canvas, for it combines a sense of looking, of *sighting*, with the deliberate arrangements of pictorial structure. Between seeing nature as it was and constructing it as a picture there was no incompatibility. Monet brought with him prior ideas of what formed a suitable picture, that is, he built his picture upon what he was seeing, but he had chosen a partly predetermined vantage point which organized his vision. Although he had a seemingly unique sighting, this vantage point was not his own, but a social construction based upon earlier art and the recommendations of travel guides. Furthermore, to reach that spot he had probably taken the pathway that had been carved into the nearby cliff (fig. 29). Viewing nature had literally altered the landscape.[23]

To examine Monet's picture closely in this fashion is necessary when we write out an analysis of his art, but it removes us from the impact of the original. When freshly seen, the picture strikes us by its drama: the dominating bulk of the pierced cliff, and the contrasts of its jagged edges with the sky and of its flat surfaces with the water below. Our awareness that nature here is only a painter's artifice suits the romantic quality of the scene, for our emotions are engaged not just by the remarkable formation, but by awareness of the artist's reaction to it. He chose a moment just before sunset, when the sky had already acquired a slightly lurid pallor, to induce a mood of a fading day, of there being nothing of present time, of earthly cares. We think of

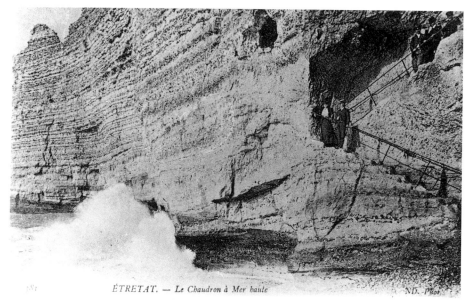

ÉTRETAT. — Le Chaudron à Mer haute ND. Phot.

29. Etretat, the Cauldron at high tide. Postcard, c.1905–10, from J.-P. Thomas, *Etretat autour des années 1900* (Fécamp 1985), pl. 28.

30. Detail of fig. 34.

vacationers' habits, and facilitated by signposts and protective railings. During his next summer on the coast, in 1870, Monet will plunge his viewers into a very different setting, for then he will not paint a private room or a coast free of tourists, but the society of vacationers out on the busy boardwalk.

Trouville, 1870

In early summer 1870 Monet again returned to the Norman coast after an intervening year that he, Camille and Jean had spent mostly near Bougival, on the Seine southwest of Paris. Despite the much later fame of his and Renoir's paintings at Bougival, Monet was selling little and constantly begged friends and potential clients for support. Then, on 28 June he and Camille were married in Paris and shortly afterwards settled for the summer in a modest backstreet hotel in Trouville. Since the mid-1860s Trouville had been twinned with Deauville, the brand-new resort built across the River Touques.[24] With its extensive open waterfront, Trouville was much grander than Sainte-Adresse or Etretat, and its far more prosperous and cosmopolitan clientele was catered to by several large hotels. They and the local casino provided for the social life of tourists and vacationers; contemporaries rightly saw Trouville's "season" as an extension of Paris.

Eight of the nine paintings that Monet did at Trouville deal, appropriately enough, with its society of vacationers and are unlike any of his paintings done before or after at Sainte-Adresse or Etretat. By concentrating on vacationers, they are in some respects closer to his paintings of Parisian bathers at Bougival, since both suburban and seacoast leisure were assertively modern subjects. Only one of the Trouville canvases can properly be called a marine, *The Entrance to the Port of Trouville* (W 154, Budapest, National Museum). Five are small studies of women in fashionable summer attire on the beach (W 158–62), either autonomous sketches or exploratory ideas for exhibitable pictures that were never carried out. In each of them Monet placed a young woman against a backdrop of the beach, making it clear that she is the subject. Camille was the model for the principal figure in *The Beach at Trouville* (fig. 31), accompanied by a woman who assumes the role of a plain older companion, a familiar figure in passages on tourism in nineteenth-century novels. The picture's Manet-like bravura disguises its underlying deliberateness, revealed by the way Camille's parasol grows from her hat and the fact that one of its tips just touches the peak of the tent to the rear.

In *Camille on the Beach at Trouville* (fig. 32), Monet's

the age-old rocks, fashioned into fantastic shapes by eons of water and wind, the very forms that gave Etretat its fame. For this reason, Monet framed his picture so as to eliminate entirely any part of the village, any reminder of present-day activity except his own as poet-witness. In this he was acting like the tourists who wish to put hotel and casino behind them for solitary experiences. Our heartfelt reaction to the original painting shows that, as viewers of the painting, we join our perceptions with Monet's. The more successfully our emotions are engaged by it, the more the picture has made us feel we are alone in front of it, despite the fact that we view it in a museum or reproduced in a book, both social constructions.

Taken together, the three principal pictures Monet did at Etretat represent different aspects of the painter's craft: a figure painting, a sketch of a stormy bay witnessed by villagers, and a more finished picture of an isolated rocky archway. There is little evidence of tourism in the two landscapes, not surprisingly, because Monet typically initiated his compositions from what he could see before him, and he was there in the late fall and winter, out of season. And yet we cannot entirely divorce the painter's life and work from that of a vacationer. His *Luncheon* is a piece of painter's work, but also the sunlit interior of temporary visitors at the seashore. *Stormy Sea at Etretat* is the kind of view one could have from the windows of the Hôtel Blanquet when the weather made strolling or bathing impossible. It is true that a strenuous walk would be required if we were to have the view of *The Porte d'Amont*, but that is the kind of experience that many vacationers boast of. We have just seen that Monet's painted view is a sighting already constructed by existing texts and

31. *The Beach at Trouville,*
1870. 38 × 46. W 158.
National Gallery, London.

model/wife is in the same costume, this time set against the sea, with the anecdotal accompaniment of two beach figures, swimmers inside the safety markers, and one symbolic ship. The intensity of the colored light convinces us that Monet truly worked on the spot, but the woman strikes us as a Parisian, only temporarily out in nature. She is not frolicking on beach or in water, nor even seated on the sand, but posed like a well-to-do bourgeoise. Monet has. again constructed a scene, as he had in *Terrace at Sainte Adresse* (fig. 17), in which the painted ideal belies his actual impecunious circumstances. In this he was conforming to the habits of middle-class men who exalt their own standing by displaying their wives in splendid dress, free of the contamination of work, in gardens, parks, or at the seashore.[25] The underlying complexity of this conception of decorous leisure is exposed by Camille's parasol, that curious device to protect middle- and upper-class women from the effects of natural sunlight, and therefore their social standing from that of fisher-

women and peasants. Here it is merely an attribute of class, for it has been lowered to reveal the woman's head.

Three other pictures done that summer at Trouville, views along the waterfront, are larger and more finished than the studies of women on the beach. In painting them, Monet acted like many another client of the middling hotel where he and his wife stayed (the "Tivoli," well back from the prestigious beach), for he placed himself among the strollers in front of the prestigious hotels that faced the water. Chief among these was the Hôtel des Roches Noires, featured in one of his most impressive paintings of that summer (fig. 34). In this veritable portrait of the Roches Noires and its society, Monet celebrated the newest and grandest of the hotels, opened only recently. It was described by the British travel writer Katherine Macquoid as "the chief hotel, and the resort of the most gaily dressed of the loungers; it is worth seeing." She goes on to say that there was "not so much as a beggar to destroy the

illusion. Truly Trouville would have seemed a paradise to that Eastern philosopher who wandered about in search of happiness; and the paradise would last – perhaps till he was called on to pay his hotel bill."[26] Monet did nothing to destroy the illusion, and his appeal today rests partly on his creation of a beggarless society, a world in which no labor is shown, in which painted harmonies of light and color stand for nature, spontaneous outdoor pleasures, and harmonious human relationships: just what the vacationer seeks.

Although far from conventionally finished, Monet's picture displays "the most gaily dressed of the loungers" seated and strolling along the terrace, waiting by the hotel entrance above, or peering from its windows, facing the cosmopolitan display of flags. The painting is so much the portrait of a society that the sea hardly figures at all. It is a brilliant interpretation of the leisure society of Trouville because it blends the spontaneous and the natural with an obviously well-regulated composition based on axial symmetry. The same balance of apparently free gesture with a strong compositional structure characterizes Monet's other boardwalk pictures. In *The Boardwalk at Trouville* (fig. 33), the Roches Noires is in the distance, only discoverable because of the bright colors of its international flags.[27] Monet has taken us below the level of the hotel terraces to the boardwalk, where we find a number of women and children, and two men, one amusingly with only a parasol for company, the other in straw boater next to his companion clad in billowing white (fig. 35). In *The Hôtel des Roches Noires* as well there are only two men among the women in the foreground (fig. 30), a reflection of the fact that men typically stationed women at the shore for successive days or weeks, while appearing themselves only at the week's end.

In representing beach society Monet was not striking out on entirely new ground, although he was claiming his place in a distinctively modern current. The

32. *Camille on the Beach at Trouville*, 1870. 38 × 47. W 160. Collection of Mrs. John Hay Whitney.

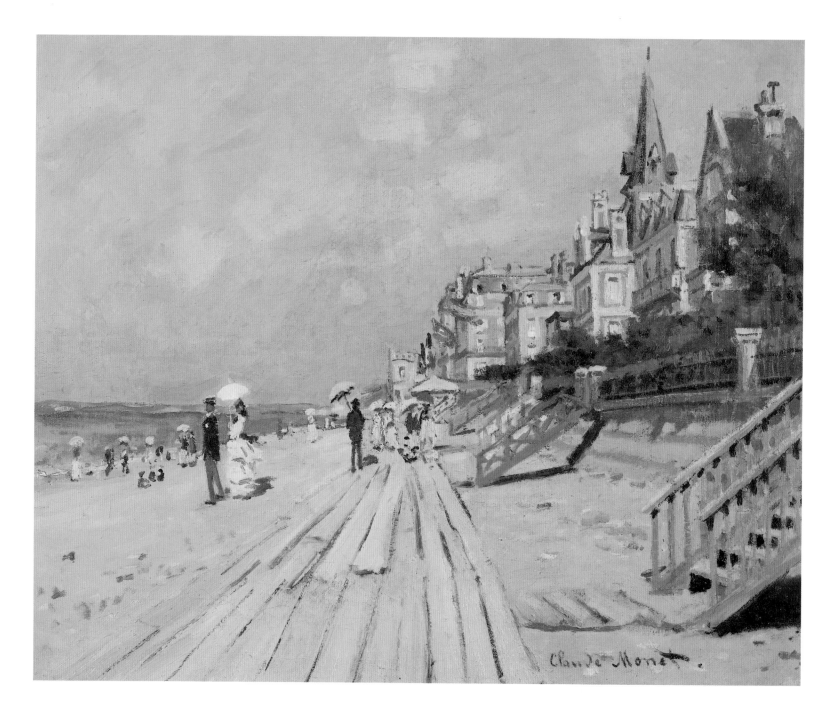

33. *The Boardwalk at Trouville*, 1870. 52.1 × 59.1. W 156. Wadsworth Atheneum, Hartford, The Ella Gallup Sumner and Mary Catlin Sumner Collection.

Goncourts, apostles of naturalism, had provided a prominent token of this current in 1867, with the publication of *Manette Salomon*, a novel devoted to contemporary artistic life. Coriolis, one of their protagonists, proved his modernity by painting resort society at Trouville. And Courbet, the self-proclaimed Realist and socialist, had spent three months at Trouville in 1865, and was at Deauville in 1866, guest of the duc de Choiseul. (Courbet had invited Monet, Camille, and the Boudins to Deauville while he was there, and four years later served as witness to the

Monets' wedding shortly before their arrival in Trouville.) Courbet's seascapes of 1865–6 have some relevance to Monet's marines of the late 1860s, but his portraits of individual society women painted in the resorts are quite unlike Monet's studies of Camille, and he painted nothing that compares with the younger artist's beachfront canvases. It is true that Courbet had been at Etretat in 1868 (after Monet had left), but the significance of the seascapes he did there then became apparent in Monet's work only when he returned to Etretat years later, in 1883.

30

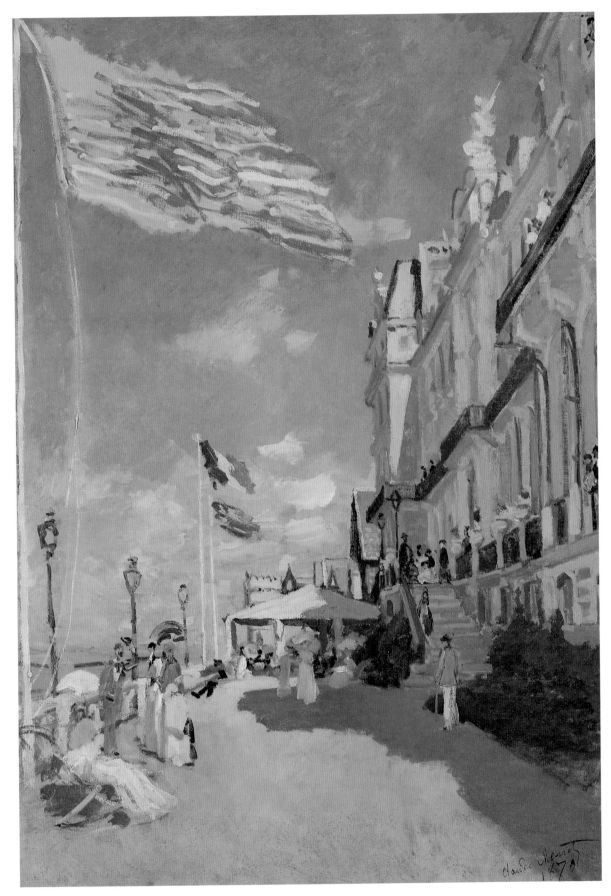

35 (following page). Detail of fig. 33.

34. *Hôtel des Roches Noires, Trouville,* 1870. 80 × 55. W 155. Musée d'Orsay, Paris.

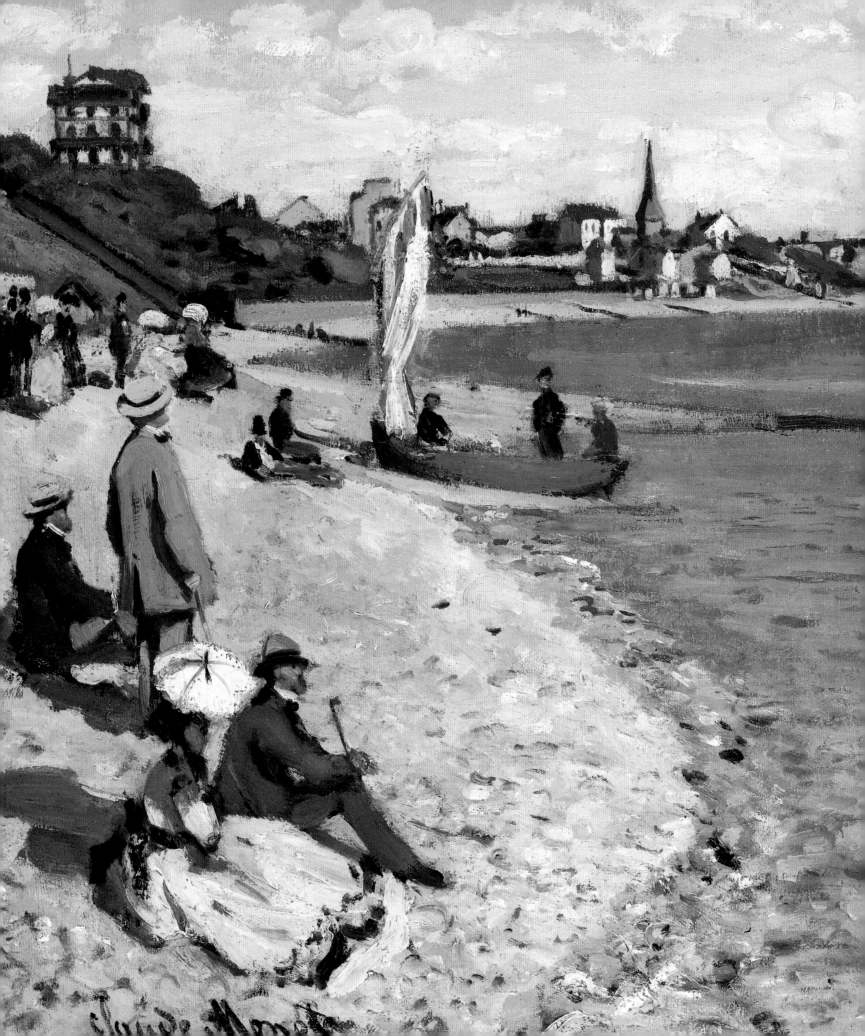

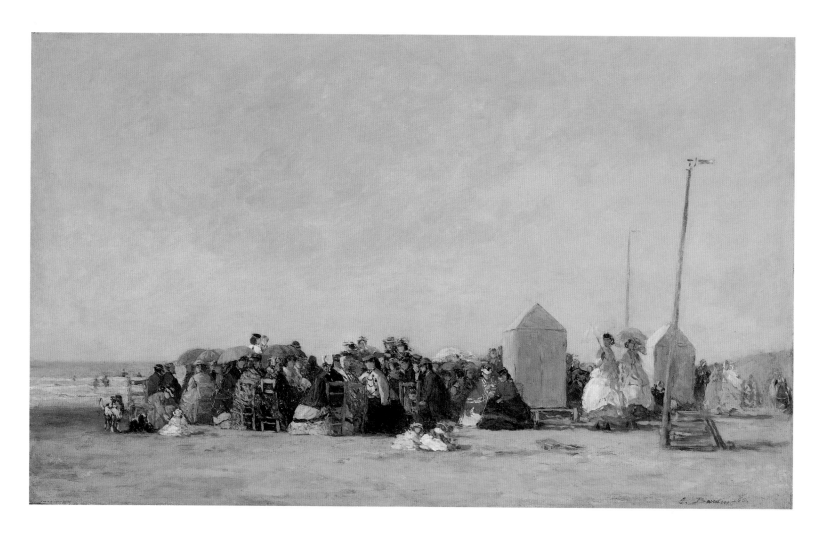

37. Eugène Boudin, *The Beach at Trouville*, 1865. Panel, 34.5 × 57.5. Toledo Museum of Art, Purchased with funds from the Libbey Endowment, gift of Edward Drummond Libbey.

36 (previous page). Detail of fig. 14.

More important than Courbet for Monet's pictures at Trouville was his mentor Boudin, whom he had known well for about fifteen years. Boudin had made a specialty of painting people along Norman beaches and had often been at Trouville. He and his wife, in fact, had come to Trouville that same summer and were frequently with the young couple. Monet knew that Boudin had clients for pictures of vacationers at the seashore, and he could more readily imagine a market for his beachfront canvases than for his pictures based upon his studies of Camille. However, despite a certain debt to his older friend, especially in the shorthand used for his figures and his vigorously painted skies, Monet painted in such a way as to assert his own modernity. The contrast shows in two superficially similar pictures, his boardwalk canvas (fig. 33) and Boudin's *Beach at Trouville* (fig. 37). By placing his horizon line higher, Monet made room for the plunging space that contrasts with Boudin's horizontal extension. His boardwalk, with its striking green steps leading up to the terrace, forms a dynamic wedge, whereas Boudin's structure suits a more contemplative view. Monet's modernity

resides in the abruptness of his spatial wedges, so different from the more subtle entries into space of earlier generations. These wedges remind us of city streets, and induce a nearly urban sense of motion. It is their starkness, their abrupt geometry, in combination with flattened-out brushwork, that recalls *Terrace at Sainte-Adresse*, (fig. 17).

The two paintings by Boudin and Monet are quite unthinkable without the social dialogue that bound Trouville to Paris, and the artists' beach paintings to their urban market. "Let us take the air on the beach," ran a song in the Parisian vaudeville *Niniche*, "and contemplate the Ocean so tranquil./Ah! If Paris only had the sea,/It would be a little Trouville."[28] However, Monet's paintings at Trouville that summer belie the dramatic events that were then wrenching France apart. Already in June there had been rumors of war, and these might have helped decide Monet upon marriage, since a married man with a child was less apt to be called up.[29] France declared war on Prussia on 19 July and quickly moved toward disastrous defeat and the end of Louis Napoleon's empire. The Third Republic

was declared in Paris on 4 September, but the war continued. Monet, unable or unwilling to pay his rent at Trouville, was trying to find some money in Le Havre on 9 September, as we know from a letter of that date to Boudin.[30] Eventually he found some, and took ship for London later that month or in October. Meanwhile, the declaration of the new republic was followed by the long siege of the capital by Prussian troops. Paris surrendered in January, but the national trauma was far from over. In March the Paris Commune was founded, and the city was cut off from the rest of the country until its brutal suppression in June 1871. Monet escaped all this because he remained in London for several months (Camille and Jean had either accompanied him when he fled or joined him there subsequently), and then went to Holland. It was only in December 1871, after about fifteen months abroad, that the Monets returned to France and settled in Argenteuil.

2 From Les Petites Dalles to Pourville, 1881–1882

Upon his return from England and Holland in December 1871, Monet settled in Argenteuil and began nearly a decade's devotion to the region near Paris and to the capital. Argenteuil had been colonized by Parisians who had come there in increasing numbers to enjoy outings away from the city. Many lived there, like Monet and his family, in rented villas; others came for shorter stays or for day trips, since the river port was quickly reached from Paris, only nine miles away. From 1872 to 1877 Monet concentrated upon the pleasure boats, bridges, promenades, riverbanks, and gardens of Argenteuil, relegating its factories to the background.[1] Then in 1877 he painted his now famous series of the train sheds and tracks of Gare Saint-Lazare, and in 1878 several pictures of Parisian parks. These were the last paintings he did of the capital, for in 1878 he moved to Vétheuil, forty miles down the Seine, and never again painted in the city nor its near suburbs.

In 1879 there came a profound change in Monet's life. In September, following a long illness, Camille died. Before her death the Monets had been sharing quarters with Alice and Ernest Hoschedé and their children. Hoschedé had been a notable collector of Impressionist paintings, but he had fallen on hard times because of failed speculations. After Camille's death, Hoschedé's absences from Vétheuil were ever more prolonged, and it soon became apparent that Alice and Claude were living together as though married, merging their two families. At the end of 1881 they moved to Poissy, eighteen miles from the capital, and then in 1883 to their final home in Giverny. (They married in 1892, after Hoschedé's death.)

In the decade of the 1870s, based in Argenteuil, Paris, and Vétheuil, Monet had seldom painted the coast in Normandy. He had made rather short trips to Rouen and Le Havre in 1873, and to Le Havre and Amsterdam the following year. From these trips (poorly documented) there are seven or eight paintings of the harbor of Le Havre, and two of the shore at Sainte-Adresse.[2] Otherwise, Monet did not paint the Norman shore again until September 1880, this time at Les Petites Dalles, about twenty-four miles beyond Etretat. Although he was there for only two weeks or so, the visit marked the first of seven consecutive years during which he painted on the Channel coast. From 1881 through 1886, his paintings at Fécamp, Pourville, Varengeville, and Etretat loomed so large in his work that they outnumber all others. His reputation was increasingly that of a painter of marines.

Les Petites Dalles was a tiny resort, once a fishing village but, like so many others, substantially altered by vacationers.[3] Monet was taken there by his brother, Léon, whom he had been visiting in Rouen; Léon went regularly to the small resort. Monet's paintings are thus closely linked with family and with traditional vacationing, as were those he had done at Sainte-Adresse, Etretat, and Trouville. He did four paintings at Les Petites Dalles, perhaps finishing them later. In two of them (W 623, 624) the viewer faces an agitated surf, an effect that Courbet had made famous in his marines of the Norman coast beginning in 1865 at Trouville.[4] In the other two the viewer looks toward the steep limestone cliffs that flank the village beach.

In one of the latter, *Cliffs of Les Petites Dalles* (fig. 39), we are a long way from the paintings at Sainte-Adresse of thirteen years earlier. In all those pictures the sea is calm (he could have chosen stormy weather had he wished), and vacationers and buildings let us know that we are on the shores of a resort. Here at Les Petites Dalles the sea is ruffled by September weather and, although the breakwater and pilings situate us on a settled shore, it is a less sociable picture. The five figures are not as distinct as those he placed on the beach at Sainte-Adresse, for their role is to help us concentrate on the weather-beaten shore rather than to give us clues to local life. Still, it is a resort picture, albeit one of a special kind. Tiny though he is, the leftmost figure (fig. 38) clearly is a well-dressed man walking with a cane, hardly a native, and the others (like Monet's brother and himself) could be visitors, although we cannot tell. The confrontation of humans with nature would be evident even without figures, because the pilings and the slanting breakwater have a geometric quality appropriate to their artificial structure. It is their human-made regularity that lets us measure the turbulence of the sea and the nearly mon-

38. Detail of fig. 39.

39. *Cliffs of Les Petites Dalles*, 1880. 59 × 75. W 621. Museum of Fine Arts, Boston, Denman Waldo Ross Collection.

strous rise of the cliff face, carried out in suitably empathetic brushwork: swirling arabesques for the surf and vertical slashes for the stained cliff (ferrous and other colors leach downwards from the soil above).[5]

Having renewed his enthusiasm for the Channel coast after years away from it, Monet returned there six months later, presumably encouraged by the purchase in February 1881 of sixteen pictures, including two of Les Petites Dalles (fig. 39, and W 624), by the Parisian dealer Paul Durand-Ruel. Durand-Ruel had periodically bought and sold Monets since 1871 but now, in addition to this large purchase, he promised regular acquisitions, so Monet could turn to seascapes with considerable optimism about future sales. This time he went to Fécamp, a major port between Les Petites

Dalles and Etretat, only ten miles by road from the latter. In successive letters to his dealer,[6] he promised to deliver seascapes to him in Paris, and requested more advances, a pattern of promise and demand that continued for years, tying artist and dealer together in bonds of mutual dependency.

Monet had been at Fécamp briefly in the summer of 1868 and had painted three pictures of boats careened in the harbor (W 117–19). Beginning in early March 1881, he initiated about twenty paintings in a productive four weeks there and at nearby Grainval; he finished a number of them over the following weeks.[7] During that month he paid a brief visit to his brother, Léon, who was again at Les Petites Dalles, and he presumably worked there on two canvases (W 644,

655) which are variants of those done the autumn before at the tiny port. Once again his marines involved him with family and with a coast he had been familiar with since his youth. It was not until 1884, when he went to the Mediterranean, that he pictured the sea distant from his native region (although he had painted the Thames at London and Dutch waters in 1870–1).

A few of the Fécamp canvases of 1881 are what we might expect from a young artist desirous of making a name as a painter of landscape. Some are of traditional subjects and compositions, two devoted to careened sailing ships in the harbor, and one to stormy weather battering the outer jetty (W 644–6). The motif of *Ships Careened in the Harbor of Fécamp* (fig. 40) recalls any number of paintings by Eugène Isabey, Jules Noël, and other Romantic artists who frequented Norman ports, but the geometry of Monet's composition, with its diagonal ships and horizontal landscape, is far removed from their more picturesque arrangements. Several other Fécamp canvases depart from these established types and grow instead from mid-century naturalism, particularly from Courbet's work. They show angled views along the shore, or surf coming forward directly toward the viewer, rather like the small group of paintings done at Les Petites Dalles.

Among the most unusual compositions of this campaign are nine painted from the undulating cliffs above Grainval, a small settlement on the western edge of Fécamp. He worked from a nearly level patch atop the rolling upland above Grainval and had to walk only a few yards in either direction to have the eastward and westward views that he painted. It was a convenient spot for taking in the shoreline, and was used by J. Gauchard, the illustrator of Adolphe Joanne's *Géographie du Département de la Seine-Inférieure*, published in 1881 (fig. 43). Four of Monet's pictures show the same cliffs from the identical perch, including *The Sea Viewed from the Cliffs at Grainval* (fig. 41).[8] For Joanne, prolific author of guidebooks, Gauchard's engraving served not just to display typical cliffs of the Fécamp region, but to offer an established viewpoint to his readers. With book in hand, Joanne's reader could climb the slope above Grainval and position herself at the already familiar view. Gauchard includes two figures (one minuscule one on the horizon) to give scale and to make us associate ourselves with solitary nature-lovers. His print and Joanne's text prompt the reader to think of the landscape, not of casinos or hotels. Of course, we are a plural readership, but the rituals of tourism and vacationing allow for the apparent paradox of large numbers (aided by books such as Joanne's and paintings like Monet's) who flock to resorts from which they can seek out recommended views by themselves. By showing less of the clifftop

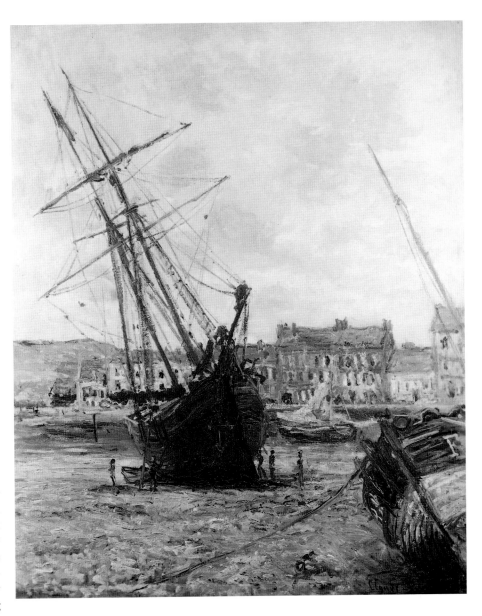

40. *Ships Careened in the Harbor of Fécamp*, 1881. 80 × 66. W 645. Collection unknown.

than Gauchard did, and by positioning the viewer somewhere above it, Monet created a more vertiginous effect (and we are more susceptible to an oil painting on a wall than to a tiny illustration in a book). Only if we actually stand on the clifftop where he did, would we realize that Monet was positioned on one side of a narrow gorge looking across to its other side. Lacking that explanation, the observer senses an odd but effective distance, a kind of seagull's view. It is an aerial suspension that Monet will exploit repeatedly in coming years at Pourville and Etretat.

Much the same is true in four other canvases in which Monet has us face around eastward from the same place and look toward Fécamp. In *The Cliff at Grainval, near Fécamp* (fig. 42) the vertigo is more accentuated than in the westward view because the

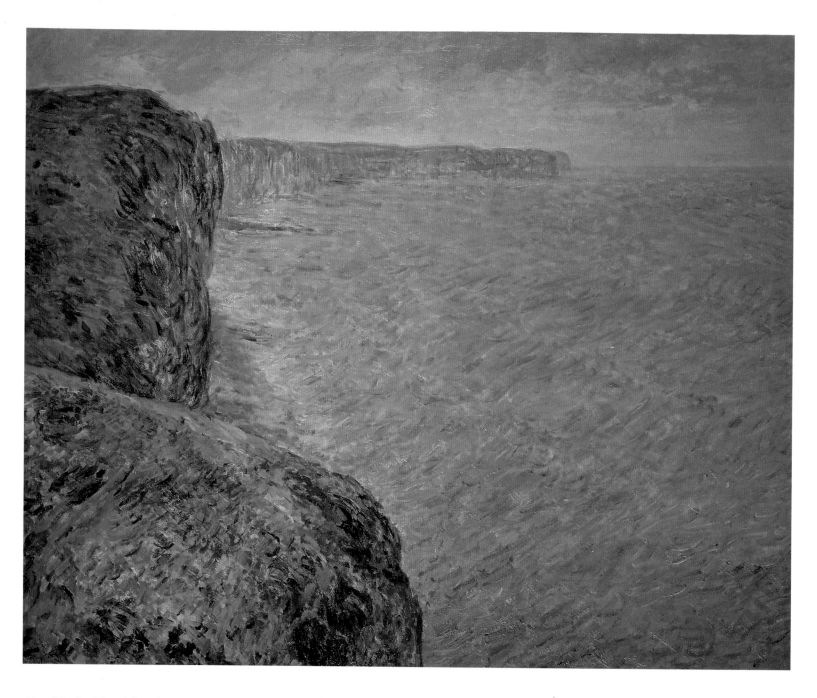

41. *The Sea Viewed from the Cliffs at Grainval*, 1881. 60 × 75. W 648. Private collection, Japan.

contrasts of light and dark, and of warm and cold colors, give the cliff, which resembles the heaving back of some great marine animal, a more tangible presence than that in the other picture. Despite some similarities, the two pictures produce different moods. When we look at the first we can think ourselves miles from any settlement (Gauchard showed the buildings of Yport off in the distance, Monet did not), and consequently we can savor the solitude that the nature-lover seeks. When we look at the second, we see sailboats and Cap Fagnet, surmounted by Notre-Dame du Salut, which flanks the harbor of Fécamp, so we cannot pretend to

any distance from the city. On the contrary, the view confesses the dialogue between nature and sea resort, between solitary traveler and tourist, that is, the dialogue carried out within the experience of the tourist at different moments of her or his adventure. Monet allowed this dialogue, but did not emphasize it because he deliberately suppressed the identity of the harbor's quays and buildings. Although we can make out the low line of the harbor seawall, we see mostly colors and strokes that are assimilated with the distant cape, and so we can forget for a moment that we are also the vacationer who lodges in such a town.

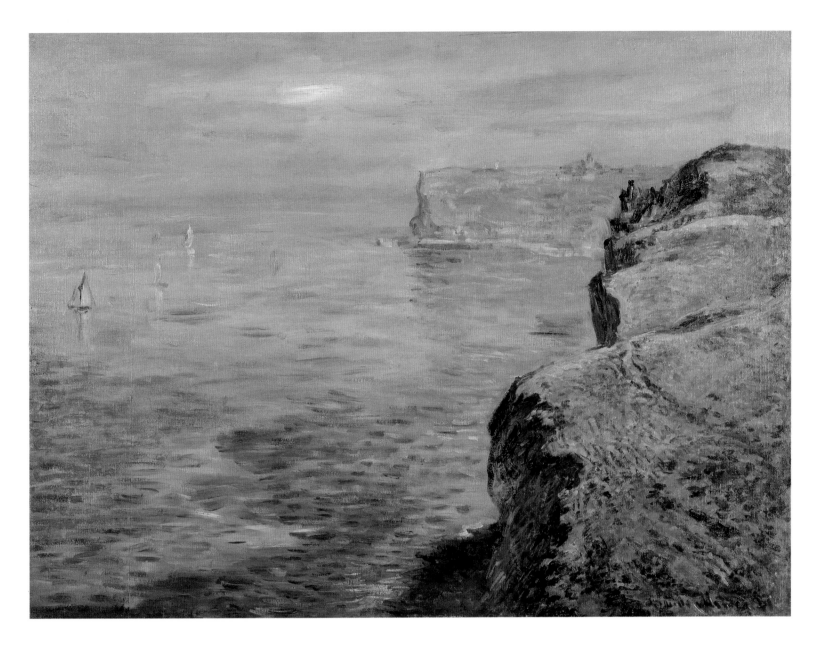

There are rather few historical precedents for Monet's gull's-eye views from the Grainval cliffs. Some sharply angled seacoasts were produced in the preceding generation, but the differences are as revealing as the similarities, including the fact that most such works are found among prints, drawings, watercolors, or pastels rather than in the more ambitious precincts of oil paintings. The Romantic vignettist Tony Johannot (fig. 44), for example, did not displace the land as much to one side as Monet did, and centered his vignette on his two figures. J.-F. Millet, like Monet a Norman, had often worked from the cliffs near Cherbourg, but his compositions were either centralized or, if slanted along the coast (fig. 45), they had large land masses and small areas of sea.

42. *The Cliff at Grainval, near Fécamp*, 1881. 61 × 80. W 653. Private collection, Japan.

43 (left). J. Gauchard, *View from Grainval towards Le Tréport*, from Adolphe Joanne, *Géographie du Département de la Seine-Inférieure* (Paris 1881).

44. Tony Johannot, *Two Women on the Edge of a Cliff,* c.1835–45. Watercolor and gouache, 42.5 × 35.5. Collection unknown.

that the water is not as far below as in the other two compositions. Curiously, the Johannot seems closer to Monet in some ways, as though the Impressionist had restored the Romantic artist's evocation of an overpowering, sublime nature. However, Monet's rejection of most devices of Romanticism meant that he would not call upon the association of a disconsolate woman with threatening nature. His untenanted scene, by its artful arrangement, can suffice to convince us of the exhilaration and vertigo inspired by such a setting.

Comparisons with earlier artists are not intended to prove influence on Monet (he may never have seen those works), but to expose the kinds of pictorial structure which had been part of the common language of artists that he had inherited. He had been stalking the Channel uplands since boyhood and therefore would have believed that his views from Grainval were his own, based upon his responses to what lay in front of him. These responses, however, were not literally instinctual but were based partly upon the language he inherited, no matter how much he altered it. Phrasing this observation another way, we might say that an artist's instinctual reaction at any one moment is a well-rehearsed one, since prior experience has been so thoroughly internalized that the painter is unaware of its origins in his craft. In addition, as we have seen, Monet's lookout at Grainval, like other tourist spots, had been socially constructed. Indeed, an artist's vision is a compound of the personal and the social and can be examined as the voice of one who is using a language shared with others. For example, Monet may seem far removed from his fellow Impressionist Edgar Degas, but his Grainval compositions have something of the oblique angles that Degas used in his urban interiors. Both artists, in their different domains, were constructing points of view that engaged the spectator's eye in new and dynamic ways, so as to energize the very act of seeing.[9] And this act is also one of control, that is, the observer acquires the commanding position of the male artist.

It is equally revealing that these two earlier artists used figures for the viewer to associate with. Johannot did not need a caption, for the emotions of a melancholy woman seeking consolation are clearly expressed by her position on a dangerous precipice overlooking a lonely shore. Millet subordinated his reclining shepherd or cowherd to the rugged coastline to produce a less vivid reaction, particularly because his figure shows

This is where the two painters reveal the unwitting assumptions of men, for each has constructed a position for himself, and therefore for the observer, in which nature is dominated by the artist's construction.[10] For male painters the nude was natural and subject to man's controlling gaze, much as were the rising mounds and clefts of landscape. Monet once acknowledged his conception of the sea as female and as all the more attractive when changeable and difficult to dominate:

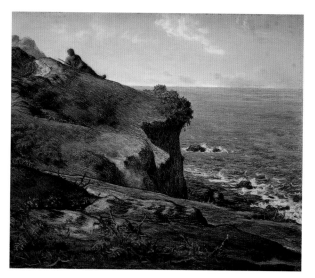

45. J.-F. Millet, *The Cliffs at Gréville,* 1867. Pastel, 43.5 × 54. Ohara Museum, Kurashiki.

but you know my passion for the sea, and here it is so beautiful. . . . I think that each day I understand her better, the slut, and certainly that name suits her, for she is dreadful; she offers up tones of a dull blue-

green and some absolutely dreadful aspects (I repeat myself).[11]

The sinuous character of Monet's clifftops at Grainval can even remind us of the backs of Degas' nudes, seen from above (fig. 46), because of the similar vantage points and the equation of nature with female form. In one confessional instance Degas partially transformed the body of a voluptuous nude into a clifftop landscape (fig. 47).[12] For neither painter is nature purely passive, because each gave his forms an organic vitality that lets us grant them some autonomy. To many male viewers this makes the control over them only all the more vital, but a female observer will presumably react differently, since she is at least partly the subject, as well as the perceiver.

Pourville and Varengeville

In early February 1882 Monet returned to the Channel coast for a sustained period of painting. (He had spent a few days at Trouville and Sainte-Adresse at the end of the previous summer, to absent himself while Hoschedé visited his family, but he did only three or four paintings.[13]) He remained at Pourville, near Dieppe, for seven productive weeks and liked it so much that he returned for the summer, this time with his combined families. He had again been encouraged by the reception of his marines. Twelve of them, mostly of Fécamp and Grainval, had appeared among his thirty-five pictures in the seventh Impressionist exhibition in March, and they were generally praised.

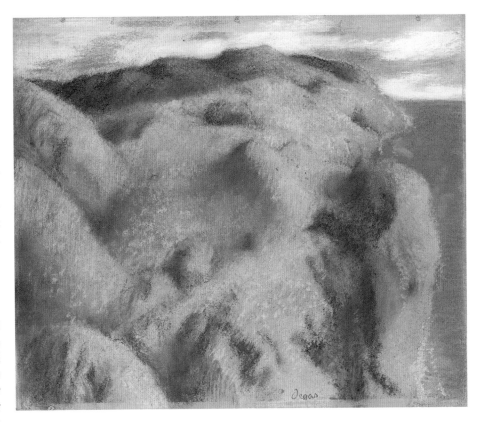

47. Edgar Degas, *Landscape*, c.1890–2. Pastel, 46 × 54.6. Galerie Jan Krugier, Geneva.

Durand-Ruel bought a number of Channel pictures at the end of April, and again the following October, so his campaign was well rewarded. He received over 31,000 francs from his dealer in 1882, which can be put in perspective if we recall that he paid his household servants 50 francs a month.[14] This does not mean that Monet thought he was well off, however, for he continued to spend more than he earned, and at every stage owed his dealer yet more paintings against advances. He also had a backlog of unpaid bills and was threatened with the bailiff in July for non-payment of a debt of 1,200 francs going back fifteen years; he expected Durand-Ruel to provide the money.[15]

There is no doubt that Monet worked hard for his money. From his campaigns near Dieppe that year, early February to early April, and mid-June to early October, we know of about ninety marines and a dozen other pictures. Some of these were finished only after his return home, but even so, it was an amazingly productive few months. Just how much this abundance was driven by the need for money we shall never know, but it was a major factor. His letters from Pourville to Durand-Ruel are devoted to money and to the related issue of exhibition strategy (his only absence from Pourville during the winter campaign was to go to Paris for the opening of the seventh Impressionist show). In other words, we cannot look

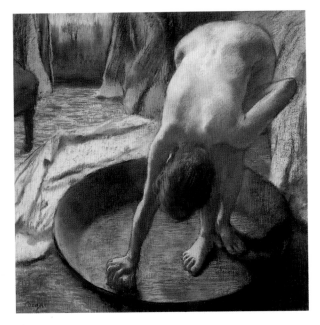

46. Edgar Degas, *The Tub*, c.1886. Pastel, 70 × 70. Hill-Stead Museum, Farmington, Conn.

upon his marines as disinterested visual poetry. They were his produce, sent back to the capital to be sold.

Just as we cannot divorce Monet's paintings from his market, so we cannot divorce them from the rituals of vacationing. Pourville was only two and a half miles west of Dieppe, where Monet had first gone in February but which he had found inappropriate for painting, the hotel being too expensive, the café, too full of "provincial types," and the cliffs, less beautiful than those of Fécamp.[16] The artist found Pourville much more to his liking. It was an unpretentious small port, with only one casino-hotel-restaurant, and it was here that the artist stayed that winter. Although he thought of himself as a Norman, he had been spoiled by years in Paris and had not appreciated the provincial life of Dieppe. Pourville was more to his liking, in part because there was less of an urban environment to intervene between himself and his preferred sites. His admiration of his Pourville landlord "Père Paul" and his wife was not because they were fellow Normans (both were Alsatian), but because of their unaffectedness, their excellent cuisine and service, and their devo-

tion to him. This reveals, of course, the artist's superior class position. He might have thought that he was "going native," but he was merely shunning reminders of urban life in order to position himself in the landscape as an insider.[17]

Monet returned later that spring to Pourville and located a rental villa so that Alice and their children could join him in the tiny port for the whole summer. Durand-Ruel, responding to Monet's enthusiasm, had also considered going there, but went instead to Dieppe; the two exchanged visits. The proximity that summer of dealer and artist reflects common bourgeois patterns of vacationing, and also the market ties that bound one to the other. Monet's extended family joined other vacationers in summer pursuits. The children watched fisherman at work, and one child was allowed to accompany the artist when he went reconnoitering in the swimming instructor's boat.

Monet, we know from his earlier work, was not the kind of artist who would paint frolicking children, and only a handful of his canvases done that year show any people at all. The figures of *The Pointe de l'Ailly, Low*

48. *The Pointe de l'Ailly, Low Tide.* 1882. 60 × 100. W 778. Mr. and Mrs. Nathan L. Halpern.

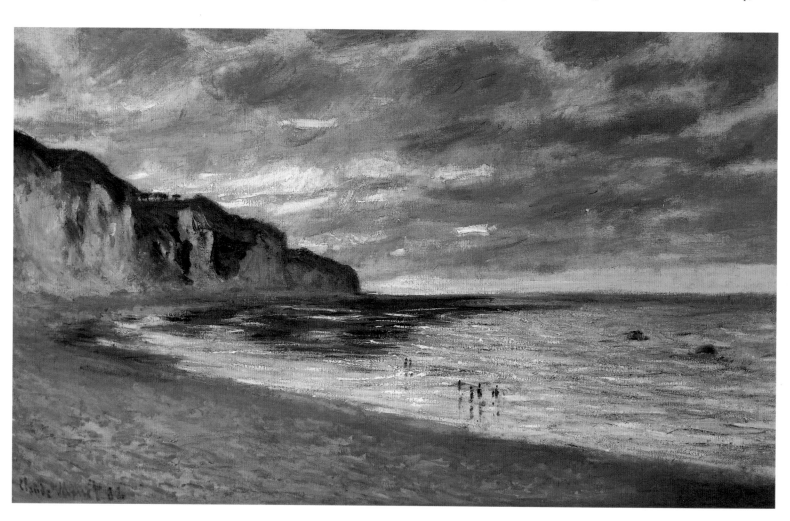

Tide (fig. 48), although minuscule, give scale to the broad expanse of water and sky in this striking picture. They may be local people seeking shellfish in the shallows, but it is more likely (by analogy with other pictures) that they are vacationers, hardy ones not intimidated by the strangely lurid sky with its contrasting yellow and mauve. The sky's yellow is reflected in the water as it nears the shore, but only from close view does it flatten the space; from normal distance the water and sky tip deeply into the distance. The presence of the tiny figures does not diminish this rather awesome prospect, but they represent the social act of seeing

nature in contrast to Monet's habitual creation of unpeopled canvases which let the viewer believe she is the only witness.

Four paintings of the 1882 campaign include small figures of vacationers, in each case two women facing the sea. Of these, *Cliff Walk at Pourville* (fig. 49) is the best known.[18] Above a summer sea sprinkled with sailboats stand two vacationers, perhaps posed by Alice Hoschedé and one of her older daughters (Blanche Hoschedé painted out of doors that summer). For Monet as for so many middle-class men, women at leisure characterized summertime generally and sea-

49. *Cliff Walk at Pourville*, 1882. 65 × 81. W 758. The Art Institute of Chicago, Mr. and Mrs. Lewis Larned Coburn Memorial Collection.

45

53 (facing page). Detail of fig. 49.

51 (right). *The Cliffs at Pourville*, 1882. 65 × 81. W 755. Nationalmuseum, Stockholm.

52 (below right). Fernand Fau, engraved by Rougeron Vigneret, *Gathering Mussels at the Roches Noires*, from Constant De Tours, *Du Havre à Cherbourg* (Paris, *c.*1890), p. 83.

50 (below left). *Rocks at Pourville, Low Tide*, 1882. 63 × 77. W 767. Memorial Art Gallery of the University of Rochester, New York, Gift of Mrs. James Sibley Watson.

shore vacations in particular. Here the two figures, small but conspicuous by their color and position (fig. 53), are intermediaries between ourselves and the scene; aware of these bourgeois women, we cannot picture ourselves alone. They help form a vacation picture in which all signs of work and city are absent; the two women and we look upon pleasure boating from an outlook marked only by exuberant growth and bright sunshine.

The vacationers of *Cliff Walk* and three other pictures were dispensed with in all the other canvases of the Pourville region. In front of these we would be tempted to set aside ideas of tourism; we could simply be lovers of natural landscape. However, when these pictures are looked at more closely, and compared with one another, we realize that they, also, are part of the vacationer's experience. In *The Cliffs at Pourville* (fig. 51) we seem to be an unaccompanied person looking out over the Channel, but the boats remind us of resort activity, and we can put ourselves in the position of the promenaders in the cliff-walk canvas. In *Rocks at Pourville, Low Tide* (fig. 50), we see locals gleaning shellfish from the tidal rocks, the kind of activity that the Monet–Hoschedé children surely watched. Vacationers sometimes played at being natives, as we can see in guidebook illustrations (fig. 52), but Monet, although he lived among other vacationers, expunged their society in his paintings. When we look at those purple rocks and the effervescent water, we imagine ourselves to be the only viewer.

Monet induces this "pure" experience not just by refusing the illustrator's anecdotes, but more importantly by the way he organized and rendered his images. His tipped-up perspective and foreshortened forms put us right on the rocks, with water pouring down in front of us so as to make us feel the hazards of leaping from one flat islet to another. His energetic brushwork calls attention to itself as gesture, not just as image, so we conflate his apparently spontaneous actions with our own act of perception. We become absorbed in our responses to this merging of nature with art.

In *Pourville, Flood Tide* (fig. 54), we face the motif

that he favored above all others in this region, one of the stone cabins built at the beginning of the century for observing coastal traffic, subsequently used by fishermen for storage and temporary refuge. Like the Grainval compositions, this canvas creates a sense of exhilaration or danger. The land is crowded to one corner, and we hover untethered over the scene because there seems to be no place for us to stand. The

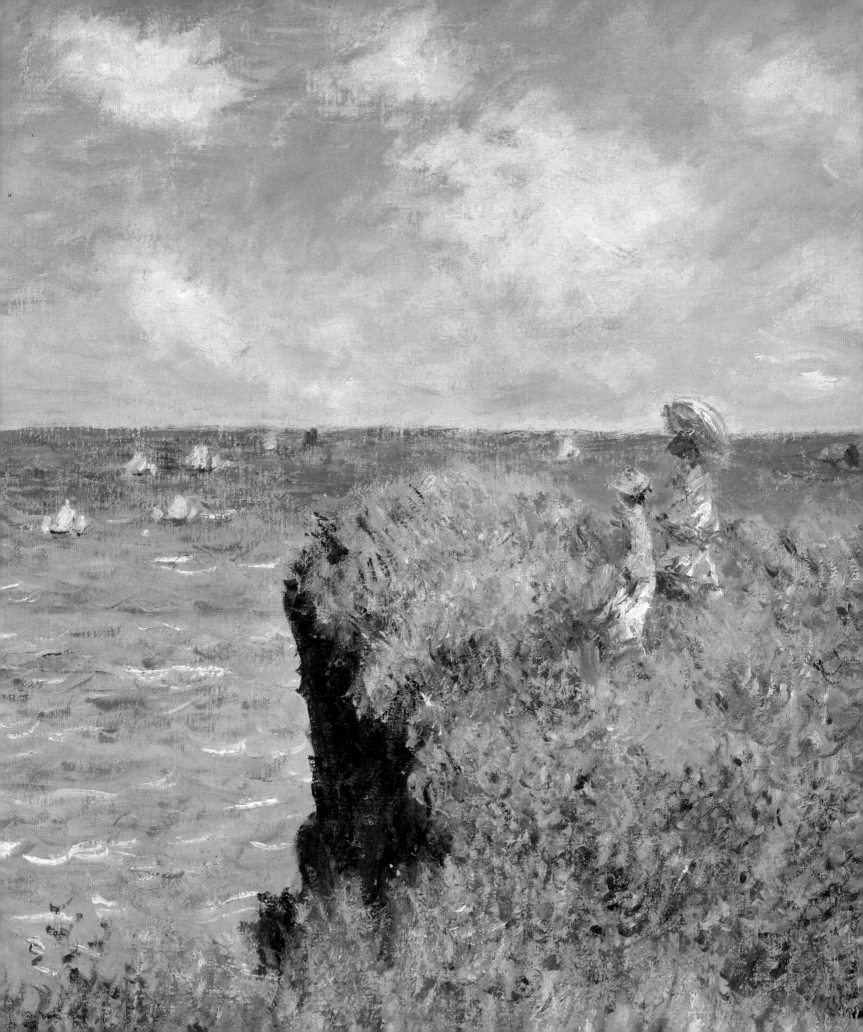

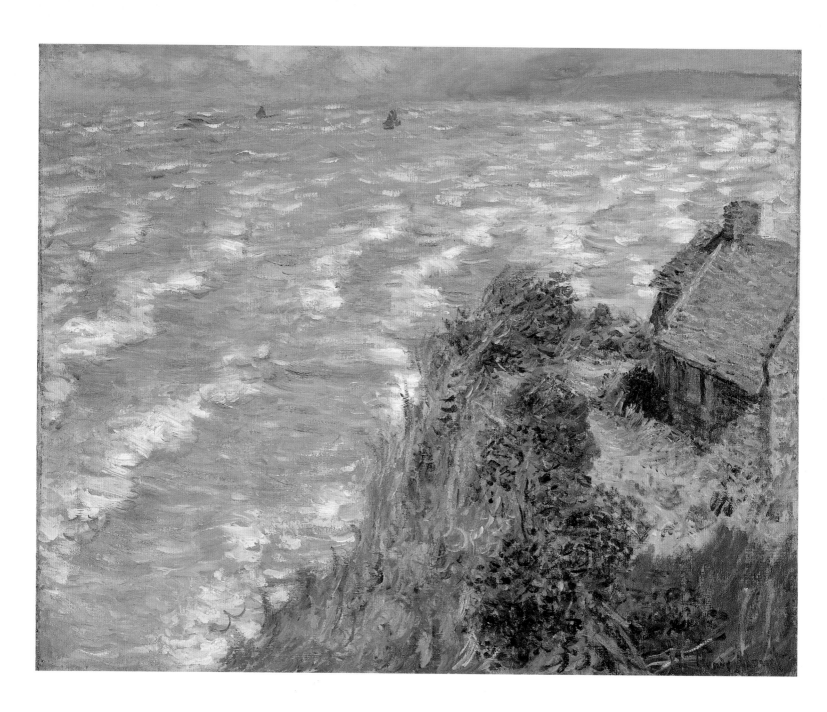

54. *Pourville, Flood Tide,*
1882. 65 × 81. W 740. The
Brooklyn Museum, Gift of
Mrs. Horace Havemeyer.

55. Detail of fig. 54.

sea is roiled up, its odd color the result of sand and
seaweed caught up in the turbulence. It besieges the
headland, but is resisted by the windswept cliff and by
the cabin, a lonely holdout against the adverse forces of
sea and wind. It is, of course, a surrogate for the artist
or tourist contemplating the sea, but since it does not
literally represent a human, the viewer is granted a
solitary presence.

In other renderings of the same cabin Monet pro-
jected an entirely different state of mind. It appears to
be an ordinary dwelling in *The Coastguard's Cottage at
Pourville* (fig. 57), and indeed "Fisherman's Cottage,"

an alternative name for it, seems a reasonable one when
we see it in such a peaceful setting.[19] This time it rises
from a luxuriant growth of bushes and wild flowers
(figs. 1 and 56). Its reds and oranges, rendered vivid by
the sunny afternoon light, stand out against the water's
greens and bluish purples. Instead of two fishing boats
beating out against a ferocious tide, a flock of yachts
glides over a calm sea. As for us, instead of surveying
the Channel, like a solitary watchman, we are more
like a promenader looking over toward a clifftop
residence.

Yet another mood arises from *Cliffs at Varengeville*

48

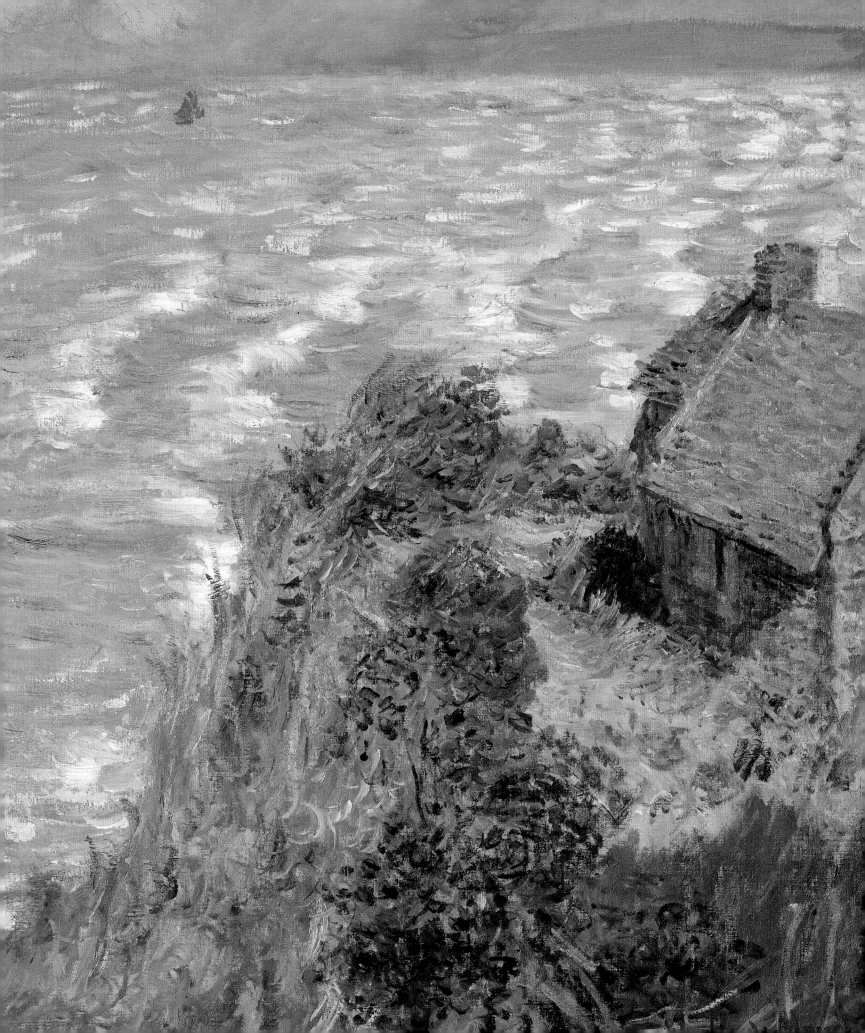

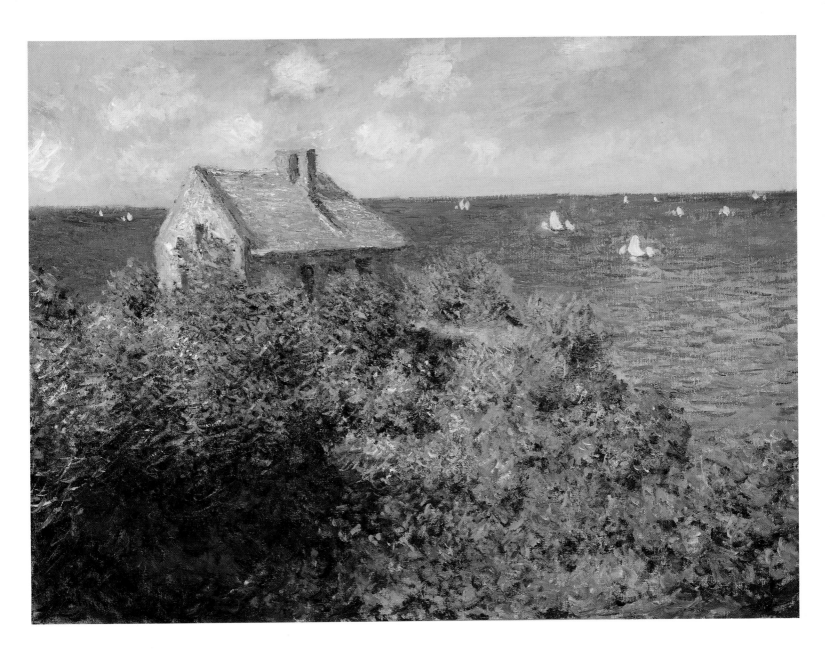

(fig. 59), where the same building is pictured from the southwest. We are positioned higher up here, but because the rank growth occupies the whole foreground and comes right up to our feet, and because we see farther along the coast, the cabin appears nestled protectively in a fold of the cliffs. In *Pourville, Flood Tide* Monet thrust the promontory out over the sea, disengaging it from the rest of the land, but here his substantial shadows connect the cliffs with the shore, and the winding perspective further explains how such headlands are formed. To add to our relative comfort, the Channel is calm, and in the distance we see the cliffs that, in the flood-tide canvas, form only an indistinct horizontal. This later picture should remind us of the view of Fécamp from Grainval (fig. 42), not just

because of the dramatic raking angle but also because the distant harbor is absorbed in an effulgence of color and light that denies it any substance. We would not recognize that beachfront as Pourville if we did not "know" it is supposed to be there. In both pictures the suppression of a built-up port lets us assume that the coastal view in front of us rises up out of some indefinite, pre-modern time. That, too, responds to the desires of vacationers who want to forsake not just the city, but present time, who want to absorb themselves in a beautiful, indeterminate nature – and subsequently in art.

We might be tempted to explain the differences among the three pictures that show the cabin by saying that they inevitably resulted when Monet changed his

57. *The Coastguard's Cottage at Pourville*, 1882. 61 × 88.3. W 805. Museum of Fine Arts, Boston, Bequest of Anna Perkins Rogers.

56. Detail of fig. 57.

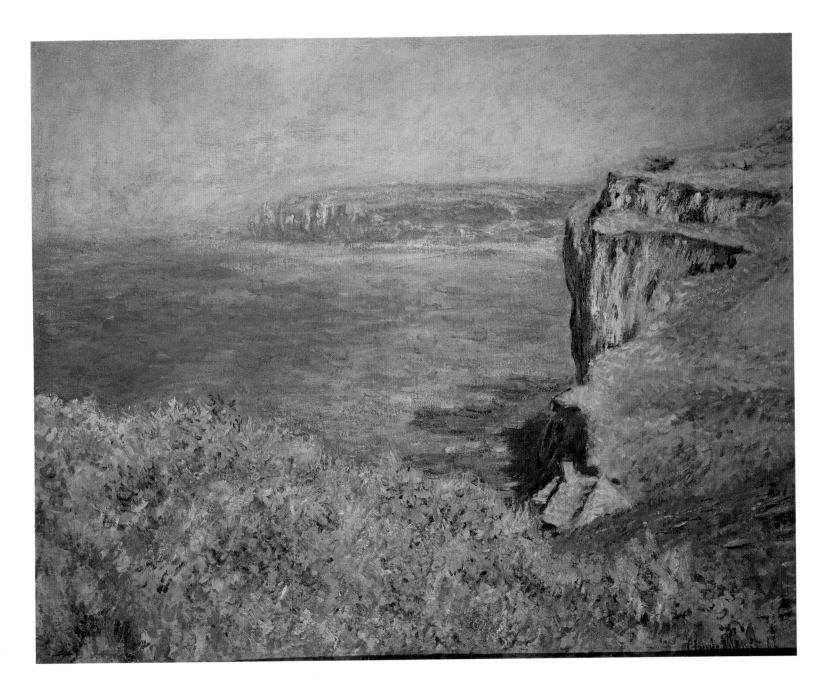

position along the cliff. That is a bogus explanation because, for one thing, he moved about in order to produce different results. More important is the fact that landscapes are not merely seen by the artist, they are constructed. Yes, he needed to stare at a specific spot in order to paint it, but first, his choice of that spot was partly predetermined by its prior descriptions and its regional fame, and second, he built up his composition in successive stages, usually terminated by final touches in his studio, far from the scene. Monet wanted us to believe that he painted in bursts of pure spontaneity, that he captured nature by an instinctual process that was itself natural, without deliberations that would interfere with the immediacy of his reactions. Indeed, he exploited his impetuous brushwork in order to emphasize this apparent spontaneity, but it was something of a formula. In the foregrounds of the three Pourville pictures we have looked at, we accept the general impression of rank growth, but cannot find precise images of stems, leaves, or blossoms.

These surfaces, in fact, result from a very artful procedure that disguises their careful preparation. In a letter to Alice Hoschedé from Pourville, Monet wrote that "most of my studies have had ten or twelve ses-

59. *Cliffs at Varengeville,* 1882. 65 × 81. W 806.

58. Detail of fig. 59.

53

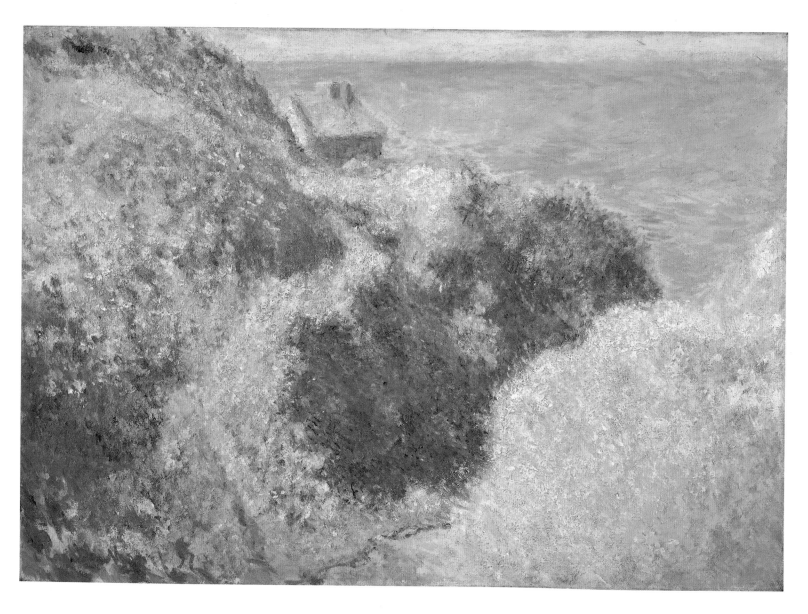

60. *Gorge of the Petit Ailly, Varengeville*, 1897. 65.4 × 92.1. W 1452. Harvard University Art Museums, Cambridge, Mass., Gift of Ella Milbank Foshay.

61. Detail of fig. 60.

sions, and several of them, twenty."[20] For the sea in *Cliffs at Varengeville* (fig. 59), he first dragged relatively dry pigment sideways across the canvas with very little pressure, creating parallels like the wales of corduroy because the paint adhered only to the vertical threads of the canvas. After this paint dried, he went back over it with elongated curving dabs of several tints of greens and blues to produce a suitable coloration and rhythm, allowing the corduroy to show through here and there as an indication of watery depth and movement. In addition to such calculated brushwork, his compositions were arranged with great deliberateness.[21] The white sails of *The Coastguard's Cottage at Pourville* (fig. 57) create an equilateral triangle that complements the portion of the sea on which they are placed as well as the shape of the cabin's gable. In *Pourville, Flood Tide* (fig. 54), the furrowed surge of the waves, abetted by

the left-to-right sweep of our eye, is repeated in the rhythms of the clifftop foliage.[22]

To draw attention to the way Monet put his pictures together is not to deny the way each of them produces a different effect. Given its dramatic impact, *Pourville, Flood Tide* borders on the Romantic sublime; *The Coastguard's Cottage at Pourville* communicates an idyllic mood rather like the rustic picturesque;[23] *Cliffs at Varengeville* is somewhere between the two, making us aware of the majestic confrontation of cliff and sea, but offering the comfort of an unthreatening vista. We can appreciate these differences if we look for a moment at the paintings Monet made when he came back to the same cliffs in 1896 and 1897, the only occasions he returned to the Norman coast after 1886. Like *Gorge of the Petit Ailly, Varengeville* (fig. 60), the later paintings, grouped in repetitive mini-series, are characterized by

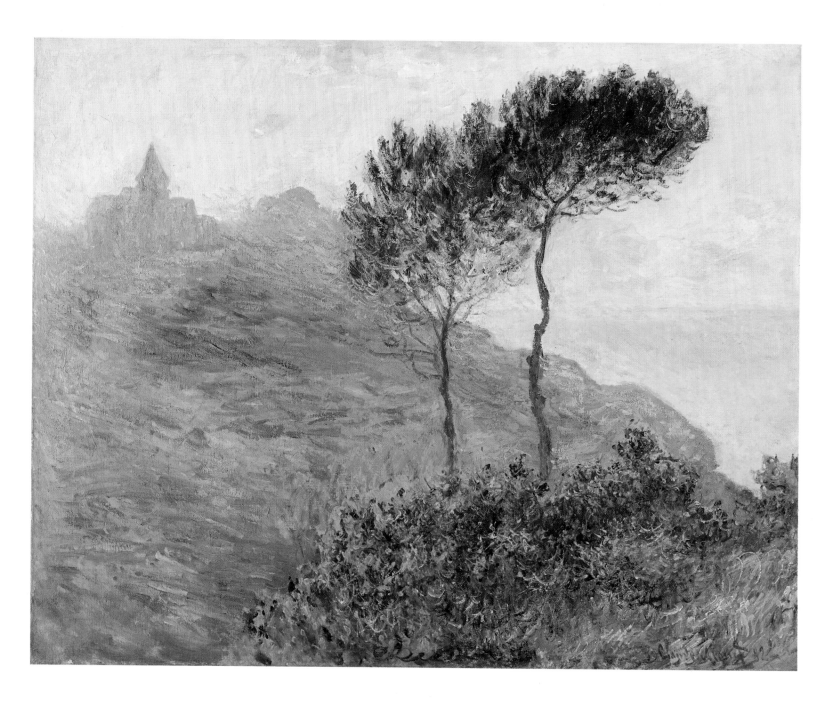

62. *The Church of Varengeville, Setting Sun,* 1882. 65 × 81. W 727. Barber Institute of Fine Arts, University of Birmingham.

rather generalized effects of light with fewer contrasting shadows, by pastel colors and softer, less defined contours, and by arabesques that play across the surface. As a result, the bulges and hollows which in 1882 evoke a whole variety of spatial and emotional responses now read as decorative surfaces of nearly the same mood (fig. 61).[24]

For other paintings in 1882 Monet went a bit further westward from the Pourville site to Varengeville, whose cliffs are continuous with Pourville's. Varengeville did not yet have the popularity it acquired after World War I, but its clifftop views,

touted by guidebooks, had already entered the annals of tourism. It was well known to artists: Eugène Isabey had frequently worked there before 1873. Monet made several paintings of the church at Varengeville which is perched on the cliff a few hundred yards from the village center. It was a mariners' church, with handsome interior vaulting evocative of ships' hulls. Still today its graveyard is dominated by the modest crosses of deceased sailors (even in death they must share space with summer residents, whose obtrusive tombs jostle theirs). Monet painted it from the opposite slope of a desolate valley, coated then and now in gorse-like

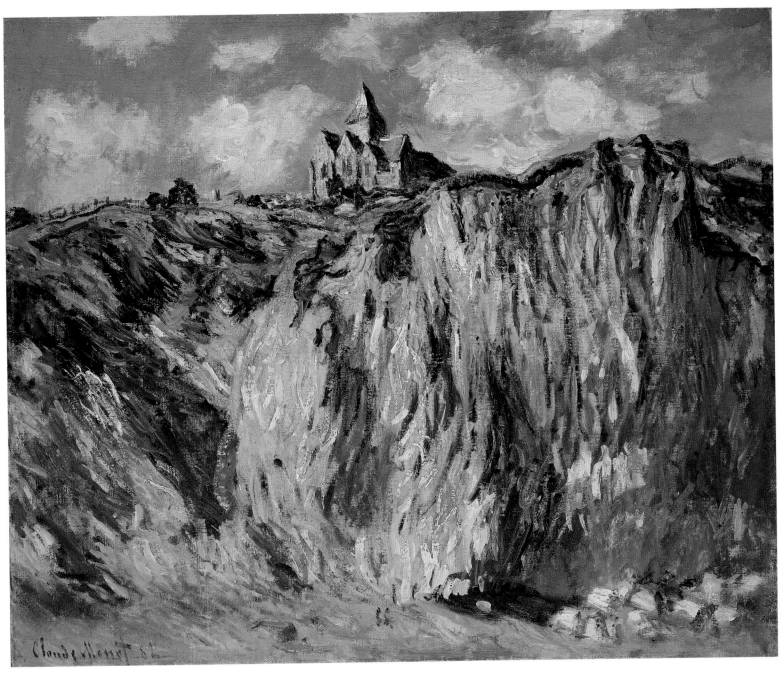

growth. In *The Church of Varengeville, Setting Sun* (fig. 62), he placed a pair of trees in the foreground which give scale and push back the receding hillside. The trees echo, in delicate movements, the pairing of the church and the bulky rise of the cliff to its right. Harmonizing the church so fully with its surroundings is surely Monet's way of insisting on its belonging there, on its age-old function as an outlook and a memorial. Two variants of this picture have nearly the same composition; another canvas is quite similar, but shows the church from a point closer to the water and has no trees in the foreground.[25]

The positioning of trees on one side of the foreground or mid-distance of a landscape is a familiar device, one associated with Claude Lorrain, the great seventeenth-century painter. Although principally indebted to the northern mode of landscape, Monet occasionally used the pictorial devices associated with Claude, the exemplar of the Mediterranean tradition. Prominent lateral trees were used repeatedly by Claude's British admirer, J.M.W. Turner, whose work Monet had encountered during his stay in England in 1870 and 1871. The right side of Turner's *Lake Avernus: Aeneas and the Cumaean Sibyl* (fig. 65) has trees

63. *The Church of Varengeville, Effect of Morning,* 1882. 60 × 73. W 794. Private collection.

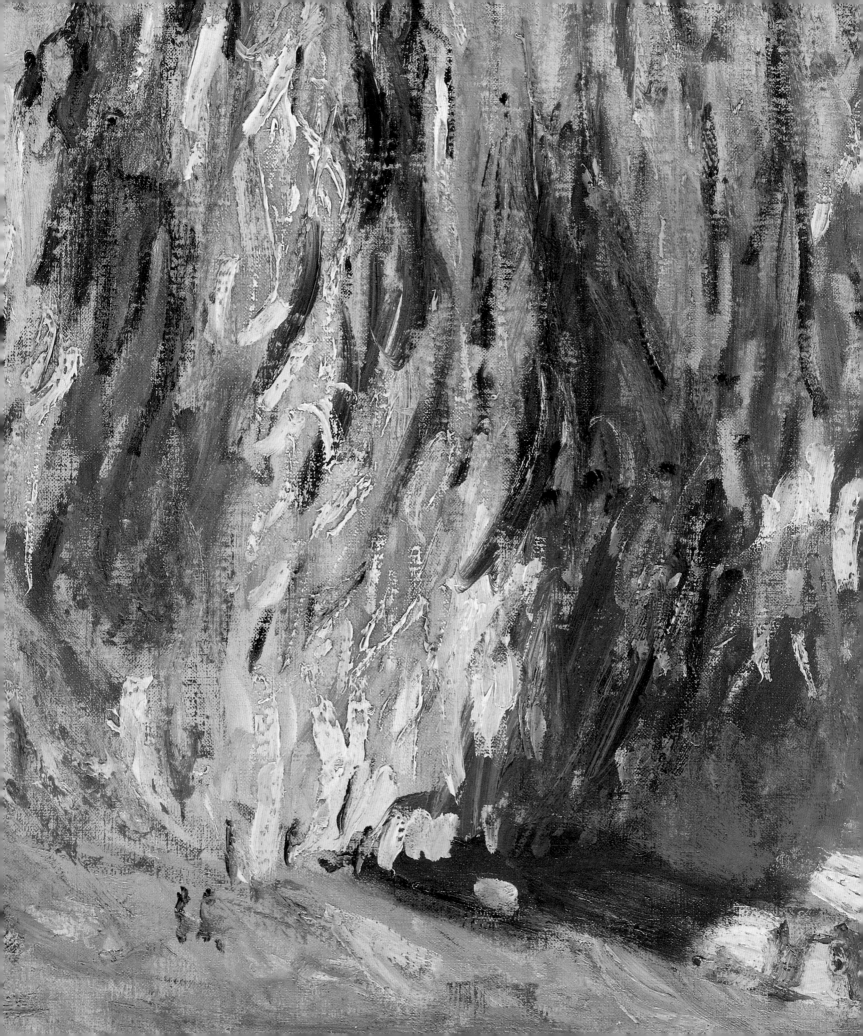

in the foreground, with rising mountains off to their left, one of them surmounted by buildings. To point this out is not to cite an influence, but instead to say that such a compositional device had become common property, a reminder that Monet was using a pictorial language, not wholly inventing one. Turner invariably has a strong central or off-center trough of space leading back to great distance, a construction rarely found in Monet; only a few of Turner's watercolors have the reduced number of planes of Monet's oil. Still, it is fair to say that Turner, more than any other painter, would have shown Monet the usefulness of *repoussoir* trees,[26] as well as the way that indefinite veils of paint can cloak a landscape in potent feelings. In Monet's picture the ruddy tones of the setting sun stroke the upper portion of the slope and the west sides of church and headland, and then illuminate the gorsy brush in the foreground. They do not touch the hillside, which sinks into a mixed purplish blue-green.

In some ways the most traditional of Monet's clifftop compositions because of its evocation of the grand tradition, *The Church of Varengeville, Setting Sun* is also one of the most moving. Its impact is matched only by three striking views of the church from the shore below. In *The Church of Varengeville, Effect of Morning* (fig. 63), Monet echoed the building's upright angles in the promontory to the right.[27] The effect of morning is to reveal, in glaring light, the monumental rise of the cliff and the diminutive, nearly fragile character of the church. The free-flowing colors of the cliff, which represent the stains that run down from the soil above, do not vaporize the mass of stone, because they are embraced in a sculptural modeling in which cool, darker colors contrast with warm, lighter ones. Tiny

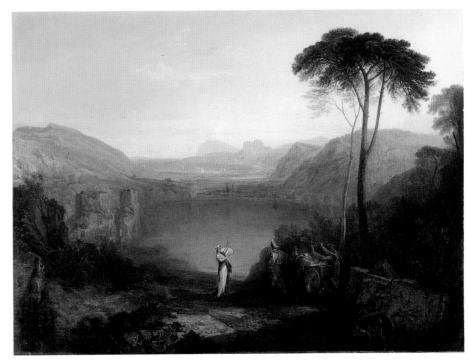

figures on the shore below, once they are spotted, further contribute to the massive scale of the cliff. They act as witnesses to the sublime power of the escarpment and remind us that all the Varengeville pictures, with or without human figures, put us in the position of the traveler who has sought out a romantic landscape. In their emotional eloquence, the sunset and morning views of the Varengeville church look forward to some of the most impressive of Monet's paintings of Etretat.

65. J.M.W. Turner, *Lake Avernus: Aeneas and the Cumaean Sibyl*, 1814–15. 71.7 × 97. Yale Center for British Art, New Haven, Conn., Paul Mellon Collection.

64. Detail of fig. 63.

3 Etretat's History and Fame

When Monet returned to his rented home in Poissy from the Channel coast in early October 1882, he concentrated upon finishing paintings he had begun at Varengeville and Pourville, and before the end of the month he delivered twenty-five to Durand-Ruel.[1] Over the next three months he initiated some still lifes and some landscapes of the Poissy region, but completed few of these, and began painting again in sustained fashion only when he arrived alone at Etretat on 31 January 1883. There, as he wrote Alice Hoschedé, he had a number of "motifs" close by, and he could work from the windows of the Hôtel Blanquet if the weather were bad.[2] He worked productively for three successive weeks, beginning about twenty-five pictures, many of which he later finished in his studio and sold to Durand-Ruel before the end of the year. In the following year – he had moved to Giverny in the interim – he returned very briefly to Etretat in August, but bad weather plagued him and he accomplished little. His longest campaign at Etretat began in mid-September 1885, when he arrived there with his large family. After Alice and the children returned to Giverny in early October, he moved to the Hôtel Blanquet and remained there at work until mid-December. Finally, in mid-February, 1886, he returned to the resort for about two weeks.

About seventy-five paintings of Etretat are recorded from the years 1883–6, with some fifty of them attributable to the fall and winter of 1885–6. As usual, many of these were finished after he returned to his studio, most within a few months; a few were parceled out over many years.[3] It seems nonetheless logical to separate them into two main groups, one for 1883–4, the other, 1885–6, for Monet dated most of them on the canvas and this tells us the likely date of their initiation, if not precisely when they were completed. For present purposes, the group date suffices and I shall refer only occasionally to the month or year of a picture. However, before we can look closely at them, we need to recapitulate something of Etretat's history. More than Sainte-Adresse, Trouville, Fécamp, or Pourville, Etretat was endowed with specific "views." These had been well established in paintings, prints,

regional histories, travel accounts, and guidebooks over a half-century before Monet's campaigns of the mid-1880s, and it is to these we must first turn. By learning about them we are in a better position to understand the extent to which Monet's pictures were a complex mixture of personal experience and social formulation. He knew Etretat intimately but this does not mean that the views he chose were special to him, and we need to familiarize ourselves with the legends that clustered around them.

Etretat, sixteen miles northeast of Le Havre, was exclusively a fishing village at the beginning of the nineteenth century, with a population under one thousand. Its vogue as a vacation spot began in the 1830s and grew apace. By the end of the century it had about 2,200 permanent residents, augmented by many thousands during the summer. Its fame then and now rests on its landscape, one of the most spectacular along the coasts of France (figs. 67–70). To the northeast, on the right when we face the bay from the village beach, is a headland of declining height that terminates in a low pierced archway, the Porte d'Amont, the "upstream portal." On the opposite side of the bay is the Porte d'Aval, the "downstream portal," more dramatic in its much higher rise, about 275 feet, its larger portal, and its detached Needle (the Aiguille), a towering pyramid some 225 feet high. If one walks along the shorefront from near the Porte d'Amont over toward the Aval, the Needle will gradually move behind the tip of the Aval until it can be partly seen through the arch, then it will be hidden entirely from sight well before reaching the southwest end of the bay (fig. 139). Monet shows all these views. From the beach near the Aval, one makes out clearly the large cavern hollowed into the cliff at its base, the Trou à l'homme, which shows as a dark patch at the waterline of Monet's paintings of the Aval.

Both promontories stretch out into the Channel to create a crescent-shaped bay; there is no harbor properly speaking, so boats have to be winched up onto a steeply rising pebble beach. From his hotel's windows, and sometimes from the beachfront, Monet painted these boats hauled up on the shore and occa-

66. Detail of fig. 86.

61

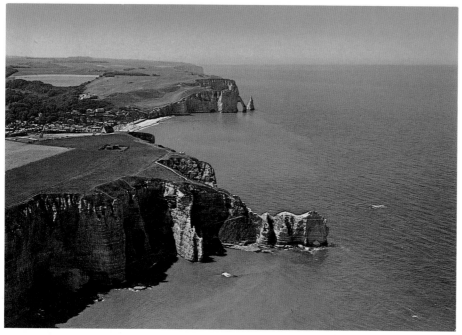

The most popular climb was on the other side of the bay, up a winding path to the top of the Aval. This pathway, formed and reformed by thousands upon thousands of visitors, was the most conspicuous alteration of the landscape by the activity of seeking the view. "Seeing" was, and remains, a powerful social agency. On the way out to the point a narrow causeway leads to a tiny enclosure hollowed out of the towering buttress-like rocks that rise above the edge. This is the Chambre des demoiselles, presumably part of ancient fortifications (its name comes from the legend of three virtuous maidens imprisoned by the cruel sire de Fréfossé). On the path near it one has remarkable bird's-eye views down onto the village. It was a favorite view of photographers (fig. 70), but not the kind that appealed to Monet. Further out on the promontory the Needle comes into view, a sight that still today, after several generations of touristic postcards, can cause one's heart to pound.

From atop the Aval one can look over to the third portal, invisible from the village, the Manneporte (presumably from Magna Porta), the highest arch of the three at Etretat (fig. 69). To get a closer view one follows along the clifftop to the southwest. For the hardy there was a very steep descent to the shore between the Aval and the Manneporte, aided by some cut steps and railings; guidebooks warned of its steepness and the risk.[4] From the shore of the enclosed bay below there is the most spectacular view of the Manneporte, one that Monet painted several times (figs. 96, 128–30, 134). Looking back from the same spot, the adventurous visitor has a vertiginous sight of the southwest side of the Aval and the Needle (fig. 127). Equally spectacular is the view of them from atop the cliff by the Manneporte, one that Monet painted three times (W 1032, 1033, 1051). Along the cliff above the bay of the Manneporte, a path leads further away from Etretat toward the Cap d'Antifer, a westward orientation that Monet painted only once (W 1039). From the clifftop beyond one can look back eastwards toward the Manneporte, a vantage point like the others that was popular in topographical prints before Monet painted it (fig. 128).

It was, of course, the pierced cliffs that led to Etretat's eventual fame, for the village itself had little claim to attention. That it was ancient is certain. It appears in medieval records as "Estrutat,"[5] and the remains of Roman roads and buildings were excavated beginning in the 1830s. Alexandre-Jean Noël's gouache (fig. 71) reminds us that the spectacular site had already been quite well known in the eighteenth century. Noël places us just beyond the Porte d'Amont at low tide, looking across the bay to the Porte d'Aval and the Needle. The scattered and modest houses of

67 (top). Etretat, looking northwest. (Color postcard.)

68 (above). Etretat, looking southwest. (Color postcard.)

69 (facing page top). Etretat, looking toward the Manneporte. (Color postcard.)

sionally showed them out in the bay. To the northeast, unseen beyond the Amont, is a declivitous gulley pounded by the waves to create the noise that gives rise to its name, the Cauldron (Chaudron). Guidebooks encouraged visitors to climb up over the cliff and part way down the other side in order to frighten themselves with the terrible grinding of the sea in the Cauldron. Steps were fashioned into the cliff face to facilitate the visitors' descent (the zig-zag pathway can be made out in fig. 68).

the village are dominated by a round tower, vestige of old fortifications that was demolished in 1869 to make way for an enlargement of the Casino: tourism has its costs! It was appropriately enough in the Romantic era that Etretat began its rise to national and international renown. The British marine artist Clarkson Stanfield drew the Porte d'Aval and the Needle for Leitch Ritchie's *Travelling Sketches on the Sea-coasts of France* of 1834 (fig. 72), the kind of book that catered to the interest the British had shown in the Channel coast since Waterloo, an interest sustained by painters like Stanfield, Bonington, and Turner. Artists and writers were, in fact, the vital agents in spreading the news about such places as Etretat:

> There [the Porte d'Aval] is something for a painter to look at, and for a poet to dream of. Gaze upon it through your half-shut lids, and you see the walls and towers of a fortress of the pre-Adamite world; and are ready to think that the unfortunate vessel on her beam-ends has but met with her deserts for intruding near a spot still haunted by the spirits of an earlier and mightier race.[6]

Stanfield's image suits Ritchie's romantic evocation, not only by figuring a shipwreck, but also by exaggerating the buttress-like verticals of the cliff to lend credence to the myth that it was a fortress of the Titans in their battles with the Gods. To stand there, this print tells us, would be to have a sublime experience, not merely a picturesque one.

"Sublime" and "picturesque," key terms in the discourse of Romantic art, had their origins in the eighteenth century, and were particularly important in Great Britain. "Picturesque" referred to objects, scenes, and qualities that were worthy of being made into or found in pictures. It was applied in the last years of the century mainly to rustic and irregular elements found in countryside and villages rather than in modern cities. The term was often paired with "sublime" but in opposition, for the latter came to mean an experience of a higher order resulting from awe or terror when confronted by natural (and occasionally human-made) forms of overpowering height, depth, or strangeness. Sublime experiences became prominent features of writings, dioramas, and paintings of the Romantic era, and by the middle of the nineteenth century the idea of the sublime was popularized and generalized. It was not limited to the mind of the perceiver confronted by phenomena in the real world (such as a towering mountain, or an industrial site by moonlight), but could be prompted by paintings and writings of awesome images.[7]

It was a sublime sensation that Jacob Venedey, a German traveler, was looking for when he visited

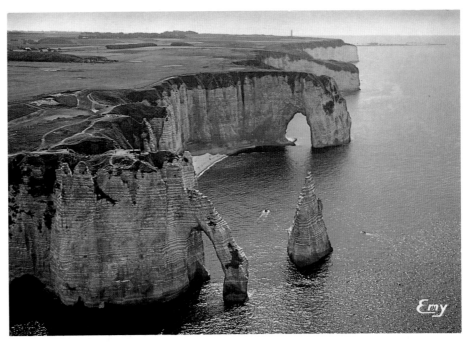

Etretat in 1837. There was no regular transport then (and no through roads), so he hitched a ride from Fécamp. Atop the Porte d'Aval, he wrote,

> the peaked rocks to the right and left of us shoot up high into the air; . . . yawning gulphs open at our feet, out of which the agitated sea sends up tones like the voice of a bard singing the destruction of his race.

70 (above). Maurice Davanne, *Etretat from the "Chambre des demoiselles,"* 1851. Photograph, 23.2 × 29.9. Yale University Art Gallery, New Haven, Conn.

71. Alexandre-Jean Noël, *Etretat*, *c.*1787, from Prosper Dorbec, *L'Art du paysage en France* (Paris 1925), pl. 2.

72. Clarkson Stanfield, engraved by R. Brandard, *Rocks of Etretat*, originally for Leitch Ritchie, *Travelling Sketches on the Sea-coasts of France* (London 1834), foll. p. 54, sold currently as postcard in Etretat.

And before us, in the sea, towers the Aiguille, a pyramid tall as a hill. For ages the sea has been silently mining its foot, or battering it with its foaming billows, but without making any impression. Fifty paces further is a semicircular recess, which may have served for the orchestra of the chapel belonging to this castle of some giant race. The roof has fallen in, but the pillars are still standing. This is a temple of God, built by God himself. My heart was too full. I could not stay long above, and was obliged to descend, to recover myself.[8]

Venedey found lodgings in Monsieur Blanquet's "Au Rendez-vous des Artistes" (later simply the "Hôtel Blanquet," where Monet stayed). He remarks on the artists who frequent the spot, and on "a little colony" that establishes the bathing season, "to enjoy the beauties of Nature and to recruit after the dissipations of Paris." Since he also remarks how cheap a full pension is (3F 50c), he cites the principal reasons for going there: fascinating nature, rest from urban cares, and economy. This triumvirate will dominate vacationing and tourism at Etretat for the rest of the century. He also says that Monsieur Blanquet had a "little library" of the writings of Alphonse Karr, already a local hero because of his publications featuring the village.

Karr was one of the most popular writers in France in the middle third of the century, particularly noted for his spirited short stories and essays. He began coming regularly to Etretat in 1833 and soon featured it in his writings. In *Le Chemin le plus court* (1838) he described its natural wonders, and recounted, suitably embellished, the story of Romain Bisson (1785–1823) who hid out in the cliffs in 1813–14 to escape conscription into Napoleon's army. The saga of "Romain d'Etretat" joined its romance to the cluster of legends about the Trou à l'homme, the Chambre des demoiselles, and the three portals. These were both written and oral texts and were so vital to tourism that they are still featured today in guidebooks and vendors' souvenirs. (And Stanfield's and others' romantic images are still today reproduced on postcards.) Karr's writings joined an increasing number of topographical prints and paintings of Etretat that appeared in Paris and abroad, and that probably had a role in encouraging more visitors.

Images like Stanfield's and publications like Ritchie's perhaps had something to do with a growing influx of British vacationers. (In his Paris-based journal *Les Guêpes* in July 1844, Karr recounts the disputes between Etretat locals and British tourists who were picnicking on private land.) By the 1850s, the British were constantly mentioned as regular members of the summer bathing colony, along with French painters and writers, and Parisians of the professional classes. Some of them demanded improved conditions of lodging and sanitation, although others came to Etretat precisely because it was unmodernized: opposing views that have ever since divided tourists wherever they go. The village began to change fundamentally. Fisherfolk sold out to entrepreneurs who remodeled or rebuilt for summer rentals; more inns, hotels, and restaurants appeared; private villas (including "Le Home" and "Carlyle House") sprang up in the village and ever more frequently on the sheltering slopes of the valley that afforded views of the sea and cliffs. Well-organized

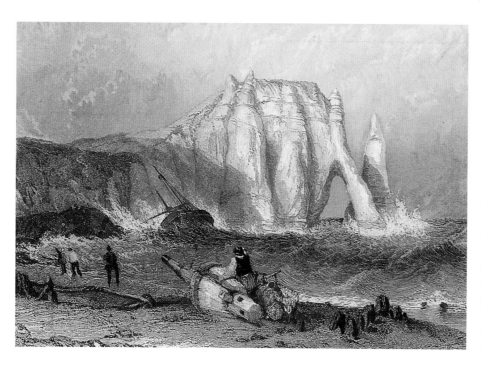

73. D. Lancelot, engraved by August Trichon, *The Porte d'Aval and the Needle of Etretat*, from Eugène Chapus, *De Paris au Havre* (Paris 1855), p. 235.

bathing establishments supplanted the informal habits of preceding years. In 1852 the Casino was opened on the shorefront, and it was progressively enlarged as the resort's fortunes improved.

Eugène Chapus gives a good idea of Etretat early in its hey-day in his guidebook *De Paris au Havre* (Hachette, 1855), well worth pausing over. It is no accident that it appeared in the series "Bibliothèque des chemins de fer" (The Railroad Library), for travel by rail began to expand rapidly after 1850, and the new industry saw the advantage of tie-ins with tourism (Chapus's book has many woodcuts, some after drawings by Daubigny, of railroad bridges along northern routes). Excursion tickets were already a common feature, although to reach Etretat one had to take a carriage from one of the nearby railheads, Le Havre, Fécamp, or Les Ifs. Chapus's account of Etretat, accompanied by a woodcut (fig. 73) pirated from Stanfield's engraving, begins with an all-important reference to its "discovery" by an élite, thereby providing incentive for others to come: "For some time now Etretat is recorded in the *diary* [this word revealingly in English] of élite tourists, these people who, by taste, become professional travelers. . . ."[9] He writes of Karr as a prominent figure in Etretat, one whose writings drew others to the village, and cites at length from Karr's story of Romain Bisson. He offers his reader more legends and references to other writers, texts that function as intercessors between the vacationers and the remarkable nature they will see. In fact, we cannot really conceive of untouched or raw nature, for nature is understood only by virtue of social texts that stand between a given site and the observer. Chapus builds upon Karr, and later travel writers upon both, so that by the time of Monet's campaigns in the 1880s, both written and visual texts, like so many barnacles, had clung to every feature of the port and determined its canonical views.

Chapus also gives a good account of the more mundane features of Etretat, particularly of its rapid growth. Fisherfolk have given way to vacationers, yet readers in 1855 are assured that many are still engaged in their traditional activities. Except for newer inns and hotels, lodgings are cramped, smoky, and devoid of most modern comforts, he reports, but of course this was charming to those seeking "authenticity" in their escape from the city. (Chapus, nonetheless, gives some hope to those looking for improvements and notes that many small houses are becoming *cottages* [again, he uses the English word].) Readers are promised folkloric rituals, but, since he is an honest reporter, Chapus points out that for the local festival of the Holy Savior (Saint-Sauveur), conveniently in August, there are now fireworks, and vacationing musicians and singers help perform the High Mass. He contrasts the skillful renderings of these sophisticated visitors with the fishermen's canticle, sung that same day with a touching simplicity.

By detailing the cohabitation of traditional customs and sights with vacationers and the alterations they cause, Chapus reveals more than many other travel writers who avoid signs of change (except, of course, to list lodgings, restaurants, and other amenities, including the Casino). In his account of the Casino, Chapus contrasts its twice-weekly dances, energized by regional visitors, with the vacationers' in-between days. The Casino, he writes, "is literally invaded by crowds on Sundays and Thursdays, when balls are held, to such a point that our Parisian women are obliged to dance elbow to elbow with women of Fécamp; on other days time is passed rather sadly at playing lotto or solitaire and working tapestry.[10]

In resorts like Etretat (for by the 1850s, we have to call it a resort), the casino was the dominant social and architectural intruder.[11] Usually linked with a bathing establishment and presided over by a directorate of local and regional notables, the casino was the center for vacationers. In Etretat this was all the more true because the village had no luxury hotels such as those in larger resorts like Trouville, hotels that had their own casino-like activities. Pressure from foreign and Parisian vacationers led to steady demands for improving Etretat's Casino. It was extensively remodeled and enlarged in successive campaigns, including that of 1869 which required, as we have seen, the demolition of an ancient round tower (fig. 71). By the early 1870s the Casino had all these facilities: a long frontal terrace; a dancehall, used also for theatrical and musical presentations; a reading-room that could be opened out to the dancehall for large entertainments (500 seats); a

salon de conversation; a bar-café with billiard tables; a restaurant; gaming-room; shooting gallery; outdoor swings and seesaws; gymnasium; children's room; a greenhouse.[12] Henry James reported in 1876 that there was some form of entertainment every night in the Casino, at the very least "a bland young man in a white cravat plays waltzes on a grand piano," alternating with "light specimens of the lyric drama."[13]

The constant balancing of Parisian enclaves with local environment was evident to visitors, although guidebooks seldom drew attention to such signs of inauthenticity (Chapus being an exception). Karr himself acknowledged in 1860 that Etretat had become a "succursale d'Asnières," a branch or outpost of the Parisian suburb known for its boating and riverside leisure.[14] Seasonal journals, published locally, and regional papers listed Parisian and other notables among those spending time in Etretat, usually as subscribers to the Casino. Among a long list of famous artists, writers, musicians, theater professionals, and the wealthy who spent seasons at Etretat (many in their own villas), we find Augustus Swinburne, Guy de Maupassant, Jules Massenet, and J.-B. Faure, Manet's friend and later Monet's host at Etretat. Jacques Offenbach had built his Villa Orphée in Etretat from the proceeds of *Orphée aux enfers*, his great Parisian success of 1858. In addition to huge parties that he offered his entire troupe (prospering a few locals and annoying others), Offenbach brought his Bouffes-Parisiens to the Casino in 1867 to play *Les Violoneux* and *Les Deux Aveugles*. In 1864 he celebrated his daughter's wedding at his villa by composing a mass; ninety Parisians were his guests for three days.[15] Not only did the famous and the wealthy re-establish a Parisian culture while ostensibly distant from the capital, but also they were themselves a draw for other vacationers who could admire them from a close distance. Of course, one of the functions of the seasonal journals was to list aristocratic and famous visitors so as to increase the village's prestige, and therefore its income. Though not yet called such, the industry of tourism had become Etretat's chief source of prosperity.

Daytime life for vacationers centered around bathing. Behind its social rituals lay the idea that immersion in salt water was good for one's health. Both sea air and sea water were praised as curative, making coastal resorts rivals of the inland spas like Vichy and Baden-Baden. Marine cures were recommended for a whole variety of illnesses, from mental lassitude and nervous disorders to asthma and consumption. The virtues of salt water were most famously endorsed by Jules Michelet in his *La Mer* of 1861, but he regretted that the mixture of local people with Parisians was ruining fishing and the traditional life of Etretat.[16] For every Michelet, however, there were a dozen other writers who touted bathing in its increasingly mundane settings. At Etretat the key figure was Dr. P.-M. de Miramont, whose activity reveals the coupling of medical science with vacationing and financial speculation. In 1851 he published a *Notice sur les bains de mer d'Etretat, près du Havre*, and established a clinic there; the next year he was registered as one of the stockholders of the Casino, and in 1855 was officially named medical inspector of bathing at Etretat ("Médecin inspecteur des bains de mer d'Etretat"). He continued to publish and promote the curative powers of sea bathing, one of a large number of medical men who built fortunes upon this feature of vacationing. For those desirous of embellished hydrotherapy, the Casino added heated indoor baths of both fresh and salt water in 1862.

For many, bathing meant simple immersion in the water, but swimming, rare before the nineteenth century, became increasingly popular (competitive swimming dates from the second half of the century). Swimming was associated with the virility of coastal and riverine workers and was another way for city-dwellers to claim closeness to nature. It was also a more sociable activity than slipping discreetly into the water, and therefore eminently suited to vacationing. Etretat's beach of rounded pebbles dropped off very steeply, so one could dive from two-wheeled boards towed into the edge of the water: Such a board is featured in Eugène Le Poittevin's *Bathing at Etretat* (fig. 74) against the backdrop of the Porte d'Amont. Le Poittevin exhibited this picture in Paris in the Salon of 1866, one of a number of paintings that over the years familiarized Parisians with the village (he had shown another of Etretat in the previous Salon). Raymond Lindon has shrewdly identified several of Le Poittevin's figures, including the diver (the adolescent Guy de Maupassant), the man with crossed arms near him (the caricaturist "Bertall," vicomte d'Arnoult), and the elegantly dressed woman further down the board (the *actrice* Eugénie Doche, famed for her *Dame aux Camélias* in 1851).[17]

Bathing was well organized at Etretat, a foretaste of the commercialization of beaches so well known to those who today hope to swim along France's shores. It is true that before and after bathing there were parties organized at the various private villas and at the inns, but once on the beach one had to pay a fee to one of three rival entrepreneurs who had subdivided the half of the shore toward the Porte d'Amont (the other half was for fishing boats). Each of them provided swimming instructors, usually former fishermen, and rented out small bathing cabins, costumes, and towels: "The Mathurin-Lemonnier concession is the most popular,

74. Eugène Le Poittevin, *Bathing at Etretat*, 1865–6. Panel, 21 × 48.5. Private collection. Variant of the painting exhibited in the Salon of 1866 (Musée de Troyes).

the most crowded. It's the one favored by artists, writers, and *élégantes*. . . . The bathing instructors preferred by women are Louis Mathurin, Maillart and the huge Aimé. They are polite, gay, robust, prudent. . . ."[18]

Etretat was notable for the fact that male and female bathers were not segregated, as was elsewhere the custom. This gave a definite *cachet* to the place, one that was noted in otherwise staid guidebooks.[19] Contemporaries describe the beach society as dominated by groups of women (men typically came on Sundays and holidays, leaving wives and children for longer stays), hence the need for prudent male instructors. The resort was also notable for its varied and informal daytime attire. Henry James took pleasure in a kind of protective coloration:

> You wear old clothes, you walk in canvas shoes, you deck your head with a fisherman's cap (when made of white flannel these articles may be extolled for their coolness, convenience, and picturesqueness), you lie on the pebbly strand most of the day, watching the cliffs, the waves, and the bathers; in the evening you loaf about the Casino, and you keep monkish hours . . . – no menace of the invasion of luxury.[20]

Others went further in the direction of local dress. The Parisian publisher Henri de Villemessant wore wooden shoes, and Alphonse Karr stumped about in fishermen's boots and slickers. This might strike us as pretentious, but most travelers will recognize the desire of the temporary resident for partial assimilation.

As for the natives, by Monet's day many of them had departed after selling their houses and land to entrepreneurs for inns, hotels, and restaurants, and to others for private villas. Fishing continued, but we know that some fishermen and their sons had become swimming instructors, and their wives and daughters, laundresses, baby-sitters, and occasional servants for vacationers. (Old photographs show women in local costume standing by the bathing cabins.) Some locals had become artists' models, either hired out as such, or merely part of the local color that any artist could exploit. The transformation of real fisherfolk into vacationers' servants and artists' models is the reverse of Karr's or de Villemessant's procedures, because the locals, undoubtedly encouraged by the chamber of commerce, artificially perpetuated their old customs and dress to provide "authentic" native life for outsiders. In these performances the distinctions between reality and illusion would not always be easy to draw.

With prints and paintings, reality and illusion cannot be separated at all. Painters and printmakers had a vital role in Etretat's prosperity, for it was they who literally gave vision to the village and its wondrous setting. Karr himself acknowledged that Le Poittevin and Eugène Isabey had preceded him at Etretat, and surely numerous artists must have frequented the place for Monsieur Blanquet to have named his hotel "Au Rendez-vous des Artistes" by 1837, when Venedey stayed there. Like Barbizon at about the same time, and Pont-Aven later in the century, Etretat was colonized by artists. Its pierced cliffs were obviously the chief reason for going there, at least initially. Another was the very fact that the village was not at first popular, indeed was difficult of access, so for a few years one could have boasted of being in on the "discovery." Each artist wished to take a hand in picturing the cliffs so as to be counted among the vanguard of cognoscenti. Although a painter might believe himself alone in front of the motif, he met

75. Maurice Davanne, *Eugène Le Poittevin's Studio-House "La Chaufferette" at Etretat*, 1851. Postcard processed in 1923, from J.-P. Thomas, *Etretat autour des années 1900* (Fécamp 1985), pl. 249.

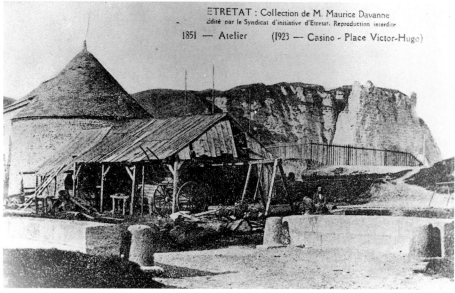

ETRETAT : Collection de M. Maurice Davanne
édité par le Syndicat d'initiative d'Etretat. Reproduction interdite
1851 — Atelier (1923 — Casino - Place Victor-Hugo)

76. Maurice Davanne, *Fishermen's Workshop, Etretat*, 1851. Postcard processed in 1923, from J.-P. Thomas, *Etretat autour des années 1900* (Fécamp 1985), pl. 248.

Romantic era, when Etretat was first put on the map of fashionable resorts. French artists, moreover, were then turning increasingly to regional French landscapes instead of to Italian sites associated with the classical tradition. Italian landscapes still had an advantage over French places (and still typified Salon painting and artists trained in the traditional manner: witness Corot), namely, the vast array of written texts that came from the Graeco-Roman underpinnings of French culture. These texts, and several centuries of paintings, meant that viewers brought prior knowledge to pictures of classical sites. Théodore Rousseau ("le grand refusé") was often excluded from official salons in the 1830s and 1840s partly because his pictures had no body of familiar written or painted texts to draw upon. His *Valley of Tiffauge*,[21] which represented a Vendéen swamp, was derisively nicknamed "The Muddle" ("Le fouillis") and "The Soup of Weeds" ("La soupe aux herbes"), because its humble native subject had no ennobling text. By contrast, Etretat not only had an inherently sublime landscape, but it was rich in legends that provided the texts that Rousseau's swamp lacked. Karr gave prominence to these legends in his recounting of the stories of Romain d'Etretat, the Chambre des demoiselles, and the Trou à l'homme, and in describing the picturesque fishing village. By mid-century, when printmakers' and painters' images reached their public in increasing numbers, Etretat was well on its way to great renown.

The first generation of artists at Etretat stayed at Blanquet's or rented rooms from local families. (Visitors later, with mixed pleasure and regret, would recapitulate the artist's climb to a picturesque attic.[22]) Le Poittevin was the first painter to construct his own villa there. In 1851 he built "La Chaufferette" and a second building, a villa-cum-studio right on the waterfront, with huge windows opening out onto the bay (fig. 75).[23] Courbet borrowed this studio for his campaign there in 1869. Hugues Merle (1823–81) built the villa "Les Oiseaux" in 1860, and Charles Landelle (1821–1908), "Casa Landelle" at about the same time. Like Karr, these painters became local notables, and by the end of the century their villas were pictured on postcards, along with those of bankers, politicians, and other wealthy landowners. Karr, Isabey, and Le Poittevin all had streets named after them before 1890, proof enough of the significance of artists to the fame and commerce of the village.

In addition to artists who took up residence in Etretat, countless others worked there for one or more seasons. Mention has already been made of Noël and Isabey. Louis Garneray (1783–1857) included Etretat in his album of engravings *Ports de France* in 1821, and Etretat figured among the lithographs in the important

fellow artists at Blanquet's hotel, and consciously or unconsciously held up his work against theirs. Artists, that is, were drawn to Etretat in part because other artists frequented it, and Monet was no exception.

The developing iconography of Etretat was a communal invention, but that did not rule out originality which then, as now, was often a matter of variation upon a known theme. Originality could be enhanced by a new motif, and the striking cliffs of Etretat suited the search for sublime nature which characterized the

Cours complet du paysage (c.1835) by J.-L.P. Coignet (1798–1860). Charles Mozin (1806–62), a specialist in Norman coastal scenes, made both paintings and prints of the village and its cliffs. In 1851 the more obscure Maurice Davanne made a series of photographs of the village and the cliffs, later used for postcards (fig. 76). Corot was there in 1872 and presumably earlier, but his choice of subject reveals an artist more at home with the picturesque than the sublime. Only one painting shows the cliffs (the Porte d'Amont, inconspicuously in the background); the others show nearby thatched cottages and farms. Closer to Monet's own predilections were two artists he knew well, J.B. Jongkind, who was there in 1851, 1853, and 1865, and Courbet, whose important campaign there in 1869 will shortly be discussed. Delacroix, the premier Romanticist, had also visited Etretat, presumably in 1835. The fact that Monet eventually owned one of his watercolors of the Porte d'Aval cannot be used to propose a special relationship, but at least it is proof of Monet's consciousness of the pictorial tradition that he shared with other artists.[24]

4 Etretat, 1883–1884

Courbet was on Monet's mind when he arrived at Etretat at the end of January 1883. He wrote Alice Hoschedé, "I count on doing a large canvas of the cliffs of Etretat, although it is certainly bold of me to do that after Courbet who did it admirably, but I will try to do it differently. . . ."[1] There is no doubt that he was thoroughly familiar with the older artist's work. He had known him well in the 1860s, and his dealer Durand-Ruel, whom he often saw, included Courbet importantly in his sales and exhibitions. Moreover, he must have attended the painter's retrospective the previous year (Courbet had died in 1877), in which there were eleven canvases of Etretat,[2] and this event may well have encouraged his own return to the resort. The older painter had spent six weeks there in late summer 1869. Monet, we recall, had passed the winter of 1868–9 in Etretat, but, although the two were well acquainted, there is little reason to connect their visits that year. Now, however, Courbet's Etretat pictures were well established as famous prototypes that Monet would have to reckon with, and for this reason we should look at them before turning to the younger artist's work.

Courbet said that he had been commissioned to go to Etretat in 1869,[3] which apparently means that one or more of his dealers or clients specified pictures of Etretat, hoping to obtain the work of a famous place by a famous artist. He began a large number of pictures, finishing them later in his studio. Counting replicas that he made (a sign of their saleability), we know fourteen canvases showing Etretat's cliffs and several dozen views of the sea, presumably from the shore at the port. Two he signed 1870 and showed in the Salon that year, *The Wave* and *Cliff at Etretat after a Storm* (figs. 78 and 79). They were the largest landscapes he had ever painted without significant human or animal figures, and, because of the painter's notoriety, they gave more than ordinary prominence to the seaport. Their size was commensurate with their importance, since from the outset Courbet destined them for exhibition at the Salon. The state bought *The Wave* in 1878 for the Musée du Luxembourg in Paris, and it and Courbet's other Salon picture were shown in the posthumous

retrospective of his work in 1882, so Monet was not the only one who knew them.

The Wave could, one supposes, have been painted at any number of Channel ports, but at Etretat, because the beach drops off sharply, the surf can pound the shore several feet below its crown (and many feet below, at low tide) to produce the effect that Courbet saw from the large windows or the doorway of Le Poittevin's studio (fig. 75). The beached boats are a sign of the rough seas, and a reminder that Etretat was not a port but only a bay exposed to the open Channel. In *Cliff at Etretat after a Storm*, the famous Needle is out of sight behind the promontory of the Porte d'Aval. In the foreground on the left is the door of a cave cut into the limestone. On the right, in front of the beached boats, is a washerwoman's wooden paddle in a communal holder. Further back, directly above the paddle near the water's edge, is a large group of women in local costume, kneeling down. They are almost

77 (facing page). Detail of fig. 94.

78. Gustave Courbet, *The Wave*, 1870. 117 × 160.5. Fernier 747. Musée d'Orsay, Paris.

invisible in the scale of a reproduction, but easily spotted in the original (fig. 80), although it is commonly said that the picture contains no humans at all.[4] These women indeed characterize an aspect of life at Etretat featured in guidebooks as one of its most picturesque customs (fig. 81). Because a fresh-water stream runs unseen under the cliff and surfaces among the pebbles at low tide, laundresses simply scooped out a hollow and did their own and vacationers' wash.[5] Obviously, Courbet made them inconspicuous, but he included them because they typified this portion of the beach at low tide.

These and other pictures by Courbet were on Monet's mind in early February 1883, because he was planning an exhibition of his own at Durand-Ruel's to open at the end of the month. The idea of a "large canvas" nagged him for weeks. He sometimes referred to two such pictures (perhaps an echo of Courbet's Salon pair), one of the cliffs, the other of boats along the shore. He wrote about numerous smaller pictures he was doing, intending to finish them in his studio,

and in one letter suggested that a big painting could perhaps be accomplished from one of these.[6] As it turned out, no large canvas was done, and no smaller one was ready in time for the opening of his show on 28 February. Instead, he exhibited many paintings of the Pourville-Varengeville campaign of 1882, having probably touched up some of them in the week before the exhibition.

Although no outsized canvas resulted from his three weeks at Etretat, a number of his standard dimensions (typically horizontals of eighty-one centimeters wide, less than half Courbet's big canvases) were begun and then worked on later in his studio at Giverny, where he had settled the previous spring. These included views of boats on the beach and of all three of the famous portals. Mentions of them are frequent in his letters from Etretat, although we can seldom deduce which particular pictures were at issue. The letters also disclose that he worried greatly about whether or not they were sufficiently new. Before he went to Etretat he had spent a week in Le Havre where he had envisioned

72

new compositions for his forthcoming exhibition. When bad weather persisted, he had moved over to the smaller port. Letters written his first day there express fears that his pictures at Etretat would be "less new" and "perhaps not so varied" as the ones he contemplated at Le Havre, which, alas, were never described.[7] Four days later he wrote his companion that "I only have one fear, it is that these new things might not be as different from my other things as those I ought to have done at Le Havre. There's my chief worry, but I can't prevent myself from being seduced by these admirable cliffs. . . ."[8] In other words, determined to do new compositions to enhance his exhibition, he was concerned because paintings by Courbet and others had established views of the cliffs from the most favorable vantage points, leaving him little room to maneuver. When altered weather prevented him from working on paintings of boats on the shore, which *were* "new things," he had to turn to "two or three stupid motifs of the cliffs."[9]

It was not easy to devise new ways of siting the familiar cliffs. In *Etretat, Rough Seas* (fig. 82), he painted the turbulent sea beating against the Aval, a common theme in compositions of the Romantic era, like Clarkson Stanfield's (fig. 72). Stanfield's composition is a composite that shows the Aval and the Needle as though seen from across the bay (compare fig. 86), but the fore- and middleground as though from close by. His shipwreck and the abandoned and decayed structures on the beach encourage the viewer to think of humankind's vulnerability in face of nature's powers.

The strength of these associations with the Aval was such that Monet could not entirely suppress them. His composition perpetuates the struggle of mariners and cliffs with the surging waters, and his foreground shows fishermen alongside their boats. Prominently nearby are some *caloges*, those disused boat hulls that were thatched or planked to provide storage. *Caloges* and fishermen were regular residents of Etretat's beach; there is no shipwreck, and the Needle does not appear because it would not be seen from his vantage point. In working out this composition, Monet was making a reprise of his first picture of the site (fig. 25) which he had painted fifteen years before. That earlier painting is a rapid sketch that seems almost caricatural in its handling, compared with the richly colored and far more complex handling of the completed work of 1883.

The new composition was painted from a room in the Hôtel Blanquet on the second or third floor, a higher vantage point than the earlier one, and higher than Courbet's when he worked at Etretat. Its plunging view curiously distances us from the surf, compared with Courbet's large canvas *The Wave* (fig. 78). There we are confronted by the rising surf with an exhilarating directness that both attracts and threatens us. Here we take on the more dispassionate view of a tourist, someone eager to seize upon nature, but more as a picturesque motif seen from a window than as a sublime experience. Views from windows or balconies were prominent in Impressionism, and Monet had contributed importantly to the genre, including *Garden of the Princess* (fig. 19), *Terrace at Sainte-Adresse* (fig. 17), and two views of the boulevard des Capucines (W 292 and 293). In such pictures Monet did not represent the window frame, nor did he when he worked from the Hôtel Blanquet, so the viewer is not made insistently aware of his vantage point. However, although we sense the window only half-consciously, it enters into our reading of a painting, not the least because of the age-old association of painting

81. Laundresses at Etretat. Postcard from J.-P. Thomas, *Etretat autour des années 1900* (Fécamp 1985), pl. 145.

80. Detail of fig. 79.

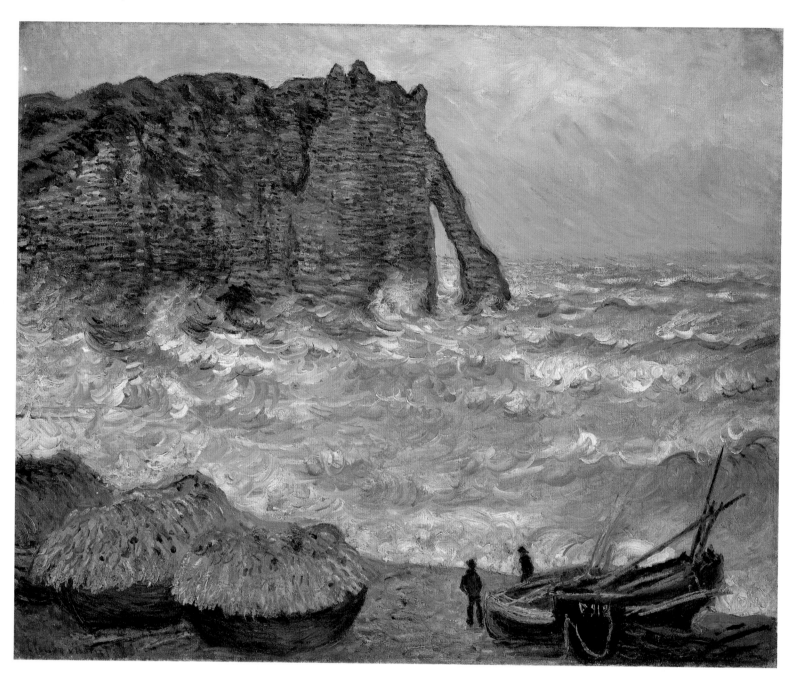

82. *Etretat, Rough Seas,*
1883. 81 × 100. W 821.
Musée des Beaux-Arts, Lyon.

with a window onto nature. Monet gave new vitality to this association because, instead of painting a panoramic view, he narrowed the zone of vision so that it corresponds to the aperture of a window.[10] This kind of framing directs our attention to the picture's organization, hence to Monet's "motif" as much as to nature.

Courbet's other major painting of Etretat, *Cliff at Etretat after a Storm* (fig. 79) is nearer to Monet's *Etretat, Rough Seas* than the older painter's *Wave.* Taken either from the ground floor of Le Poittevin's studio or its terrace (closer to the Aval than Monet's hotel), it does not seem like a window view. The title tells us that it

is after a storm, but there is nothing here of Stanfield's rather operatic *mise-en-scène*. More naturalistic than romantic, the picture conveys the idea of a recent storm principally in the pattern of clouds in the broad sky. Monet relied less on such relatively subtle signs and restores something of Stanfield's romantic picturesque. He covered fully half of his canvas with the lurching undulations of the sea, which rises into foam as it beats against the foot of the cliffs (almost hiding the dark patch of the Trou à l'homme). Its force is heightened because it flows beyond the left edge of the canvas, suspending the cliff in a horizontal plane. To sense

74

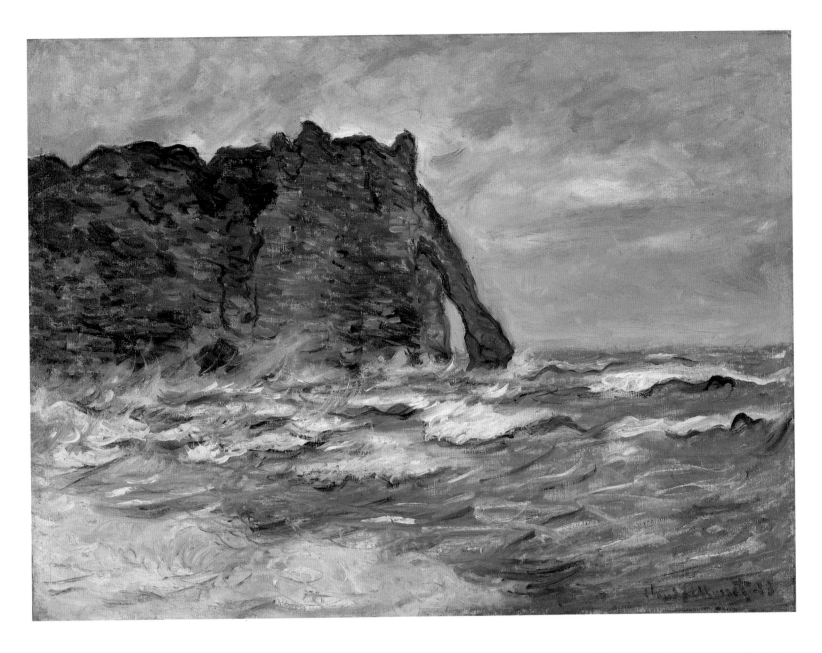

this effect, compare it with the left side of Courbet's composition which is filled with the low bluff that takes on the guise of a building, acting as an intercessor between us and the Aval. (Compare it also with Stanfield, who brought the water closer to the left edge, but nonetheless showed how the Aval is joined to the land.) Furthermore, Courbet's cliff, for all its free working with the palette knife, has more internal modeling in light and dark, whereas Monet's has a nearly uniform surface of free-flowing horizontal bands. These are less convincing as three-dimensional substances, and are more evidently an assortment of brushstrokes. In earlier years Courbet had helped give Monet courage to loosen up his brushwork, but by now the younger artist had gone well beyond the disclosures of craft that his predecessor was willing to make.

The differences between Courbet and Monet cannot be set down to a greater or lesser degree of naturalism, which is a relative term, varying with each generation, and which in painting always means a construction, not a copy. Monet's rendering makes the sedimental layering of the cliffs more obvious than Courbet's. Like a kind of visual shorthand, Monet's streaks emphasize the striations and simultaneously shape the cliff more as a single rising plane than as a strongly indented surface. Courbet's flat applications of paint are just as evidently *paint*, but they only hint at the horizontal layering of the chalk and flint and seem calculated instead to stress the solidity of the limestone. Similarly, Courbet's fore-

83. *The Cliff and the Porte d'Aval*, 1883. 60 × 81. W 819. Private collection.

75

ground tips back deeply, and it has more incident (including the laundresses at the water's edge) to help locate us in a tangible space. Monet's foreground is reduced to a few elements which seem as much visual symbols as objects inhabiting a continuation of our own space. Painting can indeed seem like a window on the world, but Monet's window is more like a frame unattached to walls and floor.

In other pictures of the Aval, Monet eliminated the shore entirely, reducing his compositions to cliff, water, and sky. To paint *The Cliff and the Porte d'Aval* (fig. 83) he stationed himself at terrace level about half-way across the bay. Lacking a foreshore – we sense it in the lower left corner because of the break-up of the combers, but we do not quite see it – we feel that the water is much nearer to us than it is in the window view. This picture is as close as Monet will come to Courbet while at Etretat. In Courbet's *The Wave* (fig. 78), however, the strongly modeled waves have a nearly sculptural tactility, as do the clouds which respond to their rhythms. Monet's sky is a vaporous backdrop by comparison, and his waves have a frothy and insubstantial appearance, although this results in modern eyes (trained by Impressionism!) in an equally believable sensation. They are less sculptural than Courbet's because less modeled. Instead of curving walls of dark tones rising up to whitecaps, there are only undulating ribbons of dark paint and a variety of intermediate tones so thinly painted that we can see the canvas through them.

This picture is much less worked-over than *Etretat, Rough Seas* and closer to the state of a quickly seized impression, a *pochade*. In the energetic brushwork of his picture Monet induces an emotional response to nature that was customarily associated with Etretat, but he does this without the embellishment of Stanfield's romantic shipwreck. His brushwork becomes the vehicle of artistic expression, merging an empathetic reading of the image with the patently obvious gestures of his hand. Monet was proud of his ability to capture effects of light and weather in relatively few sittings, but he distinguished such pictures from more exhibitable ones. In one letter he wrote that "since I've been working from my window I've done a large *pochade* which does very well, I think, as a *pochade*, but impossible to finish nor even to exhibit. You'll see it, it is something on which to base a large canvas."[11] In 1883, moreover, he was under pressure from Durand-Ruel for a certain "finish," and this might explain why the canvases he turned over to his dealer that year had the relatively greater completion of *Etretat, Rough Seas*. He did not release *The Cliff and the Porte d'Aval* to his dealer until 1892, when the evolution of his fame and his art made such sketchiness acceptable.

From a further distance Monet created potent images of the cliff without the aid of stormy seas and agitated brushstrokes. In *Etretat, Setting Sun* (fig. 86) and similar compositions he silhouetted the Aval against the strong colors of a sunset sky and brought those same colors forward on the water as patchy reflections. In doing so he augmented the traditional association of sunset with the poetry of declining day by surrounding the oranged-red sun with faded purples, and by setting the purplish-blue cliff against the luminous greens, creams, and blues of the sky and water. His brushstrokes are relatively subdued so as to defer to the effects of color, but they retain their quasi-autonomy as the marks of his activity. In this picture the Needle has come almost fully into view. In the one previously discussed (fig. 83), a portion of the Needle shows through the arch, but its color (suitable to a grey day) does not readily distinguish it from the cliff. From across the bay the Needle assumes the prominence that Stanfield and many earlier painters gave it, for it is the Needle and the Porte d'Aval taken together that had long been the principal visual symbol of Etretat, its "logo" in today's jargon. Because the Needle repeats the shape of the archway, and the gap between them has the same shape, upside-down, the result is a flat silhouette that reads instantly as an emblematic form. This is true of two cognate pictures (W 816, 818), but in those Monet represented the fishing fleet returning to port, adding a narrative element that is absent from this more austere composition.

Although Monet's canvas says "Etretat" immediately, it is not quite the "stupid motif" that he worried about. Besides giving it the distinctive color and brushwork that, he knew, could grant the variety and newness he sought, Monet eliminated the beach and any other sign of the local setting. He condensed the power of the signature arch and Needle by casting the silhouette into shadow, by sharply differentiating its colors from those of the sky and water, and by making it into a horizontal plane that defies our knowledge that it curves toward us. The radical flatness of the whole composition is nonetheless tempered by the fore-shortened reflections that come forward across the bay. The brushstrokes also are larger nearer us, an arbitrary convention that has little to do with reality but that works with the imagery to push the water down and back into imaginary depth.

Monet created quite different moods, less poetic, more down-to-earth, when he featured boats on the shore of the bay. *Fishing Boats and the Porte d'Aval* (fig. 87) is brushed just as freely as *The Cliff and the Porte d'Aval* (neither was a completed work sold in 1883), but its thatched *caloges* and boats constitute a focus on human activity. In other pictures we seem

84. Detail of fig. 83.

to be alone with nature. Here we look out from a window of the Hôtel Blanquet a few feet further along the building than when he painted *Etretat, Rough Seas* (fig. 82).[12] The narrow strip of beach in that picture allows the sea and the cliff to dominate. By reducing the scope of the cliff and expanding the shore, Monet shifted attention to the port itself, even though the sea is still so heavily charged that the boats would have had to remain on the embankment. In both window pictures Monet was painting what he could have seen, but he was also perpetuating the images traditionally associated with Etretat. The earlier advertisement for his hotel (fig. 88) showed *caloges* and boats against the backdrop of the Porte d'Aval, one of many similar images, so we know that Monet puts us into the setting that vacationers would have anticipated.

The *caloges* were specific to Etretat, and the fact that Monet featured them in many pictures shows that he was more willing to incorporate standard images of the vacationers' world than Courbet, who never painted them. The presence of the *caloges* on the beach during Courbet's visit is well documented. We can only guess that he excluded them from his compositions because

they were prime examples of the picturesque which he was combatting in his art. Monet no longer had to wage that battle, since Courbet and others of his generation had evacuated from high art the earlier conception of the picturesque, and consequently Monet was free to explore aspects of the pre-Courbet tradition and adapt them to his own new art.

Monet put *caloges* and boats together in several other paintings, including *Fishing Boats* (fig. 89), also taken from a window of the hotel, this time looking out over the bay. One of those sold to Durand-Ruel in December 1883, it has denser, more complex skeins of paint, more finish than the painting just discussed. (Its *caloges* are thatched, however, and this accounts for some of the difference from the nearest *caloge* in *Fishing Boats and the Porte d'Aval*, which is instead covered with tarred planks.) Three fishermen animate the scene, one of the few pictures that introduces local life, not just a local vista. Even so, it is a selective aspect of life at Etretat. In his letters of February Monet mentions the colorfully garbed sailors at the local carnival he frequented. He would not paint them in that guise, however, for that would introduce a distracting anec-

85. Detail of fig. 82.

79

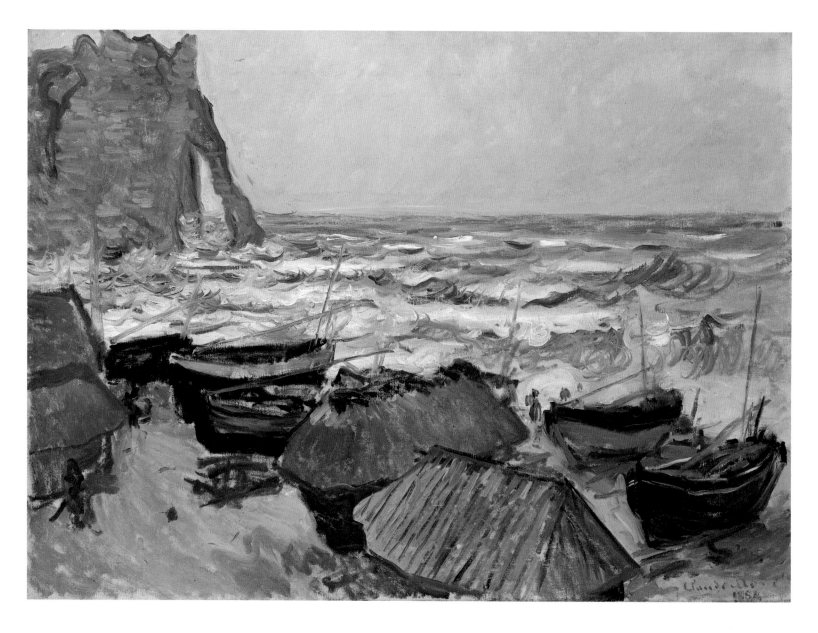

87. *Fishing Boats and the Porte d'Aval*, 1883. 73 × 100. W 822. Wallraf-Richartz-Museum, Cologne.

dotal element foreign to his conception. Except for mariners and townspeople on the shore, all facets of daily life are absent in his compositions, which have the wilful seriousness of seaside paintings in the grand tradition.

A somewhat more festive air emanates from *The Beach at Etretat* (fig. 90), which Monet painted from part way up the well-beaten pathway that led from the western end of the beach up to the Aval. Among the many-colored boats stand townspeople, mostly women as we can tell, despite their summary treat-ment, from their white caps and their dresses. They are awaiting the arrival of two fishing boats (probably the vanguard of the local fleet), whose berthing on the steep pebble beach requires not just a communal greeting, but also the active help of many women to winch them up to

the terrace level. Monet's picture gives no hint of the work involved and instead is a readily grasped "motif" (the word he constantly used in his letters). By using a high horizon line he sprinkled the boats and tiny figures upwards on the beach and bent the surf up to the Porte d'Amont, a rising panorama that displays the port's activity and its setting as a decorative ensemble. Its modern aspect resides in this decorative-ness, incompatible with a topographer's careful docu-mentation and with a social realist's interest in physical labor.

If, however, we need to be reminded again that this kind of canvas was carefully, not quickly elaborated (this is one of the finished pictures sold to Durand-Ruel in 1883), we find it in the way he framed this composition and several others of the Porte d'Amont.

80

framed his canvas this way because this is what he saw. He also saw the entire village and the rising eastward slope of the valley; so the real question is, why did he frame it this way? And why did he also exclude the village when looking in the other direction, toward the Porte d'Aval?

The answer seems to be that images of the village would have been incompatible with the kind of picture he was constructing, "marines." This had been true of Courbet, for he, too, painted only the cliffs, the bay, and the beach. Both artists wished to avoid the picturesque paintings of seaside villages that had been a staple of artists like Eugène Isabey in the middle third of the century (fig. 92). Depictions of quaint old buildings, quays and costumed natives were too patently theatrical, too sentimental by Courbet's standards, and subsequently by Monet's. By omitting the village, and by reducing the natives to summary motifs, Monet proclaimed his distance from picturesque Romanticism, but he also avoided the most obvious signs of contemporary life, particularly of the vacationers' lodgings that dominated the beachfront at Etretat. In his paintings we admittedly see what the vacationers sought, but without reminders of their social environment. Moreover, these exclusions are consistent with

Here he eliminated the entire village except for a turreted building on the extreme right edge at the base of the rising cliff (fig. 91), a form we might not identify had we not anticipated it from photographs. Similarly, we recognize the two slanting triangles lower down along the right edge as roofs of *caloges* only because we know them from other paintings. It is not enough of an explanation to say that he

88. The Hôtel Blanquet at Etretat, from Compagnie des chemins de fer de l'ouest, *Album-Guide illustré des voyages circulaires, Côtes de Normandie* (Paris 1881), p. 39.

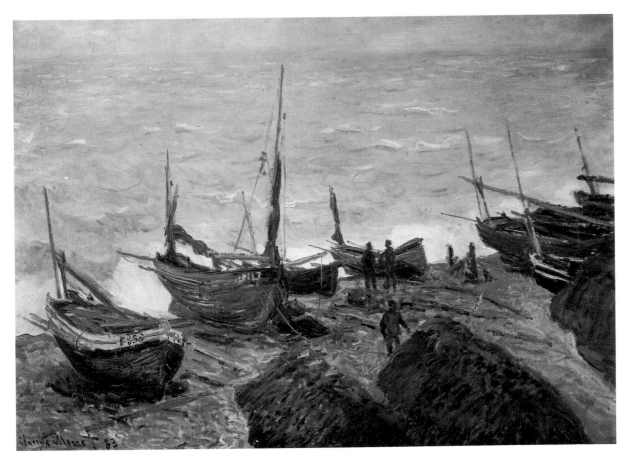

89. *Fishing Boats*, 1883. 65 × 92. W 823. Collection unknown.

90. *The Beach at Etretat,* 1883. 65 × 81. W 828. Musée d'Orsay, Paris.

his earlier practice. At Grainval and Pourville (see Ch. 2) he had so placed his visual rectangle as to cut off the seaports or to include only an inconspicuous portion of them.

Rough Weather at Etretat (fig. 93) is a less sociable view of the Porte d'Amont, although we see two locals, one gesturing, the other holding his cap against the wind. They are visual equivalents of "Look! See!", the kind of witness figures that Monet had used at Etretat in 1868–9 (fig. 25) and occasionally afterwards. At first sight they hardly seem necessary because we readily accept the illusion of the pounding surf. However, they give scale to the waves and to the sloping beach and

make us aware that we are on the upper level of the shore rather than above the whole bay, as we were in the previous picture. Monet laid in the surf with the calligraphic freedom he used for *Etretat, Rough Seas* (fig. 82), but that was a window picture, whereas here, positioned closer to the water, we see that the surf produces a foamy vapor that has the softer, cottony look of clouds. Our closer vantage point, and the two witnesses, also remind us that the Porte d'Amont is not, after all, a lonely promontory, but one end of a busy roadstead. We have other reminders in the dark zig-zags on the top of the cliff (they show in the other canvas as well, and in contemporary photographs)

which mark out the paths that natives and vacationers created by going to different points on the other side, including the Cauldron and the next promontory, both views that were touted by the guidebooks. Yet again the marks of Monet's painting enfold aspects of the vacationers' experience, although modern historians too often explain them solely in terms of picture-making.

Fifteen years before, in the winter of 1868–9, Monet had taken one of those upland paths to reach the far side of the Porte d'Amont, from where he had painted one of his most theatrical seascapes (fig. 28). In 1883 (and again perhaps in 1884)[13] he returned to nearly the same place, this time inside the bay a few yards from the forward point of the promontory, to paint *Etretat, the Beach and the Porte d'Aval* (fig. 94). For the earlier picture he had used dramatic contrasts of light and dark and applied his paint in rather flat strokes that appear to be side by side, for the water and sky as well as for the precipice. In the new canvas he relied on color far more than chiaroscuro, and he intertwined his brushmarks in a complex skein of more varied widths and directions. The tan matrix of the limestone in the foreground is complicated by splashes and wobbly streaks of dilute reds, greens, oranges, violet-grays and variations on creamy tones, and by narrow ribbons of more intense brick reds, wine reds, and greens that mark the stone's sedimental layers.

A.-J. Noël had chosen the same spot a century before (fig. 71). There is no reason to think that Monet knew the earlier composition, but it stands as proof that his viewpoint had been established by earlier artists and

visitors. Both artists show the Aval across the bay, framed on the left by a portion of the cliff and in the foreground by fallen chunks of limestone that low tide has exposed. Noël had a topographer's interest in displaying the port's characteristic features: *caloges*, buildings, fishing boats, and pierced cliffs. He fortified the significance of this view by stationing in the foreground a mixture of fisherfolk and visitors. Monet puts us, as it were, in the position that such visitors would have had, but he eliminated the village entirely. He limited signs of its activity to the minuscule brown spots on the distant water. We can read them as boats only because they appear with less ambiguity in other pictures.

For another revelation of the particular qualities of Monet's art we can return to Courbet. In his *Cliff at Etretat* (fig. 95) Courbet shows the Aval and the Needle from the center of the bayfront; a boat lets us know this is not an entirely abandoned shore. Like other naturalists of the mid-century, he discarded both the narrative detail that Noël favored and the dramatic devices used by painters of the Romantic era. Although his picture is far from photographic – we see the marks of brush and palette knife – its subdued textures and carefully managed chiaroscuro create an illusion of material existence that no longer interested Monet. We need only compare the well-modeled cliff and Needle with Monet's to feel the gap between their conceptions. Oddly enough, despite the fact that Monet took his distance from Romantic artists in many regards, he was like them in asserting his own presence so that "reality" was patently *his* work, *his* interpretation of the world.

92. Eugène Isabey, *The Beach at Granville*, 1863. 83 × 124. Musée de Laval, Laval.

91. Detail of fig. 90.

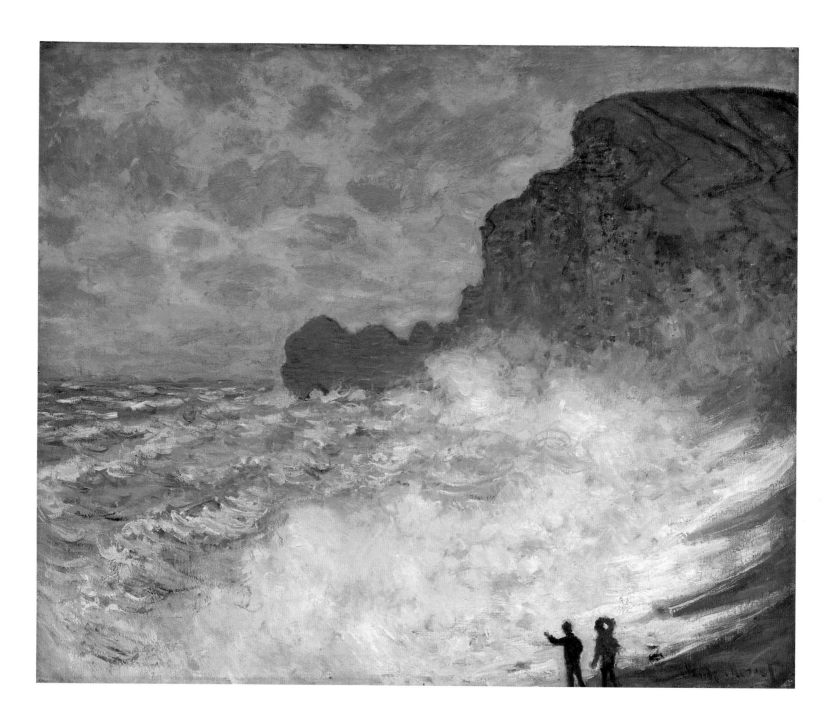

93. *Rough Weather at Etretat*, 1883. 65 × 81. W 826. The National Gallery of Victoria, Melbourne, Felton Bequest.

Of course, Courbet's painting was *his* own interpretation, but Monet's subjective presence is far more obvious. Courbet's illusions are built upon modeling in light and dark; his colors cohere in each zone in closely associated tints, energized but not disjointed by his brushwork. Monet depends more upon color than chiaroscuro; his colors are much more intense, and he separated them out into individual patches and strokes that never entirely dissolve into an image that lets us forget his painter's marks. Furthermore, in the Courbet our eye can move smoothly from the foreground to the cliff, whereas in the Monet we are remarkably close to the foreground elements and must then leap back into the distance without the aid of intermediate signposts. Such a disjuncture joins with the apparent immediacy of the artist's marks to persuade us that we ourselves are creating the scene, that we have somehow recapitulated the artistic craft by which he formed his images. We are in Monet's grasp, as it were, because we can register his images only by puzzling out his expressive surfaces.

Where Courbet shows us how the cliff is attached to the land and to the bay, Monet gives us a series of

84

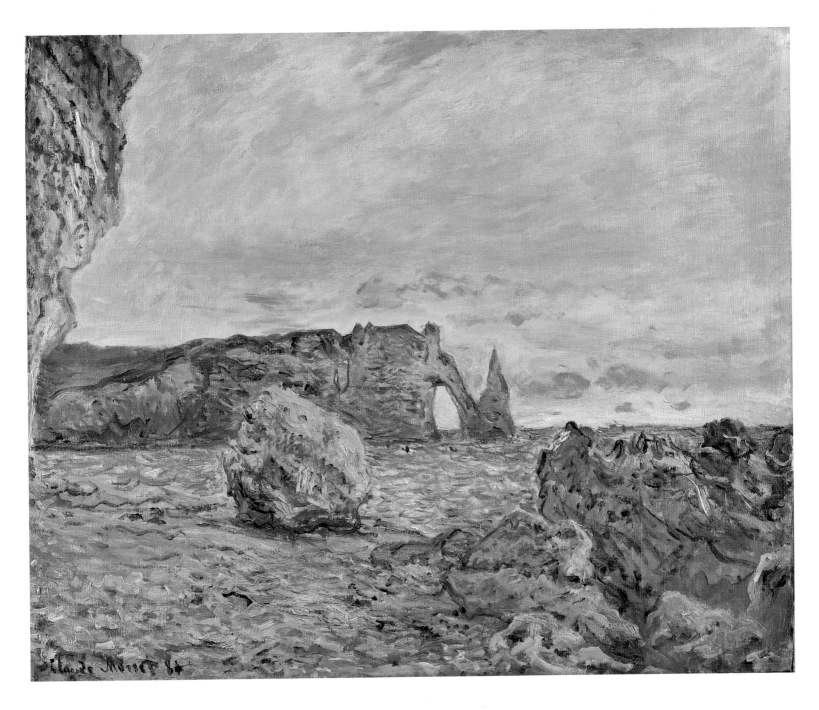

discontinuities. This is not a new feature of his art, because the early painting from the Porte d'Amont (fig. 28) also made us jump from near to far distance. However, the new painting is more unusual because of the fragmentary intrusion·of the cliff on the left edge. This is a structure of perceptual abruptness that is found in some of Cézanne's contemporary landscapes, and earlier in many of Manet's and Degas's urban pictures, a structure that treats the frame as a mobile device which creates a whole out of partly dissociated fragments (an effect that looks forward to Cubism). In

Monet's paintings it parallels the experience of the tourist, whose concern is to capture a view quickly and then move on to another, rather than to settle in front of it as a resident. A touring vacation is often a collection of views, which are visual signs and fragments of modern experience. If postcards and amateur photos are domestic souvenirs of these views, paintings can be their grand cultural memories.

To round out his first extensive group of views of Etretat, Monet also went around beyond the other end of the village to the bay separating the Porte d'Aval

94. *Etretat, the Beach and the Porte d'Aval*, 1884. 60 × 73. W 907. Marauchi Art Museum, Tokyo.

95. Gustave Courbet,
Cliff at Etretat, 1869.
76.2 × 123.1. Fernier 719.
Birmingham University,
Barber Institute of Fine Arts.

from the Manneporte. From the shore there he painted two pictures that he turned over to his dealer later in 1883, *The Manneporte* (fig. 96), and *The Needle at Etretat, Low Tide* (fig. 98). The first of these looks westward to the largest of Etretat's arches. To transmit something of the power and drama of the huge portal, carved out by eons of water and weather, he made the afternoon sun pour through its opening to undercut the shaded wall of limestone that faces us. In this contrast he formed a two-part arch, the smaller open to the air, the larger outlined by the darker face of the cliff (which he cut off at the top, just below the point where the sky would have been exposed). Below, the water throbs and swirls over the partly exposed tidal rocks, and one huge spray threatens two tiny figures (fig. 97), mere squiggles of paint that Monet has placed atop the flat rock to act as witnesses to nature's sublime powers and to give scale to the opening. The composition is far simpler than the first painting he ever made of the portals at Etretat (fig. 28), but to most viewers today its emotional impact is greater because we are dwarfed by its height and bulk.

Of all the paintings of this campaign, this one is the closest to the Romantic conception of the sublime, in which the human observer is overawed by singular manifestations of nature's power. We would never mistake it for a Romantic painting because of its limitation to a fragment of nature rendered in striking surface geometry, so different from the expansive compositions of an earlier era, but its retention of the sublime is reason enough to call it a "neo-romantic" composition. Already at Grainval in 1881 (pp. 39–43) it seemed fitting to evoke Romantic prototypes for certain pictures, and "neo-romantic" is a term that

might then have been employed. However, it is at Etretat that we increasingly find parallels with Romanticism, and the term will be commonly used when we turn to Monet's work there in 1885.

In the other picture of the Manneporte painted in 1883 from the same bay (fig. 98) Monet looked eastward, back toward the Needle and the Porte d'Aval. It was only at low tide that he could have had these views, because high tide left no convenient viewing point along the steep shore of this bay. He gave low tide a prominent role in this picture. The striking crags, glowing creamy-yellow in the afternoon sun, rise above the broad purplish reach of tidal rocks darkened by seaweed and shaded by the cliff behind us. The two tiny figures that Monet also added here allow us to gauge the size of the rocks and remind us that we are not alone, but in a kind of guidebook nature. They are either vacationers who sometimes picked their way among the exposed rocks, or local people who gathered small shellfish at low tide.

Monet's sensitivity to the tides was second nature to a son of the coast, and to him they were as important as the time of day and the weather. In his letters he frequently refers to the tides as a constituent element of his activities, a changeable one like the weather and the degree of sunshine. Rising or ebbing tide could alter a given motif, and he would grumble about it: "it is still necessary that sunshine or gray weather coincide with the tides, which have to be low or high according to my motifs."[14] Nature was subordinated to the needs of his craft – he did not try to make a random copy – yet he had to examine its conditions closely in order to formulate a convincing response. He felt obliged to wait impatiently for sun, tide, and weather to align themselves according to his needs. If he could not control the tides in reality, he could do so in his pictures. The entire display of nature, in other words, was substantially edited, and we have only Monet's controlling patterns to observe.

Monet's letters attest to his constant preoccupation not just with the tides, but with possible sales and exhibitions. When he arrived at the village, we recall, he first thought of a large canvas that could challenge Courbet, but he worried that the familiar sites – "stupid motifs" – would not free him to make truly new pictures. By including the Manneporte and its bay in his first sustained campaign of painting at Etretat, Monet rounded out a veritable portrait of the resort's most notable features. Was there a strategy in this assortment of motifs? Some would say no, out of conviction that he simply chose different views that pleased him, but this would be naïve. The personal and the idiosyncratic are not incompatible with the social, that is, with market interests, so his search for new pictures

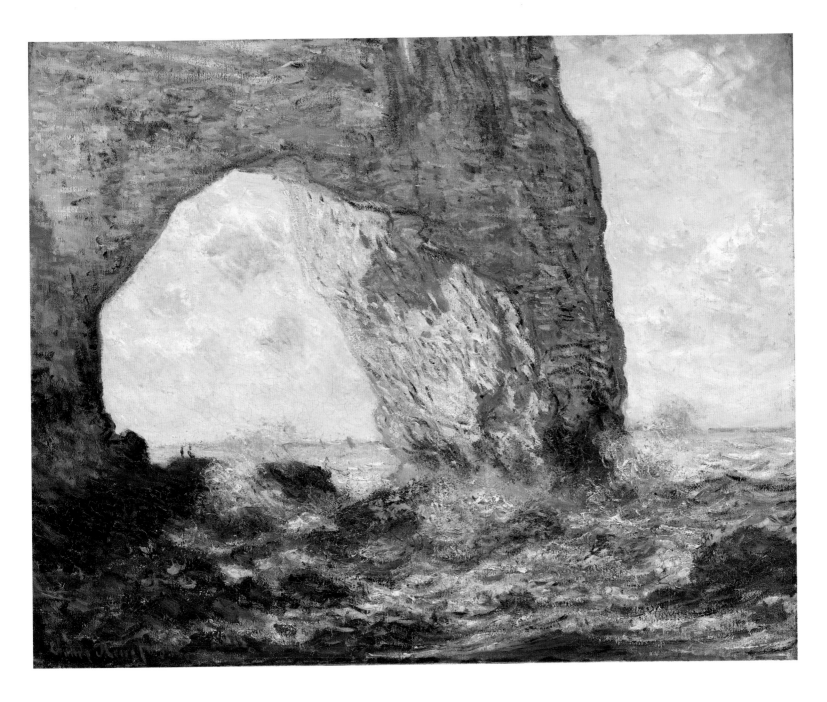

was not in conflict with society's foreknowledge of Etretat's cliffs. An artist's originality, that which distinguishes him sufficiently from others, is what eventually makes his paintings worth collecting. It is true that Monet made highly original responses to his motifs, but equally true that these motifs formed a panorama of well-known features of a world-famous resort. The personal and the social were merged, as they are, in different guise, in the experience of the non-painting tourist.

Monet never completed a "large canvas" of Etretat *à la* Courbet, but this curiously reveals his place in the rapidly changing art market. Courbet was habituated to the periodic public exhibitions for which artists typically prepared outsize paintings that claimed attention and value. Much time was sacrificed to these major canvases, leading to a tiered production of a few large works and a larger number of smaller easel paintings. Monet had submitted a few large compositions to the Salon in earlier years, but such pictures became less frequent after he began to participate in the Impressionists' independent exhibitions in 1874. No canvas done at Etretat from 1883 through 1886 was more than one meter wide, and most were smaller than this (his

96. *The Manneporte, Etretat,* 1883. 65 × 81. W 832. The Metropolitan Museum of Art, New York, Bequest of William Church Osborn, 1951.

87

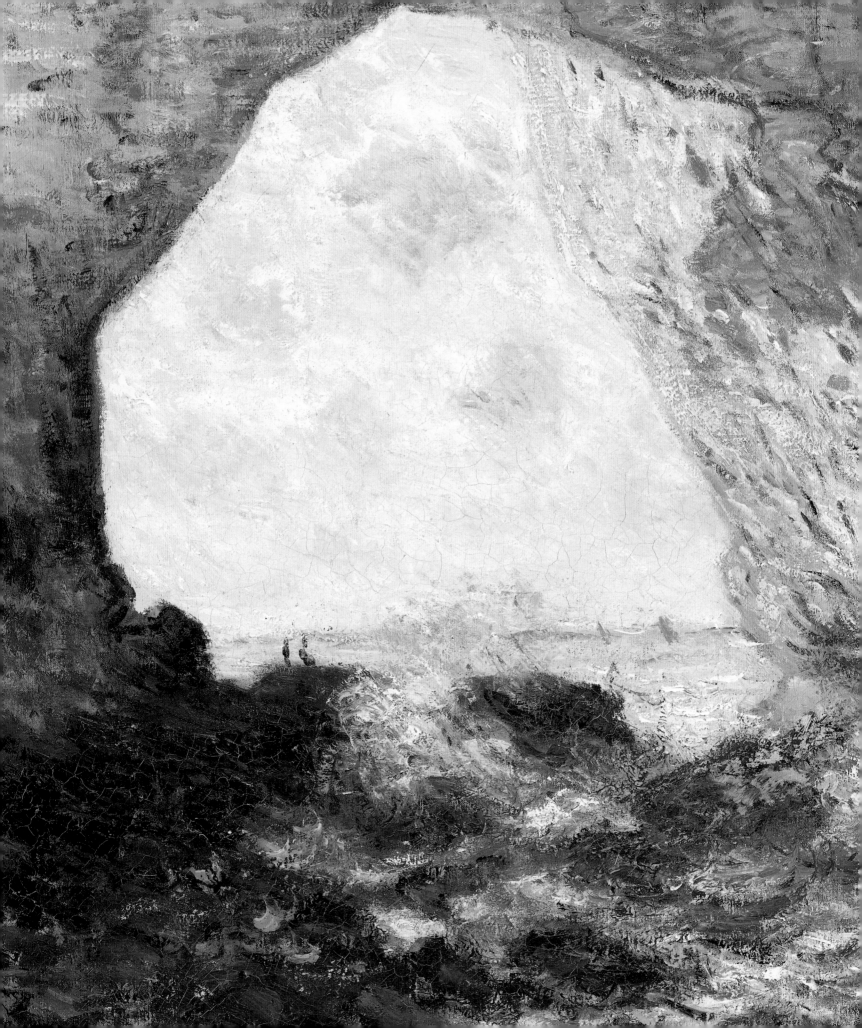

largest was 81 by 100 centimeters, less than half the surface area of Courbet's two Salon pictures). He gave his time to many small pictures instead of to a few large ones, partly because their modest scale suited the market for privately owned easel paintings which he had access to, as distinct from the large sizes that suited public places. His lingering wish to produce two large paintings during his first days at Etretat in February nonetheless reveals his awareness of the other market.

We have to be cautious when we analyse Monet's strategy, because we cannot identify all the pictures he began at Etretat in 1883. Many were finished only in following years and cannot be distinguished from those initiated during subsequent visits. However, we can discern a pattern from what is known. We are sure of eight of the eleven pictures of the resort that he sold to Durand-Ruel between July and December 1883, and these eight tell us two things. First, at least seven of the eight (and perhaps all eight) are finished pictures that were more likely to find buyers than his sketchiest work.[15] Second, this group offers a panorama of Etretat, showing each of the three portals, the boats and *caloges* on the beach, sunset and broad daylight, stormy and calm seas, high and low tide. In this fashion Monet subjected the whole setting to the control of the compositions that he put on the market that year. He

98. *The Needle at Etretat, Low Tide*, 1883. 60 × 81. W 831. Collection unknown.

appropriated the public realm of tourist fame and offered it back to the public, as his own creation, marked by his own perceptions.

97. Detail of fig. 96.

5 Interlude at Bordighera

Before he returned to Etretat for his second major campaign there, Monet spent three productive months on the Riviera, his first important venture south of the Paris region. The Mediterranean coast was so different from his native region that he had to work unusually hard to convert it to his uses. His response to a new landscape could not be instantaneous since he could not simply copy what he saw. He needed to absorb enough of its character to devise suitable compositions and to adapt his palette to a new range of color and light. The lessons that we can extract from these new pictures will reinforce much of what we have deduced from his earlier art about his manner of working and will stand us in good stead when we return to Etretat. Moreover, his correspondence reveals with unusual clarity the relationships among "new things" he painted, his dealer, and his clients.

At the end of 1883, partly as distraction from concentration on dozens of flower paintings for Durand-Ruel's home (W 919–954; good relations with his dealer were essential), he had gone with Renoir to the coast near Monte Carlo and Menton for two weeks. Renoir's enthusiasm for the Mediterranean had already given him priority, for he had painted in Algeria in 1881, and then at l'Estaque, near Marseilles, in 1882, before returning to Algeria a second time. During their joint excursion Monet painted two views of Monte Carlo (W 850, 851), and then went back to that region alone, in mid-January 1884. He asked Durand-Ruel not to let Renoir know of this trip because he could work better alone,[1] but surely also because he wanted time to develop a rival set of interpretations. He based himself in Bordighera, just over the border in Italy, for eleven weeks, then spent a week at Menton before returning north in mid-April.

Renoir was habituated to the hot colors of the south, but Monet was not, and at first he had difficulty in getting used to the brilliant light. His letters, full of uncertainty and torment, show him fearful of success with the intense blue of the sky and sea at Bordighera, despite the fact that the ocean "is more than a little my element";[2] only after several weeks did he feel comfortable with the new color harmonies he was learning to use. It is likely that Renoir played a role in his adoption of a high-keyed palette at Bordighera (unwittingly confessed by his wish to work independently of his friend). Before 1880 Renoir had used intense color opposites more often than Monet, and his pictures of Algiers and l'Estaque in 1882 exploit combinations of brilliant hues that come closer to Monet's 1884 palette than any prior paintings by another artist. Delacroix's pictures of North Africa come to mind because of his predilection for broken hues and color opposites (albeit in a matrix of stronger chiaroscuro). However, even though Monet was familiar with Delacroix's work, it was Renoir who showed the way toward new color combinations, partly because it was he, among the Impressionists, who had learned most from the Romantic painter.

Monet needed time to develop a suitable palette, and he also had to approach his compositions slowly because his views had to be constructed from a satisfactory mixture of techniques and compositional devices learned in the north, knowledge of how other artists

99 (facing page). Detail of fig. 101.

100. Auguste Renoir, *Field of Bananas*, 1881. 51.5 × 63.5. Musée d'Orsay, Paris.

101. *The Moreno Garden at Bordighera*, 1884. 73 × 92. W 865. Collection of the Norton Gallery of Art, West Palm Beach, Florida.

had figured this landscape, and close study of potential sites. At Bordighera, he wrote Alice Hoschedé, "suitably grand views are rare. It is too rich in foliage, always patches with many details, tangles that are terribly difficult to render, and I especially am the man of isolated trees and wide open spaces."[3]

The constant search for "grand views" or motifs meant that despite being surrounded by new sights, Monet started out with only a few potential compositions because he carried with him pre-established ideas of what was suitable. In his first weeks at Bordighera he looked for landscapes whose elements would be familiar enough so that he could begin work. At the same time he familiarized himself with this new region so that he could alter his conception of motif to suit it. Two weeks after his arrival he was able to write that "now what I do is much better; I see motifs where I didn't see them the first days; finally it is going along more easily; also I find my first studies are very bad; they were done with great difficulty, but they also taught me how to see."[4]

By assessing his new surroundings in terms of motif,

Monet was, of course, acting as the painter-visitor, not as a native of the region. He recognized the difference when he complained about the rain that he knew the locals ardently desired that winter ("the peasants must be happy, but as for me, I'm upset that I can't work").[5] Real fruit and vegetables meant little to an artist whose own production was threatened. He wanted to take away certain motifs, somewhat like the memorable sights that increasing numbers of tourists could possess in photographs. There was already a body of views of Bordighera, Monte Carlo, and Menton, some in guidebook illustrations, some in photographs. At least twice Monet sent photographs and views of the area back to Giverny to his companion,[6] just as earlier he had mailed her postcard views of Varengeville. They bear little relationship to his exact vantage points although they might have aided his reconnoitering. John House has shown that well-reputed guidebooks for the Bordighera-Menton coast directed readers to many of the sites that Monet painted.[7] Among them was the private garden of Francesco Moreno, a wealthy man from Marseilles.

Monet used intermediaries to gain access to Moreno's highly touted grounds which he was disposed to admire even before he saw them: a zone of motifs sanctioned by fame. One of the pictures he did there is *The Moreno Garden at Bordighera* (fig. 101), which shows a portion of the old quarter of Bordighera rising above abundant and exotic southern verdure, the "tangles that are terribly difficult to render" so unlike his familiar northern vegetation. It is here that Renoir's work might have helped him (fig. 100). Not only did Renoir frequently paint tangles of foliage, but also his recent paintings in Algeria and southern France used rich harmonies suitable to these hot regions. Like Renoir, Monet chose a shaded foreground to give solidity to this unfamiliar terrain, traversed by a central path more like a forest trail than the open and well-defined pathways of his own gardens at Argenteuil or Vétheuil. The dark foreground also pushed off to mid-distance the hot colors that he only slowly adjusted to. By contrast, *Villas at Bordighera* (fig. 102) is full of the roses, blues, and other saturated and light tints that he worried about but that he persisted in, because they formed the palette that identified this region. A black-and-white reproduc-tion of this canvas destroys much of its space, which depends less upon light and dark than upon the interweaving of color opposites of similar paleness: blue and orange, red and green, lavender and yellow-orange. Also instrumental in the illusion of space is the familiar shift in brushwork from separate strokes in the foreground to more blended ones in the distance.

Monet's canvas shows the newer part of the small town, which had been rapidly expanding since the coastal railway had reached it in 1871. The villa to the right of *Villas at Bordighera* had been built only recently for the Parisian financier and collector Baron Raphaël Bischoffsheim by Charles Garnier, the architect of the Paris Opéra, who had frequented the resort since 1871. He had constructed his own villa (like Hugues Merle at Etretat, by demolishing an old chapel) in 1873, and a number of other buildings in the town. He played host to a number of famous Parisian artists, some of whom

102. *Villas at Bordighera*, 1884. 73 × 92. W 856. Santa Barbara Museum of Art, Bequest of Katherine Dexter McCormick in memory of her husband, Stanley McCormick.

helped decorate his villa's interior (Ernest Meissonier and Paul Baudry among them). Garnier, furthermore, was the author of an article, "Les Motifs artistiques de Bordighera," included in a guidebook published in 1883.[8] Although Monet apparently did not cross paths with Garnier, his time in Bordighera thoroughly involved him with the foreigners who were colonizing this portion of the Riviera. He boarded at the "Pension Anglaise" where his fellow clients were British, American, and German. At times he acted like the typical tourist. He made several outings with two British painters, including a visit to Monte Carlo and its Casino, where he lost ten francs at roulette.[9]

Monet's contacts outside the pension were chiefly with Moreno and his family, who showered him with gifts of local produce and took him on several excursions. His mind, meanwhile, was frequently elsewhere. His daily correspondence with Alice Hoschedé kept him abreast of events in Paris, aided by his subscription to a clipping service. He corresponded regularly with his dealer about current work, his need for money, and exhibition strategy, and exchanged letters with several others, including one of his principal patrons, de Bellio. While in the south he also had fortuitous encounters with three other collectors of Impressionist art, among them Ernest May and one of the Hecht brothers. Bordighera and Menton may have been new to him, but his season there was part of a growing interest the cultured élite of Paris was taking in the Riviera, which was beginning to rival the Norman coast as an ideal vacationland. The presence of collectors and other notables in the south must have given Monet confidence that he would have a market for his new work.

Monet's success at capturing the particular qualities of the Mediterranean coast came slowly, and he returned north in mid-April without, he said, a single canvas that was fully satisfactory. However, he did not need much time to capitalize upon his work there. No sooner had he reached Giverny than he began to retouch his recent body of work. He wrote Durand-Ruel: "I need to see everything tranquilly, in good conditions. I've worked for three months, giving myself plenty of trouble, never being satisfied in front of nature, and it is only here in recent days that I see the course to take with a certain number of canvases."[10] This letter is a confession, if ever one were needed, that work in the studio was the determining phase of his procedures, despite his repeated insistence to journalists that he only worked from nature. He prudently added that this retouching and finishing would reduce the number of paintings he could deliver, but that they would be all the better and his dealer would understand if he asked more for them.

Monet sent thirteen of the Mediterranean canvases to Durand-Ruel at the end of May, and nine more (including that illustrated in figure 101) in mid-June. Another twenty were parceled out over coming years. Among the recipients of his new work were the famous singer-collector J.-B. Faure, who purchased *Villas at Bordighera*, Berthe Morisot, to whom he gave a replica of the same picture (W 857, on long-term loan to the Musée d'Orsay), John Singer Sargent, who acquired a canvas of the Moreno garden (W 867), and before 1900, at least eight American collectors, including Charles Haviland, Stanley R. McCormick, Alfred A. Pope, and James F. Sutton. These acquisitions were made at a time when a vanguard of well-to-do Europeans and Americans were forsaking the English Channel for the warmer shores of the Mediterranean coast, and it is likely that Monet's pictures of the Menton-Bordighera region shared in this southward deviation of the leisure industry. They were not, however, to typify his work of the 1880s, for he spent only one other season in the south, going to Antibes in 1888. Otherwise, he devoted himself to more northerly landscapes, including two more trips to Etretat, where again he could plunge into work on sites which had deeper resonances with his earlier art and life.

103. Detail of fig. 102.

6 Etretat, 1885–1886

Upon his return from the Riviera in mid-April 1884, Monet established a routine that prevailed for a number of years. Long periods at Giverny, ensconced in his extended family, would alternate with campaigns spent further afield, when he would stay in hotels or lodgings for several weeks at a time, as he had at Bordighera. At home he worked in his studio on canvases brought back from those trips, and he also undertook new pictures of Giverny and its environs. These included the meadows near his home, the banks of the nearby rivers and streams, roadways and hillsides often showing Giverny and other villages (usually in mid-distance), and a few pictures that feature his and Alice Hoschedé's children. Although he often secluded himself in his studio, his months in Giverny were generally sociable times, when he and Alice frequently entertained visitors. We get a hint of this domestic life from a picture that John Singer Sargent painted of Monet at work (fig. 105) in a meadow near his home, with a female guest or member of his extended family nearby. The canvas on Monet's easel is *Meadow with Haystacks near Giverny* (fig. 106),[1] whose pastoral mood typifies most of his paintings in this corner of Normandy. We should remember this kind of picture when we look at his pictures done along the coast, for the alternation of home and away is a pattern that has bearing on his seascapes, even though we are seldom aware of it.

Monet's only foray outside his home terrain later in 1884 was a brief visit with Alice Hoschedé and their children to the familiar Petites Dalles and to Etretat, in August 1884. Thwarted by bad weather and distracted by his family, his few days then in Etretat resulted in very little, apparently limited to some retouches on canvases begun the previous year that he had brought with him.[2] While there he renewed contact with J.-B. Faure (who subsequently bought one of his Bordighera pictures [fig. 102]), and when he returned to Etretat a year later, accompanied by Alice Hoschedé and their children, he took up Faure's offer to stay in one of the villas he owned in the port.

On 17 September 1885 the painter settled in Etretat with his extended family for the tag end of the bathing season which, thanks to Faure, they passed more comfortably than other hotel-bound vacationers. It was the last time this decade that Monet traveled with family to one of his distant sites, for he preferred to work alone, as he said, that is, to be free to work in concentrated daylight hours. His paintings are a product of the seasonal alternation of home and away, and the daily alternation of solitude and evening company. In other words, the energy invested in his apparently solitary views of natural settings partly derives from this seesaw rhythm. His position was always on one end of this alternation, defined by its opposition to the other end, or freedom from it. Because he painted at Etretat after the high season we might be inclined to exclude tourism and vacationing from his paintings, but this would be a mistake. We shall see that these out-of-season compositions disclose the vacationer's viewpoint in more than one way.

When his family returned to Giverny on 10 October, Monet moved to the Hôtel Blanquet and again devoted himself to painting the port and its famous cliffs. Alice Hoschedé spent a few days with him in November, and he visited Giverny and Paris in early December, otherwise he led a celibate's life at the resort until mid-December. Other painters were there, although most of them left in October, at the end of the bathing season. Among them were the fashionable genre painter Georges-Hugues Merle, who had inherited a studio on the bay from his father,[3] and the little-known Marius Michel, who let Monet use his hotel room as a look-out and who clung to him to his eventual discomfort. Monet stayed beyond the season in order to paint the port in its more tranquil aspects, but he regularly spent his evenings in the company of others, in local restaurants and cafés, or at the dining-tables of residents, including the manager of the Hôtel Blanquet, the director of the Casino, and one of the principal local landowners, Monsieur de Frébourg. The wealthy Frébourg lionized him, as Moreno had in Bordighera, and toward the end of his stay he dined more often at Frébourg's château than elsewhere, enjoying both the food and the company of other guests.

104. Detail of fig. 127.

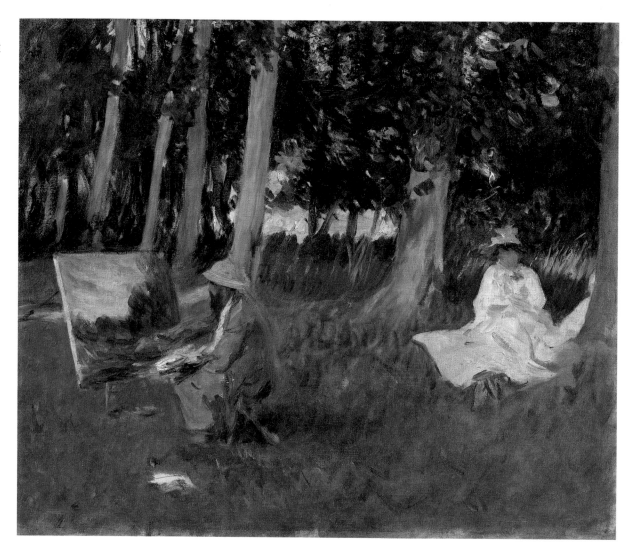

Monet had more than one visit that autumn with Guy de Maupassant (it was he who had earlier urged Monet to visit Bordighera). De Maupassant's family had long been established in Etretat; his mother was the daughter of the painter Eugène Le Poittevin. A year later Maupassant published a highly romanticized account of Monet's work at Etretat, in which he figures the painter literally hurling stormy foam at his canvas.[4] His article was one of a familiar type regularly appearing in the Parisian press, the "letter" from a summer resort by a notable writer. Monet therefore took a place, albeit an embellished one, in this particular dialogue of Paris and the seashore. For that matter, he regularly received *Le Figaro* when at Etretat, as well as newspaper clippings from both Alice Hoschedé and Durand-Ruel, and he kept up a lively correspondence with other artists, including Caillebotte, Pissarro, and Sargent.

Monet's interaction with Paris, including the art market, was conducted principally through his extensive correspondence, as at Bordighera. He wrote constantly to Durand-Ruel, and was beginning to play him off more openly against the dealer's archrival, Georges Petit.[5] In addition to selling directly to Petit, he agreed to participate in that dealer's International Exhibition the following June, alongside conservative artists, and accordingly refused to join his erstwhile comrades in the Impressionists' exhibition held at the same time. (His market sense was not infallible, however, for he had no confidence in Durand-Ruel's new venture in the United States, where about forty of his pictures were shown in 1886, leading to some immediate purchases and shortly afterwards to many more.) He also agreed to take part in an invitational exhibition in Brussels (the "Société des XX") in February, so it is little wonder that he was anxious to produce lots of paintings. From the beginning of this campaign, in fact, he deliberately initiated canvases in several kinds of

light and weather so that he could always have something to do regardless of the elements. He also launched several paintings of nearly identical motifs which he could work upon in his room, and he had other pictures delivered to him that he had begun during earlier visits.[6] His constant preoccupation with his market, amounting to obsessive concern at times, made him feel that he was a worker in oil paint, driven to produce. Of course, one advantage of Etretat, compared with Bordighera, was his complete familiarity with the place, which meant that he had in mind many views for his production.

Monet was a prodigious worker, of that there is no doubt. On 17 November and again on the 19th, for example, he spent the morning at La Passée, inland from the village center, the afternoon at the Manneporte, and the early evening up on the flank of the Porte d'Amont. This meant several kilometers of hiking up and down steep inclines, although he probably paid someone to help him transport his material. On another day he worked at six different sites.[7] At times he hired a boat to take him across the bay to the Trou à l'homme, and around the tip of the Aval to the Cap d'Antifer; he probably also used a boat to reach the

106. *Meadow with Haystacks near Giverny*, 1885. 73.6 × 93.4. W 995. Museum of Fine Arts, Boston.

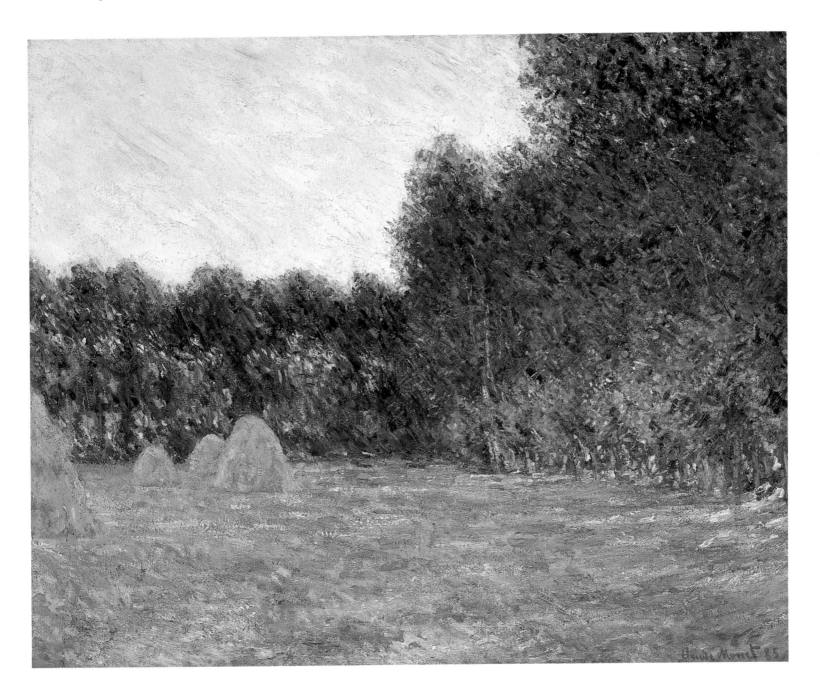

107. *Wintry Landscape, Etretat*, 1885. 65 × 81. W 1020. Collection unknown.

combination of severe winter weather and distress over his unresolved relationship with Alice Hoschedé prevented any work.[11] Paintings signed 1886 must therefore indicate those brought back to Giverny in a sketchy state and finished only in following months. Of five paintings delivered to Durand-Ruel in late December 1885, only three are assuredly identified, and only three more for 1886.[12] Because many other Etretat pictures left Monet's studio years later, and may then have been retouched, the dates 1885 and 1886 should be regarded as an indication of their initial conception and work; we shall be unable to assess the effects of intervening years. It would be interesting to learn the chronology of the fifty-one works, but the evidence is too scattered, and in the following pages they will be treated essentially as one group. One token is available: all but one of Monet's known and conjectured sales of Etretat works for 1885 and 1886 are of finished pictures, so he continued to regard his *pochades* as unsuitable for the market. We should consequently continue to make distinctions between the two types.

The distribution of Monet's motifs in 1885 was similar to that in 1883, although he began many more canvases. Nearly half of his oils, twenty-four, show the Porte d'Aval and the Needle; ten feature boats on the beachfront; only six represent the Porte d'Amont, and an equal number, the Manneporte. Entirely new sites are rare. One canvas pictures the Cap d'Antifer beyond the Manneporte (W 1039), and four show inland landscapes. Three of the latter, including *Wintry Landscape, Etretat* (fig. 107), represent the rising slopes of La Passée, a cultivated but shaggy landscape that appears to be miles from any tourist center. It was, however, a common promenade for visitors on the southwest edge of the village. Anthony North Peat, a British vacationer, gave a sketch of it in 1868. After lamenting that croquet (a British import) was not catching on, despite the efforts of the local club, he wrote:

> Meanwhile let me recommend La Passée, where this popular game is celebrated, to the serious attention of all persons engaged in love-making or flirting of any kind. The romantic wood which clothes the hillside is eminently designed for the research after botanical or entomological specimens, or for the pursuit of sylvian [sic] studies in general. It is rich in spots peculiarly appropriate to those *têtes-à-têtes* wherein brown hats are to be seen in close propinquity to scarlet *berrets* [sic].[13]

Monet knew of these associations with La Passée but scorned them because, unlike Manet or Renoir, who made contemporary social intercourse a vital element of art, he formulated a nature that excluded gregarious modern society. The modernity of his landscape was

bay of the Manneporte (his apparatus was cumbersome). He became angry at changes in the weather, even lamenting the return of sunny days when he had been working on gray-weather pictures (although his stock of multi-weather canvases allowed continued work in his room). And he grew furious on several occasions when the local fleet delayed its departure. Once he set his easel up on the shorefront in mid-afternoon, anticipating the boats' departure at 4 o'clock; time passed until finally night came, when he learned that a falling barometer had made the fishermen change their minds: "I was furious because they made me lose my time."[8] This means that the fishermen did not tell Monet what they were thinking, although he was in their midst, so he remained the painter-visitor, not an adoptive local or the seasoned Norman that he liked to fancy himself. Like other visitors, he grew impatient when bad weather kept him indoors and there was nothing engaging to see out the window: "I can't spend my time always doing the same thing from my window, especially since the boats aren't leaving and there's nothing interesting."[9] He wanted to be entertained, in a manner of speaking, although he had some compensation in being able to move about the hotel and choose different windows to paint from.

Fifty-one paintings are known that were begun during Monet's autumn at Etretat in 1885.[10] It is true that he returned for a few days in February 1886, but the

108. *Etretat, the Beach, and the Porte d'Amont*, 1885. 60 × 81. W 1009. Collection unknown.

more the way he painted it than its setting. In other words, what he omitted from his painting tells us a great deal about his aspirations (and the widespread admiration of his pictures tells us something about twentieth-century desires!), and we need to investigate his surroundings if we are to understand how and why he selectively edited them.

Etretat's shingle beach was its principal playground, but in 1885 Monet painted out of season, as he had in 1868 and 1883, and so found it easier to avoid signs of bathing and tourism. He never painted the hotels, the restaurants, and the casino that dominated the bay, even though these formed his daily environment, because they would give away the fact that it was a resort. *Etretat, the Beach, and the Porte d'Amont* (fig. 108) preserves the idea of the bay as it could have appeared decades earlier. It is the only view of the Amont that was thoroughly worked (it is one of those delivered to Durand-Ruel in December 1885). He was higher up on the cliff of the Aval than when he had painted the Amont in 1883 (fig. 90) and paid correspondingly more attention to the promontory than to the port, this time showing the chapel on the clifftop. No building at all

appears on the right edge, and only a few beached boats respond to the mariners' chapel above to let us know this is a fishing port.

More animated is *The Beach and the Porte d'Amont* (fig. 109) which, like several of the 1883 canvases, features the port's activity. Its vertical format favors the beach and the near portion of the cliff, so strikingly carved out in light and dark. The clouds over the distant portion echo the shape of the cliff and close off the sky to emphasize the sheltering aspect of the bay. Although also a wintry scene, its strong midday sun and its warm palette conspire with the prominent, if summarily treated boats, to produce a mood of gaiety that corresponds more than the other painting to what a tourist might wish to remember. It also has a somewhat less finished appearance and was apparently sold by Monet only shortly before 1912, that is, at a time when Fauvism would have made such sketchiness seem quite normal and more saleable.[14] In fact, it now seems anachronistically to be like a slightly chastened Fauve painting. The boats in the foreground could reappear in a painting of Nice by Matisse without causing much disruption.

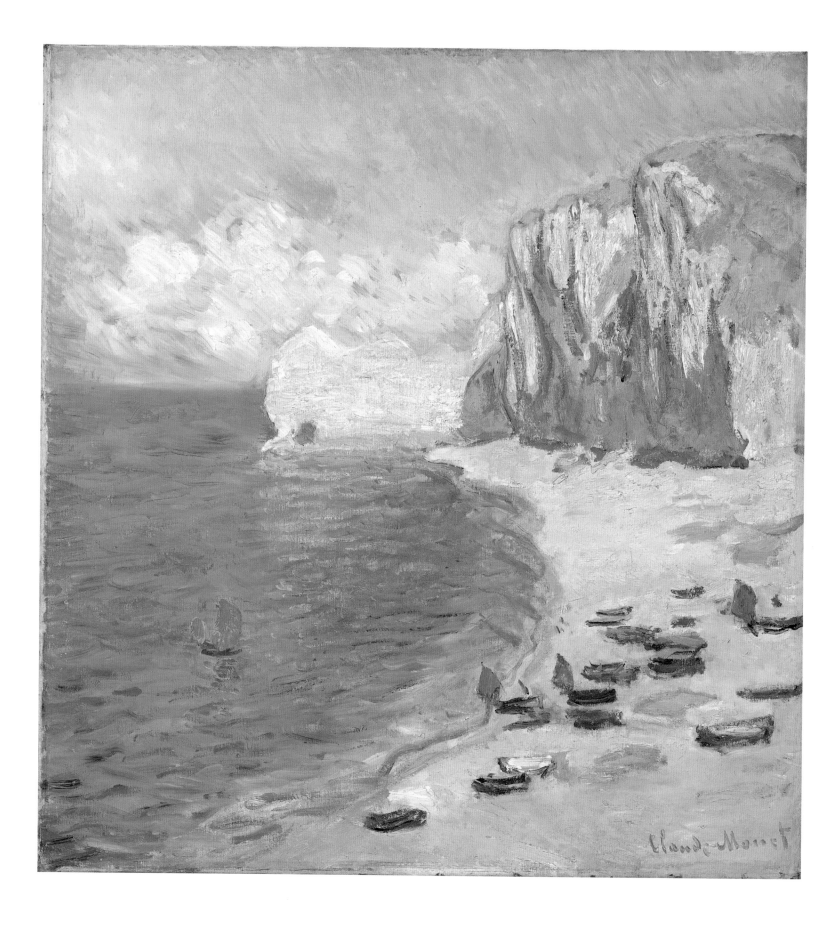

Just how Fauve-like this canvas is becomes readily apparent when it is juxtaposed with a painting by Monet's mentor Eugène Boudin (fig. 111). Boudin did not paint from such a height, because he wanted to retain a stronger grasp upon the particulars of human activity on the beach. He draws us into communication with local life in what can be described only as a more humble conception of a painter's role; whereas Monet, in both his paintings, takes us up in the air with a commanding distance that disdains participation except through a disembodied eye. In releasing us from participation, Monet gives us the vision of the tourist who seeks views, not immersion in local life. To ensure these grand views, Monet also avoided anything that would remind us of other vacationers. When Joseph Pennell made a drawing for a travel book of 1900 (fig. 110), he included bathing cabins and the edge of the village, as well as fishermen alongside their boats. By contrast, Monet was making unique oil paintings, objects of fine art which he defined by their distance from travel illustrations.

In a few canvases Monet brings us much closer to the beach, but we still lack the engagement with other humans and their artifacts that Boudin provided. From his window in the hotel Monet made several pictures of beached fishing boats, bringing them closer to our eye than in the comparable paintings of 1883. In *Fishing Boats* (fig. 112), he found compensation for a gray day in painting the lower hull of one boat flamingo red, the upper hull of another yellow-green, and for the nets being dried atop a boom, a filmy green over underlying multi-colored strokes. Compared with Boudin's painting, these boats are outdoor still lifes observed from a height sufficient for us to know that we are not standing next to them. In another window view that includes some of the same boats (W 1029, Budapest, National Museum), the frame of the composition and of the hotel window seem to coincide because of

111. Eugène Boudin, *Etretat, the Porte d'Amont*, 1887. 47 × 65. Collection unknown.

the way a post sticks up from the base of the picture. It is the post of a winch, as can be seen in photographs of the port (fig. 123), where many of them rise up between parallel curved timbers. One photograph (fig. 113) shows Monet's vantage point, which was one of the topmost windows of the building on the right edge, the Hôtel Blanquet. From there he also looked straight out to the bay to paint a striking pair of pictures that feature *caloges* and boats, *Boats in Winter Quarters* and *The Departure of the Fleet* (figs. 115 and 116). The building on the right edge of these canvases is the irregularly shaped stone building nearly in front of the hotel (by drawing imaginary sight lines over the photograph, we can place Monet in the uppermost corner window of the hotel). The photograph also shows just how foreshortened are Monet's two views of the waterfront; its real depth comes as a surprise.

From such photographs (see also fig. 117) we discover that the tilted parallel forms in the foregrounds of the paired compositions were based upon a disused boat winch. Without such photographs, or paintings like Boudin's *Etretat, the Porte d'Aval* (fig. 111), we might never decipher these forms. The outlines of a winch can be found in both of Monet's paintings in the gap between the stone building and the righthand *caloge*, but it is equally difficult to read. It is clearer in the calmer scene, where its socket can be discerned, but in the other it could readily be confused with the kind of schematized human whom Monet often paints. Many such figures are on the beach in *The Departure of the Fleet*, but their rudimentary treatment would never

Falaise d'Amont, Étretat.

109 (facing page). *The Beach and the Porte d'Amont*, 1883. 67.5 × 64.5. W 1012. The Art Institute of Chicago, Gift of Mrs. John H. Winterbotham in memory of John H. Winterbotham; the Joseph Winterbotham Collection.

110. Joseph Pennell, *Falaise d'Amont, Etretat*, from Percy Dearmer, *Highways and Byways in Normandy* (London 1900), p. 331.

112. *Fishing Boats*, 1885.
73 × 92. W 1028. Seattle
Art Museum.

let us know that they had just gone through the ardu-
ous exercise of launching the boats by hand, pushing
them down the gravelly incline.

Even though such work was a conspicuous element
of what he saw around him, Monet would never
represent it. For him, art was dedicated to a realm of
work-free nature, and the representation of labor was
incompatible with his conception of a "motif" or a
"grand view." (This suppression of labor suits the
middle-class conception of both art and nature and
helps explain why Impressionism became such a cul-
tural commodity.) Other visitors at Etretat were
intrigued by the fact that it was principally fishermen's
wives and daughters who helped launch the boats and
who undertook the donkey-work of winching them
up on the beach (fig. 117):

> The dark brown sails, patched and discoloured, tell
> of many a storm-tossed night and many a day of
> hardship. On a boat coming in, the women of the
> village swarm down to the beach, their first motive
> being to hear the news, and the next to wind up the
> windlass by which each smack is hauled up on the
> beach high above the water-mark. Men take no part
> in this arduous undertaking. I have seen as many as
> twelve women engaged for half an hour in pushing

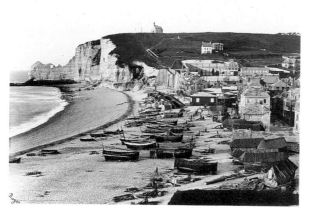

114 (facing page). Detail of
fig. 109.

113. Etretat, the beach and
the Porte d'Amont, 1888.

104

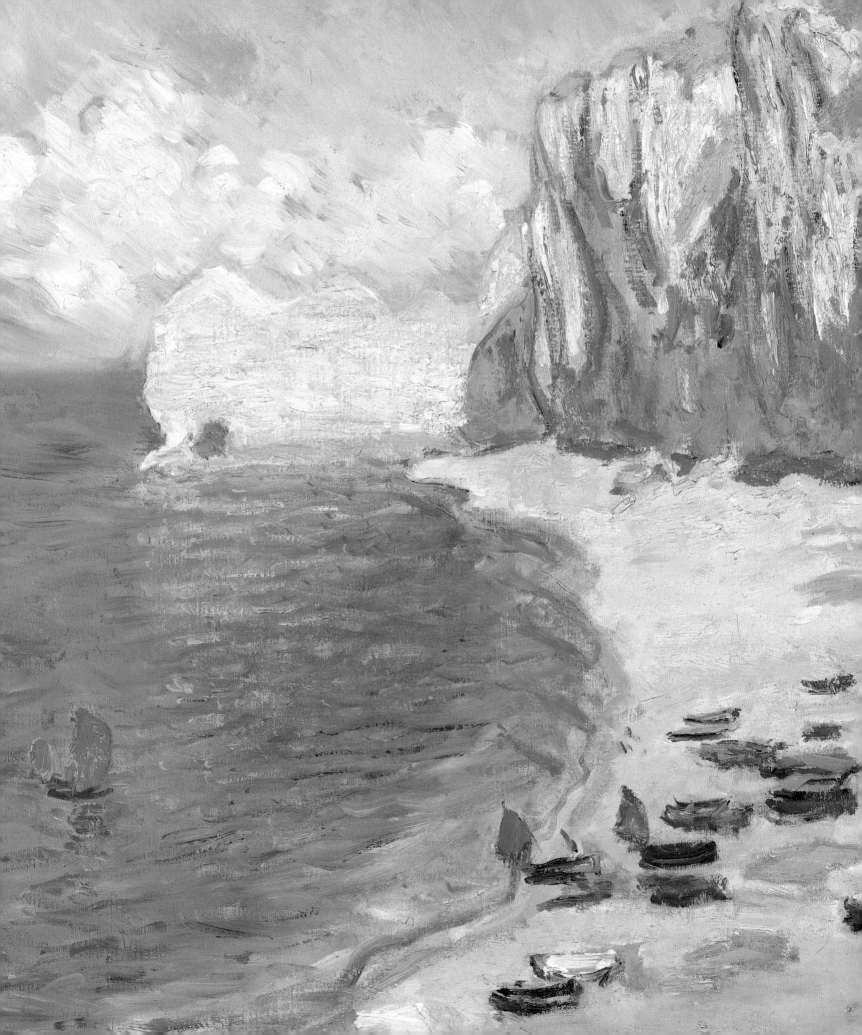

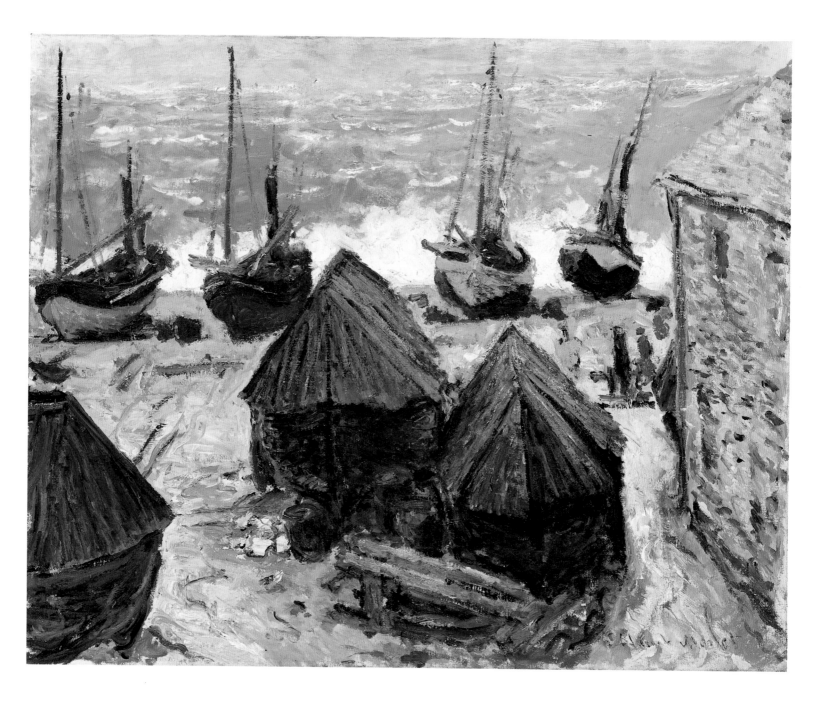

115. *Boats in Winter Quarters*, 1885. 65.5 × 81.3. W 1024. The Art Institute of Chicago, Charles H. and Mary F.S. Worcester Collection.

round the spokes of the huge wheel by which the rope to which the boat is attached is wound up on shore, whilst crowds of men and boys looked on without the slightest offer of putting their own shoulders to the wheel.[15]

Monet's withdrawal from village life into his hotel room signifies the inward-turning odyssey of modernism, the removal of paintings from mundane reality, from close ties with a social environment. By ignoring the labor involved with his motifs – and this includes the labor of hotel and restaurant workers, transporters,

etc. – and by refusing easily read details, he forces us to concentrate upon his pictures as painted gestures that draw attention to themselves, thence to the artist who made them, and finally to our own acts of perception and our vicarious adventure in a kind of "nature" that is intertwined with tourism.

This journey to non-urban places, which is also a journey to one's interior, was the hallmark of Romanticism, and therefore "neo-romantic," as we have already seen, is an appropriate term for a number of Monet's Etretat pictures. *Boats in Winter Quarters, Etretat* (fig. 115) has echoes of Théodore Rousseau's

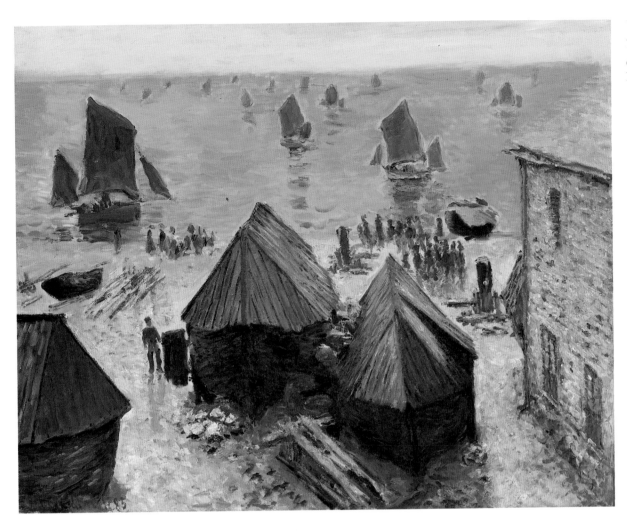

116. *The Departure of the Fleet*, 1885. 73 × 92. W 1025. The Art Institute of Chicago, Mr. and Mrs. Potter Palmer Collection.

Jetty at Granville (fig. 118) of fifty years earlier, not because Monet saw that picture but because beached ships had become a cultural sign for humankind's often antagonistic relationship with the sea. In Monet's picture, the rough waters stand for natural forces that are thwarting human aspirations, the beached fishing boats are poignant images of suspended productivity, and the old boat hulks, used only for storage, are symbols of winter and old age. We enter this symbolic world precisely because Monet has deliberately avoided the kinds of detailed imagery that would draw us into a reading of social immediacy. He obliges us to accept these larger symbolic forms, and it is their lack of narrative detail that proves so effective: the flowing runnels and slashing streaks of his paint encourage our empathetic reaction.

Boats in Winter Quarters has a different expression from its calmer pendant (fig. 116), both in imagery and in brushwork. This other painting shows the departure of the herring fleet, and its hopeful imagery has been rendered with a less agitated surface. Not only are the

brushstrokes more contained, but also they bring the objects into sharper focus. The tarred planks atop the *caloges* retain their individuality here, the beach tips back into depth more convincingly, and the building on the right is fully vertical. We might be inclined to think that it was painted with greater deliberation,

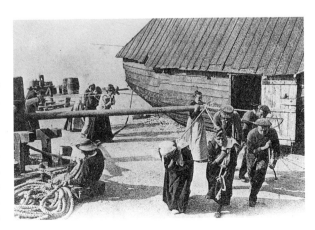

117. Etretat, winching a boat. Postcard, from J.-P. Thomas, *Etretat autour des années 1900* (Fécamp 1985), pl. 127.

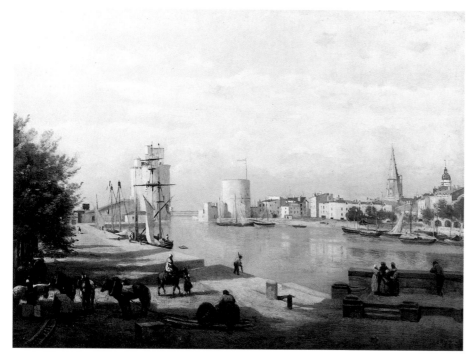

120 (facing page). Detail of fig. 115.

118. Théodore Rousseau, *The Jetty at Granville*, 1831. Panel, 17.8 × 42.9. Wadsworth Atheneum, Hartford, The Ella Gallup Sumner and Mary Catlin Sumner Collection.

119. Camille Corot, *Port de la Rochelle*, 1851. 50 × 71. Yale University Art Gallery, New Haven, Conn., Bequest of Stephen Carlton Clark.

but both pictures have the same degree of finish, and the more emotional effect of *Boats in Winter Quarters* is the result of professional calculation. It was built up in stages, and much of the apparently passionate brushwork is a result of artful fakery. The water, for example, consists of large impasted strokes in swooping horizontals which were then painted over with smaller strokes of related tints that do not disturb its energetic form; the same is true of some of the evocative streaks in the foreground, where as many as five different tints were deposited atop a single underlying stroke. Such strokes give us the impression of spontaneity, but the colors we actually see

do not literally coincide with them. They are, quite astonishingly, colored brushstrokes, representations of spontaneity.

In both pictures we are far from one of the most famous window views of mid-century, Corot's *Port de la Rochelle* (fig. 119). Corot's naturalism posited a harmonious world that seems not to require the painter's intervention (although that, too, is a pose). Working from a hotel window was a way of painting directly from nature (this was the first such picture Corot exhibited in public), of getting away from studio recipes and fanciful landscapes in order to concede to nature its own realm. Corot subordinated himself to this realm, whereas thirty-five years later, Monet seems bent on restoring Romanticism. His Etretat pictures amount to a partial renunciation of his own earlier naturalism. For example, *Terrace at Sainte-Adresse* of 1867 (fig. 17) stands between Corot's naturalism and Monet's neo-romanticism of the 1880s. It is another window view, but its figures form a society that we can readily approach and its flowers and flags are a hospitable setting. This picture, and the others at Sainte-Adresse and at Trouville, imply a lack of barrier between viewer and resort. They characterize the more naturalistic and the more sociable Monet of the 1860s and 1870s, whereas now, in the 1880s, Monet often plunges us into moods of brooding solitude.

In several paintings of the Porte d'Aval and the Manneporte Monet created even more striking images of aloneness. In these pictures we are brought extremely close to the cliffs in unusual compositions intended to make us feel small and powerless in front of awesome nature. *The Cliff of the Porte d'Aval* (fig. 121) could suit the words of Jacob Venedey, when he climbed the Aval in 1837 (see above, pp. 63–4): "yawning gulphs open at our feet, out of which the

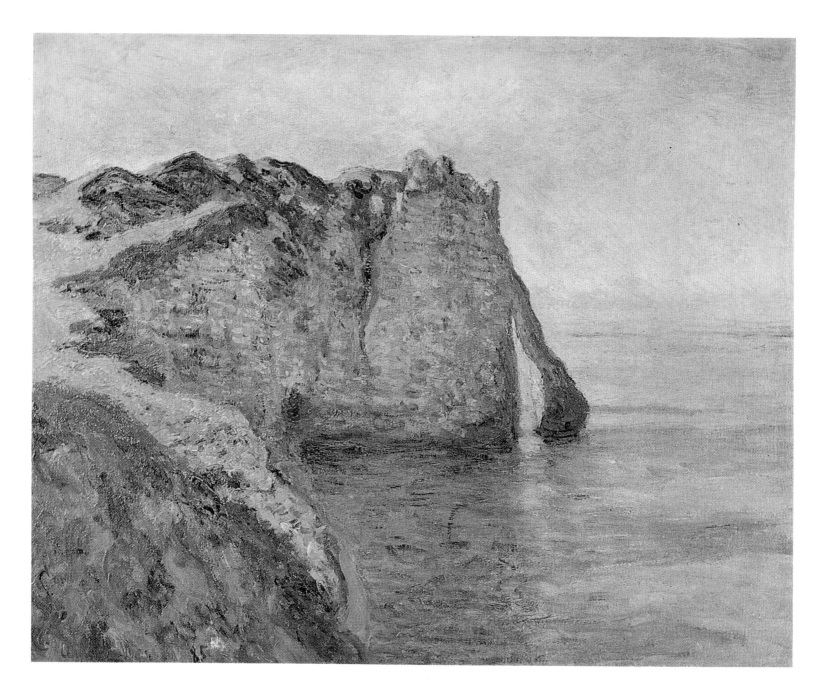

121. *The Cliff of the Porte d'Aval*, 1885. 65 × 81. W 1018. Collection unknown.

agitated sea sends up tones like the voice of a bard singing the destruction of his race.'' The neo-romantic quality of this canvas shows immediately when it is placed next to other painters' work. The visiting American George Inness, working in a different tradition, painted the cliff a decade earlier from the same angle, but from well inland (fig. 122). His pastoral foreground, the village roofs, and ships on the Channel together situate the cliff fully in its setting, something Monet avoided even when he painted the beachfront. Monet's vantage point was just inland from the first of the beak-like projections of the cliff in Inness's picture.

Just beyond it we can see a portion of the descending spur that dominates the foreground of Monet's composition. Monet uproots us from Inness's pastoral surroundings and forces us to come to terms with a more circumscribed but more emotional experience. His picture is an inventive variation upon the Romantic sublime, in distinction from Inness's origins in the tradition of the picturesque. Like Romantic poets and painters of sublime landscapes, Monet stresses his own feelings in front of nature more than nature's "objective" reality. Steven Levine summarizes it well: "The sublime is simply the heightened consciousness of beholding one-

self beholding the world."[16] Giving primacy to the self, Monet's paintings communicate the reactions of a privileged individual who convinces the viewer of distance from the city and its crowds, from work and its corollaries of reason and community.

The subjective content of Monet's paintings becomes still more obvious when we compare him with his mentor Boudin. Boudin's painting of the Aval, dated 1887 (fig. 111), is, like the Inness, more picturesque than sublime. Signs of vacationers are absent, but we see the Aval through the boats and winches on the beach, and no matter how free the brushwork, compared with that of Inness, it is more delicate than Monet's and more dependent upon modeling in light and dark than in color.[17] Because we are suspended in mid-air when we look at Monet's painting, the rivulets of thick paint seem almost to flow out of the picture, reinforcing the sense that one's breath has been taken away by the wonder of the site. We do not need Stanfield's wrecked ship (fig. 72) to heighten our emotions, for Monet does away with much of Romanticism's imagery in his reinterpretation of the sublime, and instead works on our feelings with his expressive brushwork, his strong color (here especially the contrast of orange-yellows with blue-violets), and his eye-tugging perspective. We have seen the antecedents of his gull's-eye perspective in his earlier work at Grainval and Pourville (figs. 42 and 59), although in those pictures the brush-strokes are somewhat more subdued and the color is underpinned by a stronger play of light and dark modeling. Closest among these earlier pictures is *The Sea Viewed from the Cliffs at Grainval* (fig. 41), both for its composition and for its brushwork. That viewpoint, we should remember (Ch. 2, p. 39), also involved an illustration in a guidebook, so, although it might seem miles from any habitation, Monet was treading on vacationers' ground. It lacked specificity, nonetheless, whereas images of Etretat's pierced cliffs, because they were ubiquitous in French visual culture, would have been instantly recognizable.

To someone unfamiliar with the French coast, *The Cliff of the Porte d'Aval* would appear to be an isolated promontory, yet the swooping tongue of land in the foreground shows in old photographs (fig. 123) as well as in Inness's picture. Had we stood alongside Monet when he began this picture, we would have been on a secondary cliff trail just a short distance from the most traveled path that led to the outer tip of the cliff. There would have been buildings not far behind us, and the whole of the village would have lain under our right hand. Because all signs of the resort have been expunged in this picture, should we not say that they are irrelevant? No, because if Monet had wished to find

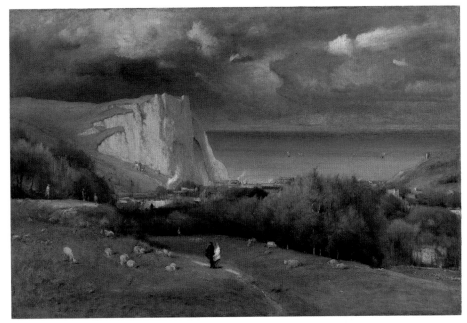

a truly lonely coast, he could have done so easily. He instead chose a very famous vacationers' site and therefore established a dialogue with foreknowledge. The meaning of the picture is in this dialogue, which is none other than the ideal traveler's experience: a famous place, seen in a new light. The cliff had become a visual cliché, but instead of the customary view from the beach, Monet constructed one that seems to

122. George Inness, *Etretat*, 1875. 76.2 × 114.3. Wadsworth Atheneum, Hartford, The Ella Gallup Sumner and Mary Catlin Sumner Collection.

123. Etretat, the beach and the Porte d'Aval, *c.*1888.

124. *Etretat, Rainy Weather,*
1885–6. 60.5 × 73.5. W
1044. National Gallery, Oslo.

125. Detail of fig. 124.

involve the viewer in the experience of climbing up the cliff, *alone*. He and the viewer define their moment of ecstasy by detaching themselves from the crowd for a seemingly unique moment before untouched nature. Its uniqueness, however, is defined by its very opposition to the crowd that at other times one is part of. Without that antiphonal colloquy, the sense of uniqueness would lose its *raison d'être*.

Except for a variant of this same composition (W 1019), Monet's other views of the Porte d'Aval were, like those of 1883, from a considerable distance, either from the bay, or from the flank of the Amont. The incessant rain of which he complained all autumn appears in *Etretat, Rainy Weather* (fig. 124), the painting that had so impressed Maupassant in November (above, note 4). It does not have the well-worked surface of the other paintings so far discussed, but Monet obviously considered it to be one of those spontaneous works that capture a particular effect so well that it should not be carried further. He showed

it at Petit's gallery in 1886 as *Temps de pluie (impression)* (*Rainy Weather [impression]*), the added word signaling its improvisatory quality so that viewers would not anticipate a finished picture.[18] He applied the paint rather thinly; we can see the warm priming in most areas. Rain is suggested by the diagonal streaks over cliff and sky, and by the gray tonalities of the scumbled strokes throughout the canvas. *Fishing Boats Leaving the Port* (fig. 126) is just as thinly painted, but it was not exhibited in Monet's lifetime and is likely to be the kind of canvas that he intended to work on some more. He began it from a spot well up on the side of the Amont, after impatiently waiting day after day for the local fleet to set sail. It was a motif that he particularly yearned for, because of its "admirable" animation.[19] The departure of the fleet was certainly a worthy motif (Venedey had enjoyed it in 1837), because it gave color, scale, and activity to the water, and because it dealt with the traditional core of Etretat's existence as a port. As Etretat's real business

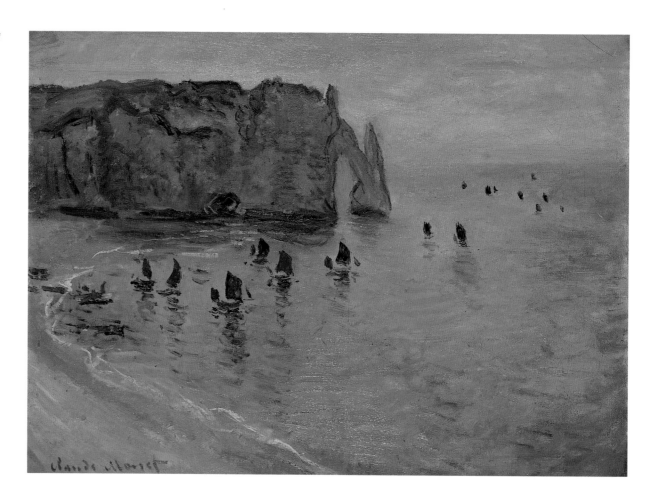

126. *Fishing Boats Leaving the Port, Etretat*, 1885–6. 60 × 81. W 1047. Musée de Dijon.

became that of catering to vacationers, travel guides lamented the decline of fishing, and they urged visitors to watch out for the fleet's embarkation or return as a picturesque local event.

Monet painted the departing fleet from his hotel window also (fig. 116) and from the other side of the village, in *The Needle and the Porte d'Aval* (fig. 127). This composition places the viewer on the shore by the Manneporte, looking back eastward as in the painting of 1883 (fig. 98). Here the huge fallen boulder lets us know that we are tucked under the cliff overhead, which casts its late afternoon shadow out over the Needle and the Aval. This canvas is more thoroughly worked than *Fishing Boats Leaving the Port*, and our eye takes pleasure in moving over its surfaces, more varied in texture and color than the other. The sun strikes the top of the cliffs and illuminates the boats headed out to sea. They are far smaller than in the other two pictures, but our eye is drawn to them nonetheless because their brown sails, turned orange by the angled sun, stand out strongly against the surrounding blues. Monet put a small boat, oars extended, in the shaded water between the Needle and the Aval (fig. 104). It gives scale to the composition, but in this peaceful afternoon setting the elevated cliffs, despite their looming height, do not seem threatening. When Monet turned around to face the Manneporte, he produced very different kinds of pictures.

The Manneporte was not quite as famous as the other two pierced cliffs and had been less frequently represented, although it is considerably larger and inherently more sublime. Monet began four paintings of it in 1885 and carried three of them to completion by the end of 1886.[20] Although far outnumbered by his paintings of the Porte d'Aval, they have loomed larger in modern writings, probably because their forceful surface geometries appeal more to twentieth-century sensibilities. They have been compared more often with abstract art and with Japanese prints than with the history of Etretat and its fame as a vacation site.[21] However, although we must indeed grant that it is Monet's means that produce different effects from the same arch, these means are not exclusively abstract. They are inextricably bound up in associations with real objects and with other works of art in Monet's own European tradition.

To see the Manneporte even from a distance necessitated a climb up the cliff of the Aval, and to reach

Monet's preferred viewing point one had then to climb down to the shore on an extremely steep zig-zag path. An alternative route would be to take a boat around the point of the Aval (like the boat in *The Needle and the Porte d'Aval* [fig. 127]). Henry James and Anthony North Peat were among the travel writers who did not mention the Manneporte at all, probably because the effort of getting to it was not compatible with the gregarious relaxation they favored. Not so Monet, who prided himself on his physical prowess and who had already painted the arch in 1883. Now, two years later, in addition to launching four pictures of the giant portal from its bay, he climbed along the top of the cliff for two paintings of it from the southwest, a *pochade* (W 1038) and a completed canvas (fig. 128). In this view, often engraved for guidebooks, we can appreciate the fact that the Manneporte is one of a whole series of promontories that reach out into the Channel.

It is to Etretat's particular fortune that three of its cliffs are pierced through. They had become famous during the Romantic era because of age-old European associations with such a singular natural form. Claude Lorrain's *Landscape with Perseus, or The Origins of Coral* (fig. 132), painted two centuries earlier, can remind us that representations of natural arches are intended to fill us with wonder because they are witnesses to powerful but unseen forces that have acted across time and that have often been given spiritual meanings.[22] Monet's own pictures of the Manneporte were given an additional charge of the sublime when he was swept off his perch by a huge wave, losing his easel and painting gear and leaving him with nightmares.[23] This event has been used by modern historians to add to the interest of Monet's work, so when he painted the Manneport he forged new links in a long chain of associations of danger and sublimity with ocean-pounded cliffs.

In *The Manneporte* (fig. 129) the massive weight of the stone arch towers over us. When he first painted it in 1883 (fig. 96), Monet used tiny human figures to

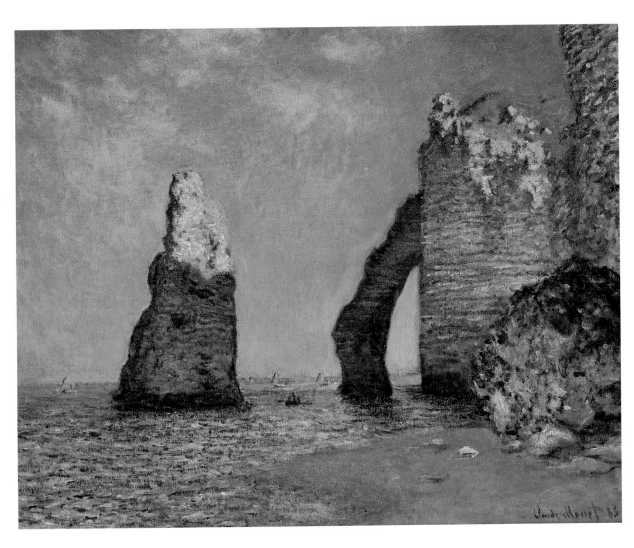

127. *The Needle and the Porte d'Aval*, 1885. 65 × 81. W 1034. Sterling and Francine Clark Art Institute, Williamstown.

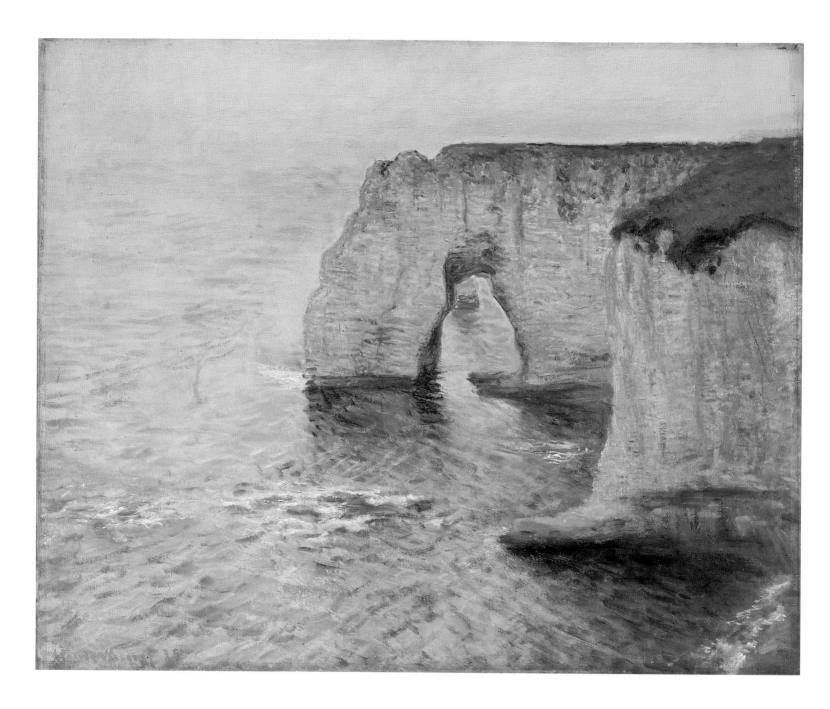

128. *The Manneporte,*
Viewed from the West, 1885.
65.5 × 81.3. W 1037.
Museum of Art, Philadelphia,
The John G. Johnson
Collection.

129. *The Manneporte,*
Etretat, 1885–6. 81.3 × 65.4.
W 1052. The Metropolitan
Museum of Art, New York,
Bequest of Lizzie P. Bliss,
1931.

give scale and a sense of threat from the turbulent waves, but here the sea is calm and there are no figures. The earlier picture has a dramatic contrast of light and dark, based on a late afternoon sun, that suits its more Romantic imagery. In this later canvas, as John House has pointed out,[24] Monet has taken a lesson from the lighter palette of his work in Bordighera, and the contrasts of pinks and oranges with blues and violets have a larger role than light and dark in modeling the layered stone. Thanks to these flickering colors and the ruffled texture of the brushwork, Monet formed an active surface for the cliff. Its chalky stone is seen

not as an obdurate, unchanging substance, but as a receptacle for the shifting effects of light, air, wind, and water.

The change of palette compared to the picture of 1883 does not make it any less sublime. By treating the cliff as subject to the effects of time – its archway was a conspicuous witness to the eroding power of the sea – Monet showed his sympathy with the view, so prominent in the Romantic era, that the coastal palisades were formed by battles between sea and stone, and in terms of geological time were only temporary forms. Michelet referred to such cliffs as

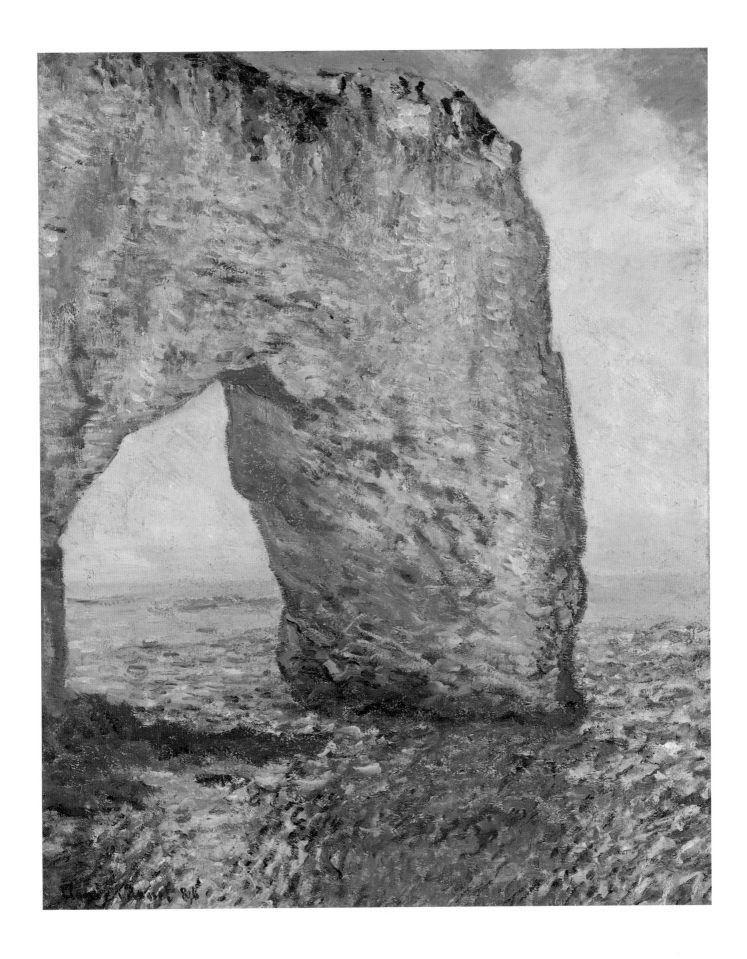

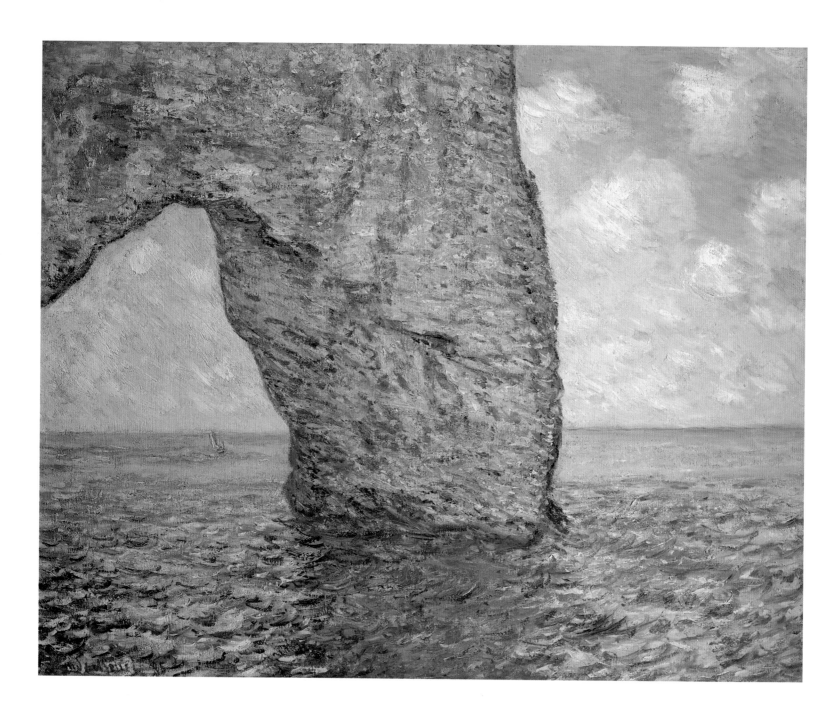

130. *The Manneporte at High Tide*, 1885–6. 65 × 81. W 1035. Mrs. A.N. Pritzker, Chicago.

131. Detail of fig. 130.

the superposed strata in which one reads the history of the globe, in gigantic registers where the accumulated centuries open wide the pages of the book of time. Each year consumes a page. It is a world in demolition that the sea is always eating away at the base, but that rains and frosts attack even more above.[25]

Despite the flutter of Monet's colors we sense the cliff's massiveness and height because of the way our eye scans the vertical composition. At the base of the canvas we look down upon choppy diagonal strokes

that suggest that the water could flow underneath us. At the top we look up to where the midday sun strikes the exposed rocks. The strip of cliff that holds up the archway on the left is so narrow that our wonder at the cliff's mass is all the greater, and we can easily sympathize with the astonishment and apprehension that lay behind Venedey's exhilaration. He had divided the sublime into two equally powerful experiences:

On considering these marvels from below, we are filled with astonishment; but they elevate us – they lift us up. Above, on the contrary, we are filled with

118

132. Claude Lorrain, *Landscape with Perseus, or The Origins of Coral*, 1674. 100 × 127. Viscount Coke and the Trustees of Holkam Estate.

134 (facing page). *The Manneporte, Etretat*, 1885–6. 92 × 73. W 1053. Collection unknown.

133. Joseph Wright, *Grotto at Salerno*, c.1774–80. 101.5 × 127. Yale Center for British Art, New Haven, Conn., Paul Mellon Collection.

awe. Below, we feel apprehensive of the fall of those masses, but above we are seized with a giddiness, which stuns and annihilates, and deprives us of the power of being afraid.[26]

Monet's paintings of the Manneporte take us "below," where we perceive one of Venedey's two kinds of sublime experience. Not all these perceptions of Monet's painted arch are alike. In another of the Manneporte pictures (fig. 130) there is no support at all on the left edge of the canvas, but we are less apprehensive. Our eye is not drawn upward since there are no sunstruck rocks, and the larger openings left and right draw us out to the calm water, where an orange sail is a comforting sign. There is more harmony than drama in the colors, for the palette is dominated by cool greens[27] and the contrasting warm tones are much more subdued than in the vertical picture.

Still another mood is projected by a canvas of the Manneporte which is closed on both sides (fig. 134). Unlike the "green" painting, in which high tide contributes a calming effect, the receding sea here has exposed tidal rocks in a broth of choppy foam. It is as though the artist had taken a section from his dramatic early picture (fig. 96), although here there is somewhat less contrast between the strongly lit inner wall of the arch and the shaded cliff. In this picture we could almost think ourselves inside a cavern, and indeed it evokes images of seaside caves that had long haunted the European imagination. Some of these had become tourist attractions. Joseph Wright's *Grotto at Salerno* (fig. 133) is an example taken from the grand tour of the eighteenth century, although Fingal's Cave in the Hebrides is perhaps a more famous ocean cavern. Monet never painted the Trou à l'homme at Etretat, which was likened to Fingal's Cave in travel literature, but this walled-in version of the Manneporte is sufficient to attach him to the Romantic tradition. He also painted a less dramatic and more picturesque variation upon this theme in the *Needle Seen through the Porte d'Amont* (fig. 135), a return to the site of his early canvas (fig. 136). The broader reach of the painting of 1868 lets us see the archway as an aperture, but in this later composition a nearly flat wall of rock almost puts us inside a seashore grotto.

More closely allied to the pictures of the Manneporte are two of the Needle seen through the Porte d'Aval (W 1049 and fig. 138). To study the Needle for this pair, Monet had to limit himself to low tide when exposed rocks gave him a reasonably secure platform. More than his paintings of the Manneporte, the silhouetting of the Needle inside the arch seems an obvious painter's device. The tourist's concentration upon looking is reborn, as it were, in

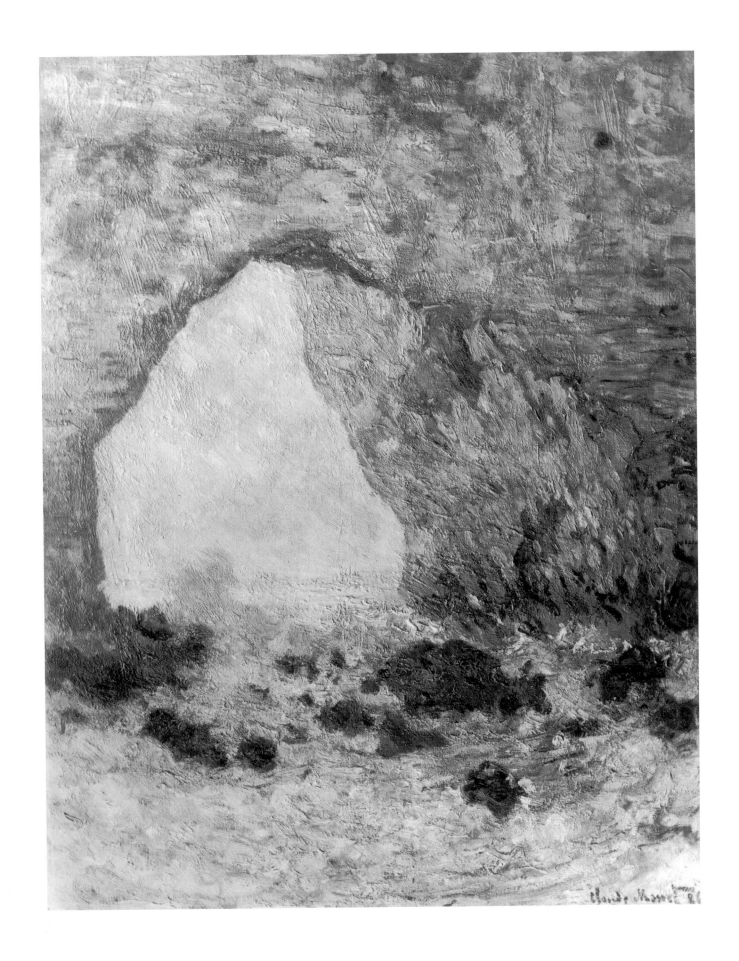

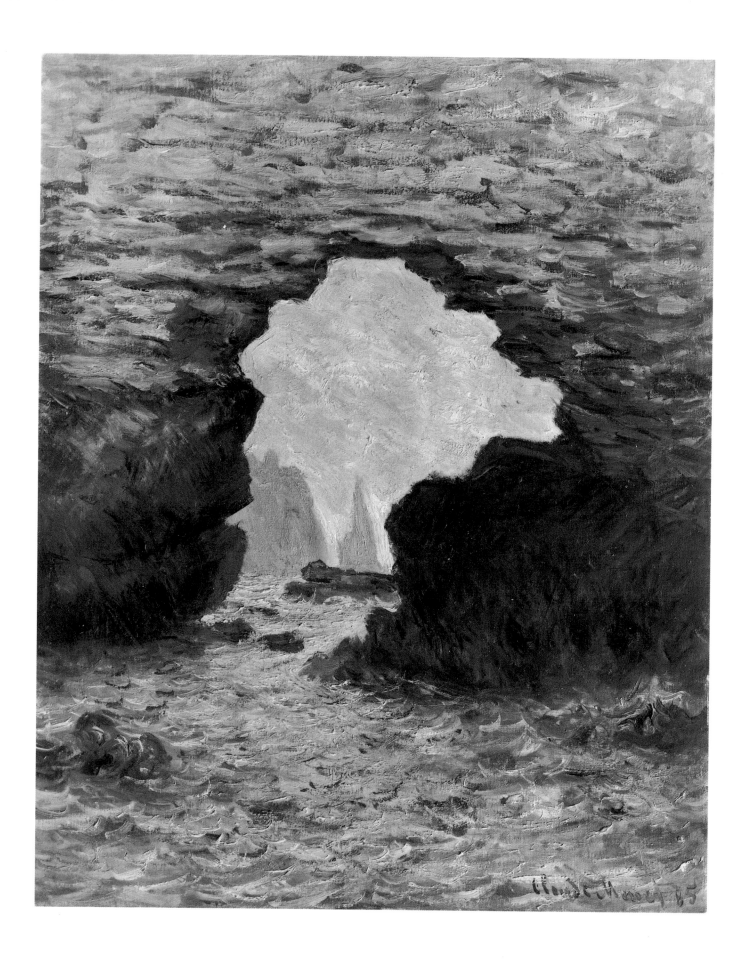

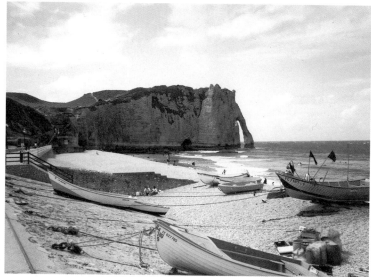

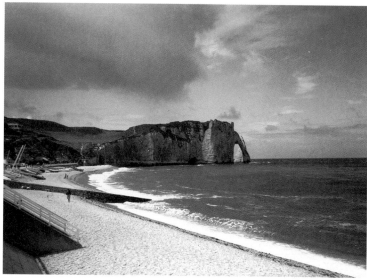

135 (page 122). *The Needle Seen through the Porte d'Amont*, 1885–6. 73 × 60. W 1040. Collection unknown.

136 (page 123). Detail of fig. 28.

137. Three successive views of the Porte d'Aval. Photographs by the author, 1991.

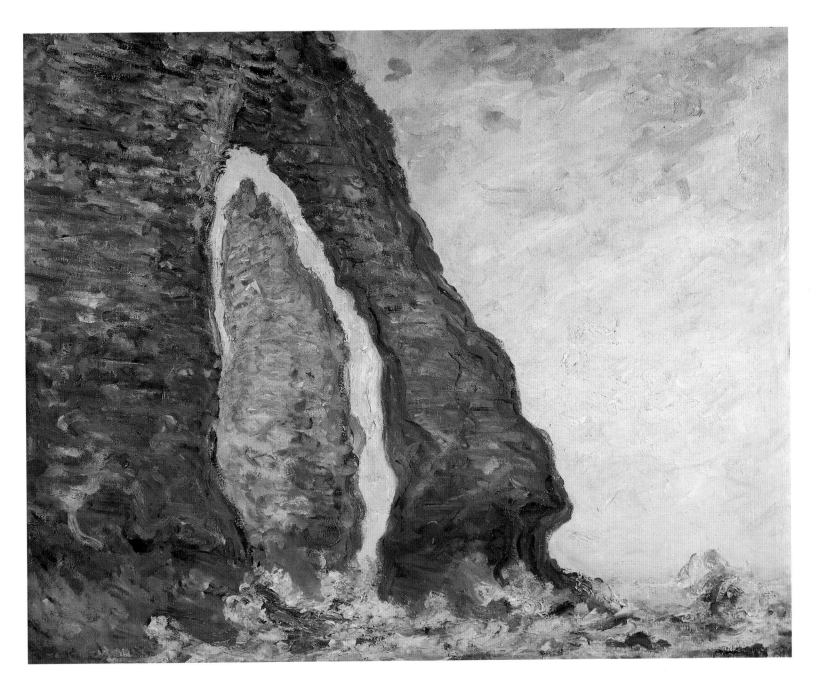

138. *The Needle Seen through the Porte d'Aval*, 1885–6. 73 × 92. W 1050. Mr. and Mrs. Nathan L. Halpern, New York.

the viewer's acute awareness of orienting oneself carefully for a notable view. This kind of sighting is merged with the decorative structure of the pair of canvases, but it is not just a painter's device. It recapitulates the game of looking that has constantly been played by visitors to Etretat. They notice the way that the Needle appears within or outside the arch of the Aval according to one's position along the shorefront. Because the overall shape of the cliff does not appear to alter during such a promenade (fig. 137), the Needle seems to be endowed with the power of moving itself.

In Monet's picture of the Needle through the arch of the Amont (fig. 135) the strategem of looking is treated differently. There the Needle is a stationary object, part of a whole little landscape framed by the portal. As the focus of the picture, it draws our eye deeply into space despite the bulk of the cliff, a perspective aided by the well-developed plane of water in the foreground. By contrast, only a narrow band of ruffled water appears in *The Needle Seen through the Porte d'Aval* (fig. 138), and its low horizon does not produce much depth. Instead of surrounding a mini-landscape, the archway so closely frames the Needle that it makes it appear like the seed of a fruit, and this pulls it forward to the surface

despite its contrasting illumination. The repeated curves formed by arch and Needle have a more flowing, organic feeling than the craggy rhythms of the views of the Needle from across the bay, and this arabesque moves through the picture, unifying it as a decorative ensemble. This does not mean that we read it as a flat surface, however, nor one that lacks emotion. Courbet once painted the archway, without the needle, from a roughly similar viewpoint (fig. 140), but his composition strikes us as a more neutral or natural rendering. His arch is comparably dark against a sunset sky, but it cedes place to the deeply receding tidal water and the broad sky. Monet's rocks have an overpowering presence by virtue of their writhing mass, and by a stronger contrast of color: his dark blues and purples stand out against the yellowish sunset. If we stare at his picture for a few moments, its rhythms force our eye upward, and then we sense the fragility of these de-licately curved masses that seem almost to tremble against the evening sky, threatening us with their potential of collapse.

140. Gustave Courbet, Beach at Etretat, Sunset, 1869. 54 × 65. Fernier 722. Private collection.

139 Detail of fig. 138.

127

Conclusion: Illusions and Realities

Parisian painters came to ask the beautiful cliffs of Etretat for inspiration and points of view which, reproduced on canvas, exhibited in our museums, bought by these too rare Maecenases who voluntarily exchange their gold for artistic works, carried far and wide the fame of these natural and splendid illustrations.

J. Morlent, 1853.[1]

This epigraph suits a book on art and tourism not only because it is taken from a guidebook but also because its author conceived of Etretat's pierced cliffs as representations. Painted images were so powerful a cultural sign that at Etretat one did not see the real cliffs as raw, unmediated nature, but as "natural and splendid illustrations." What one saw, in other words, was confirmation of what one expected to see from prior knowledge. Far from being alone in this, Morlent was typical of travel writers who conceived of Etretat as a set of views so like pictures that illusion is not readily distinguished from reality. Katherine Macquoid wrote about the cliffs as "constant and varied pictures," and the boats along the shore as "a singularly quaint background."[2] The subdivision of a site into principal "pictures" and "backgrounds" reveals the tourist's habit of looking at landscapes as though they were pictures.

Vacationers at Etretat, temporarily away from home, knew that their experience was a piece of theater. A perfect expression of this is found in the masked ball that Jacques Offenbach organized at his local villa for his silver wedding anniversary in 1869, when he and his wife appeared in the costumes of a village bride and bridegroom.[3] In real life, as we saw, many fishermen had become bathing instructors while their wives and daughters were often laundresses and servants. All of them were performers in the spectacle of Etretat, appearing in Monet's paintings as fisherfolk, shifted from the realm of the social to the esthetic, mere decorative adjuncts who assured viewers that traditional life had not changed. Vacationers came to enjoy the modern ritual of bathing against the backdrop of the cliffs, partly because of the spectacular natural setting; but which was the reality, the bathing or the backdrop?

When Monet painted the cliffs, not the bathers, he was restoring the background to a kind of reality. This was in some regards an illusion because he did not include the normal activity of the foreground. When, less frequently, he painted the shorefront, he created another kind of spectacle, a pre-modern fishing village, by omitting all references to the modernization of Etretat. And we willingly suspend our knowledge that the spontaneity of his procedures was a performance that masks the completion of his pictures behind the scenes, in his studio.

Like the tourist who wants views, and not reminders of the backstage labor that makes them possible, Monet avoided all signs of hard work. Even when he includes images of fisherfolk, they merely stand about inactively, and he treats them summarily, without individuality. Both his subjects and his technique are in concordance with the bourgeois wish for escape from the urban-industrial world and its actual laborious routines, its class distinctions and its poverty. His paintings are like tourism, which James Buzard has defined as a "compensatory region" of culture separate from the ordinary workaday life and its urban setting. Further, Buzard, writing about Henry James, shows that when witnessing poverty or misery in a picturesque place, the artist customarily pushes aside the moral questions which arise in order to allow the esthetic to flower. "Moral questions fade into moralistic impertinences because they are based on a superficial acquaintance with a place the essence of which is to be picturesque."[4] Monet's pictures, because they eschew engagement with the lives of Etretat's laundresses, hotel employees and carters, because they present sketchy, often decorative surfaces, truly suit the vacationers' view. They lack the touchability, the reality of things, and instead favor the quick take, the tourist's gaze, the village as motif. Resort reality is not the everyday, homely actions that take place there, but the illusions that constitute "Etretat."

Villagers did their best to cater to those illusions, but to accommodate visitors they had to modernize the resort's facilities. Its ancient round tower (visible in Noël's composition, fig. 71) was destroyed to make

141. Detail of fig. 143.

142. The "Fort de Fréfossé," built c.1887, destroyed in 1911. Postcard, 1903.

like the views themselves, stand revealed as social constructions.

For some summer residents, such well-framed views were daily reality. To frame a view is to control it, and at Etretat this controlling gaze was especially prized by the Parisians and other outsiders who rivaled one another for building lots with good lines of sight. Monet's views had no direct effect on the land, but the competition for actual viewpoints altered Etretat substantially. As the village grew more crowded, a good prospect was best obtained from the previously unbuilt-upon slopes of the valley. These views meant money (as does the possession of a view by Monet), not least because construction on the sloping terrain was expensive. Wealthy builders of villas at Etretat and other coastal resorts enjoyed look-out windows, oriels, towers, or gazebos, architectural members that literally framed the view for owner and guest. Angles of vision to nearby cliffs or sea were sometimes drawn on prospective ground plans, and so labeled.[6] The act of looking that dictated these structures carved up the hillsides.

For Parisians and other city-dwellers, resorts like Etretat were the ideal half of the dialogue of city and country, of urban confinement and expansive nature, of fouled air and healthy waters, of the industrial present and the pre-modern past.[7] Although they brought urban concerns with them (hence the introduction of modern comforts into the village), they also encouraged the preservation of certain aspects of old Etretat to ensure the illusions they sought. They bought guidebooks and travel accounts and patronized tourist agencies, the commercial and cultural expressions of the dialogue of the outside world with the resort. A few of them invested in railroads that joined Paris to regional centers to ensure access to the village (in Jacob Venedey's day it did not even have a proper road or organized transport). The environs of Etretat were substantially altered, as was the village, when these connections were formed with modern transport. Left to itself, the village would have remained an obscure backwater. Paris was logically the principal place where painters and printmakers exhibited their views of Etretat, and it was the source of most publications concerning Etretat (although Rouen, Dieppe, and other Norman cities had their modest shares). Maupassant published his summer "letter" about Etretat in Paris, for like Karr, Le Poittevin, or Monet, his images of the resort made sense only because they were destined for the capital. Commentators like North Peat and Henry James constantly interpolated comparisons with Paris when writing of Etretat.[8]

way for its casino; the crest of the beach was cemented into a smooth terrace; an old chapel was knocked down for Hugues Merle's studio; other buildings were replaced by inns and hotels; a Protestant church was built for foreign visitors. The exteriors of some structures were preserved although their interiors were extensively remodeled: a perfect blend of illusion and reality characteristic of an epoch that built temporary villages on the grounds of world fairs. And nature itself was altered at Etretat, not just imaginatively edited and reshaped by painters. The cliff of the Amont was carved deeply into, to extend the shorefront on its eastward end; steps were cut into rocks, and railings were added to pathways for the convenience of vacationers who mounted the cliffs for the canonical views. Monsieur Dubosc was allowed to build his ludicrous "Fort de Fréfossé" atop the Porte d'Aval (fig. 142), giving physical form to old legends and framing the view of the Needle and the bay (one had to pass through his little gateway to reach the tip of the Aval).[5]

In some paintings by Monet we sense the act of viewing quite vividly, particularly in his dramatically foreshortened compositions of the Manneporte and of the Aval and Needle, for in those cases we are more than usually conscious of his arrangement, therefore of the particular way he was looking at the extraordinary setting. At other times, as in the paintings he made from the windows of the Hôtel Blanquet, we need a moment's pause before we realize that these, too, are vacationers' configurations. Our implied presence in a tourist hotel is partly acknowledged in the detached angles of vision and in the framing, so like the aperture of a window. In this way the vacationer's hotel and the artist's studio have become one, and the paintings,

Monet's paintings, in their production, their illusions, and their marketing, also became part of the

130

colloquy between Etretat and the world at large. Like many a businessman, Monet went out into the provinces to find raw materials to carry back to his workplace ("I'll bring back masses of documents in order to make good things at home"[9]). He scurried from one outlook to another in Etretat, not just as a devotee of nature, but also as an anxious producer. Because he cultivated the illusions, not the contemporary realities of Etretat, we could also liken him to the old-fashioned anthropologist who returned from the field with images of an idealized native culture purged of cameras, utility vehicles, and campgrounds. Monet systematically eliminated summer crowds from his pictures, although, in a manner of speaking, those crowds were the clients he would hope for, once they returned to the city. He did not consciously calculate every step in the creation of his market, but he instinctively gravitated towards men of power, the class that could provide his living. He was glad to be taken up by the wealthy Parisian Faure, one of his principal clients whose summer villa he borrowed for his family vacation, and he dined frequently at the château of the local nabob, where he rubbed elbows with the village's principal men and with visiting hunters.[10] To a certain extent he was like the hunters, an outsider who came to the resort in order to take something away. Parisian dealers and exhibition galleries were the central preoccupation of the letters he mailed from the Hôtel Blanquet.

Patrons like Faure and dealers like Durand-Ruel and Petit did not expect Monet to destroy the illusions that gave Etretat its fame, but they certainly did expect him to declare an adequate modernity. His claim to attention was the new way he was rendering the familiar. Paintings of the coast done years earlier by Isabey, Daubigny, or Courbet were greatly appreciated, but Monet offered startling new perceptions of the seacoast in pictures that were becoming more attractive products on the cultural market as the decade progressed ("new things" in the commercial sense of Monet's term). His striking compositions, his free-flowing paint, and his intense palette encapsulated modernity, because this self-conscious technique, by making the painter's marks so evident, stressed the personal and subjective response to nature that was highly valued by many bourgeois art-lovers. Viewers of Monet's work, prompted by a growing number of laudatory articles in the press, learned to attach his brushwork and color not to traditional criteria, but to his "sincerity" and to his "temperament" (buzz-words of the period since the 1860s). In an era when individuality was increasingly prized, the uniqueness of the artist's response to nature acquired new value.[11]

Monet's success was to make the viewer feel like him, or like Venedey or Michelet, serious nature-lovers capable of responding individually to cliff, ocean, and sky, and not like those vacationers whose appreciation is contaminated by bathing beaches and casinos. Individualism links the tourist with the artist's work, an attachment often exploited by travel writers.[12] As Dominique Rouillard notes, many influential authors of "itineraries" and "voyages" wrote in the first person, simultaneously treating their readers as outsiders not yet privy to the site, and inviting them through their reading to assume the privileges of the insider, to convince them that they, too, can have personal, meaningful experiences. Monet's canvases function in much the same way as these texts of travel writers.

It is because they embody social qualities recast as private emotions that Monet's paintings of Etretat resonate in our culture. Even before Impressionism the sketch had become prized among connoisseurs because it was closer to the painter's hidden self, and so the sketchiness of Impressionism triumphed over conventional finish when culture demanded contact with the inner artist. We refer to "a Monet" as though the artist himself were the picture. In seeing the marks of his hand in his brushwork, our own perceiving individuality is engaged, and this helps give Monet's paintings, and those of the other Impressionists, their hold on the modern imagination. It is, of course, a *mystique* of individualism, for the ideology of modern industrial society uses the chimera of individual freedom to make palatable the coercions of a social organization over which we have little personal control.

Monet's individualism, so clearly manifested in his painterly spontaneity, was inextricably tied to his neo-romanticism, and this led to his being challenged at the very moment when he was at last finding a receptive audience. Neo-Impressionism burst on the Paris scene in June 1886, shortly after Monet's last visit to Etretat. To the artists grouped around the newcomer Georges Seurat, and critics like Félix Fénéon who championed them, Monet was indeed a romantic. For them his highly evocative and personalized technique was the incarnation of romantic individualism, as distinct from their ideals of democratic community. Neo-Impressionist landscapes, carried out in methodical "divisionist" brushwork, made his gestural surfaces and his images of turbulent seas seem like a throwback to a past era. His erstwhile comrade, Camille Pissarro, who had joined the Neo-Impressionists in 1886, disliked Monet's paintings of the mid-1880s and wrote about "the disorder that rises from this romanesque fantasy which, despite the artist's talent, is no longer in accord with our epoch."[13] He regretted Monet's "gross execution" and condemned him for being a "romantic" Impressionist, as distinct from the "scientific" Impres-

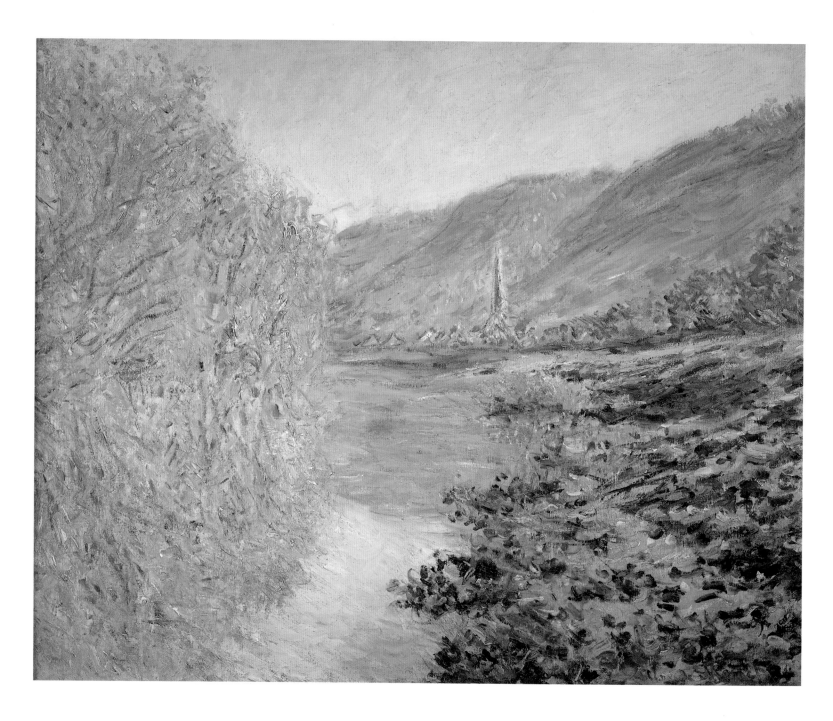

sionists like Seurat, Paul Signac, himself, and his son Lucien. Their work was "scientific" and therefore modern, because of its impersonal brushwork and its more erudite color theory.

Pissarro was right to regard Monet's self-conscious response to nature as the heritage of Romanticism, not just in his renderings of Norman seacliffs, but also in his many canvases of fields and riverbanks near Giverny which he painted in the 1880s. The pastoral landscapes of lower Normandy, not far from Paris, might seem the opposite of the sublime cliffs of upper Normandy, and

it is true that here Monet was at home, far from the terrain of tourism. We have already seen one Giverny landscape, *Meadow with Haystacks near Giverny* (fig. 106), and we might look at two others in order to expand upon the definition of Monet's neo-romanticism: *Banks of the Seine at Jeufosse, Autumn* of 1884 (fig. 143) and *Under the Poplars, Sunlight Effect* of 1887 (fig. 144). All three should be linked to the tradition of the picturesque, the antiphonal partner of the Romantic sublime.[14] *Banks of the Seine at Jeufosse, Autumn* shows a calm bend of the river about two miles upriver from

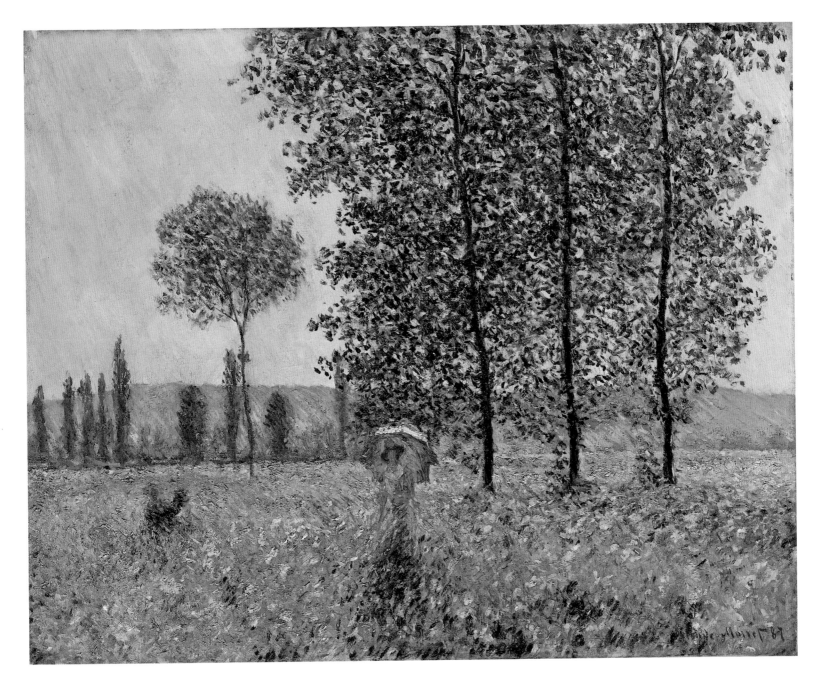

Giverny. The village of Jeufosse, like Channel ports in Monet's pictures, has lost much of its identity because Monet has assimilated it with the multi-colored vapors of distance. He also positioned himself along the calm branch of the Seine, separated from the main channel by the island to the left. The view he constructed is therefore doubly bucolic because in reality the slopes of the river valley at Jeufosse were farmed, and the Seine bore heavy commercial traffic. *Under the Poplars, Sunlight Effect* is closer to home, but it, too, is an updated version of the rustic picturesque (and it was owned by Faure, who added it to his pictures of Etretat). It

features an arcadian meadow in sunshine graced by a bourgeois promenader and flowers. In all three pictures we are far from Etretat, but also far from Paris. What was home territory for Monet was a picturesque retreat for the Parisian looking at his pictures (and a century later, a tourist mecca because of Monet!).

Pissarro's polemic, nonetheless, will not persuade us today to deny modernity to Monet. On the contrary, the "gross execution" that Pissarro objected to, conspicuous in the foregrounds of all three pictures, is the artist's claim to fame. Of course, the execution, although energetic, is not the same as that of the Etretat

144. *Under the Poplars, Sunlight Effect*, 1887. 74.3 × 93. W 1135. Staatsgalerie, Stuttgart.

133

pictures. To suit Etretat's sublime landscape Monet used agitated movements of his brush and dramatic compositions, whereas in the Giverny pictures he produced pastoral moods by more regular, fluttery strokes and calmer compositions. Whether Giverny or Etretat, Monet's networks of apparently instinctual marks have drawn the admiration of the Fauves, Kandinsky, and the Abstract Expressionists. It is therefore not a paradox to locate Monet's modernism within his neo-romanticism. At the same time, we have to distinguish his neo-romanticism from the Romanticism of the second quarter of the century, and to do so we must not just point to his modern technique, we must also see how technique and subject formed one art. We can best accomplish this by returning to our case-history of Etretat. After all, it was at the height of Romanticism that Venedey voiced his soulful reaction to Etretat's sublime portals (Ch. 3, pp. 63–4). Because few had preceded him, Venedey could have a powerful experience hardly mediated at all by existing images of the cliffs (although, of course, mediated by known representations of the sublime). By the 1880s, the pioneer seeker of John Urry's romantic gaze was rare, and when Monet and the tourist searched for authenticity then, they went to a well-trampled resort.

In letters, interviews, and implicitly in his paintings, Monet presented himself as the heir of the Romanticist who disdained the city and its restrictions, who showed the way to the view, nearly always a piece of nature seemingly untouched by urban-industrial society. He prided himself on his endurance as he clambered over cliffs to positions favored by bird-hunters. Maupassant appropriately presented him to the public in the guise of a hunter ("Last year, right here, I often followed Claude Monet, who was in search of impressions. Actually he was no longer a painter but a hunter").[15] We now know that Monet was not quite the romantic wanderer, because he chose places away from his home that were already blessed by fame, tourist places where his cares could be met by hotels, restaurants, and the workers who helped transport his apparatus. The reality of his surroundings in the 1880s was very different from Venedey's in the 1830s, but he gave us the illusions of the earlier decade. We sense the make-believe in his paintings because their decorative qualities confirm that they are indeed "motifs" and that they represent the act of painting as much as the site itself.

To be aware of these illusions is not to look disdainfully upon freedom, nature, and solitude, those romantic longings so deeply ingrained in our culture and the source of so much of its poetry, longings for mythic places whose wholeness can compensate for the fragmented and inauthentic lives of modern urban society.[16] To be aware of them, however, is to recognize the dialectical character of Monet's enterprise, to realize that his search for authentic responses to nature was not incompatible with his concern for his Paris market, and to acknowledge that authenticity and inauthenticity are intertwined.[17] Monet's responses to nature were authentic in the sincerity of their genesis, but they can be regarded as inauthentic if we were to charge him with the need to record all that was within his sight at Etretat. No one can read his letters without being convinced of his extreme sensitivity to rising or falling tides, the time of day, the changing weather, and the quality of sunlight. He needed to see what he was building on canvas, at least in the early stages of his work. His feelings were at high pitch when changing weather interfered with a picture, and he destroyed canvases that did not measure up to his standards. His search for uncontaminated experiences led him to boycott the bathing season at Etretat (he painted there mostly in autumn and winter), and to regret the company of other painters and tourists who lingered on at the Hôtel Blanquet, and whose presence reminded him of the inauthenticity of the whole resort and, probably unconsciously, of the inauthenticity of his own enterprise.

Monet's dislike of other visitors, nonetheless, only proves what MacCannell, Urry, and Buzard have shown in the context of tourism. By avoiding others, Monet confessed the fact that he defined his experiences and his paintings by opposition to vacationers, and yet he made pictures that would appeal to the urban market for solitude and pre-modern nature. Buzard summarizes this well in a passage dealing with writers that can apply as well to Monet:

> There is a dialectical relationship between the elaboration of "crowd" and "tourist," on the one hand, and the anti-tourist's privileging of "solitude," which is less a valuing of private experience than it is a rhetorical act of role-distancing in need of its audience, real or imaginary. Actual solitude is not marketable; the anti-tourist makes an image of self that can be displayed and appreciated, that can appreciate in value as others appreciate it. Even celebrated moments of solitude . . . must be seen as in some measure *existing to be celebrated*.[18]

The dialectic of solitude and social community can be found in the way Monet's clifftop views can be distinguished from those by artists who preferred the gregarious aspects of tourism. We have already touched on this when comparing Monet's regatta at Sainte-Adresse with Frederik Kaemmerer's *The Beach at Scheveningen, Holland* (figs. 14 and 23), but another comparison will characterize Monet's art more completely. Pierre Outin's *The Look-Out Point* (fig. 145),

exhibited in the Salon of 1878, shows vacationers overlooking the sea, as does Monet's *Cliff Walk at Pourville* (fig. 49). Monet's two figures have climbed up away from the resort village to escape its society, but Outin's gaggle of visitors bring their society with them. While one local woman looks anxiously down on a rough sea, an elegant vacationer, pestered by a child, looks through a telescope offered by an old salt (or a visitor dressed as one). Women chat while seated on folding chairs, a fop admires his cigar, children clamber on an old cannon probably towed there by the local chamber of commerce, and off in the distance we see the beach from which they have come. Outin's entertaining satire, so crowded in anecdote, does not let us alone with our thoughts. We are not free, in Monet's sense. By contrast, Monet's two women merely stand there, figures of detachment whose presence is vital, but who lack the narrative complexity of the other canvas. This kind of detachment characterizes the work of all the Impressionists, who believed that amusing stories were *petit bourgeois* failings incompatible with a higher (read: upper-class) conception of art and nature. Monet's rejection of anecdote encourages us to regard his work as superior especially because it appears to have been a natural or instinctive response to what he saw, one that seems to allow us, also, to devise our own lyrical responses to nature.

Monet's detachment, his avoidance of narrative, admirably suits the experience of vacationing away from the city. When he did not include any human figures whatsoever, his objectification of the view is all the more complete, and we can readily imagine ourselves in an impassioned moment of solitary vision. This is what Denis Cosgrove has called "a way of seeing which separates subject and object, giving lordship to the eye of a single observer. In this the landscape idea either denies collective experience . . . or mystifies it in an appeal to transcendental qualities of a particular area."[19] Paintings of the unpeopled coast of Etretat (figs. 124, 130, or 138) bespeak the controlling gaze of the free individual whom urban society envies because, like the quintessential Romantic writer or painter, he has found places where one can explore one's feelings in transitory freedom from the modern city. The concept of freedom, of course, forms but one half of a dialogue, for it, too, has meaning only when we posit its opposite. It is freedom *from something else*. Tourism and Monet's pictures derive their meaning from contrast with home and workplace. The antiphonal pairs of this dialectic are vacation resort and Paris, nature and urban art galleries, solitude and resort hotel, traveler and stay-at-home, illusion and reality.[20] Urban parks and swimming pools, those illusions of nature, are creatures of the modern industrial city.

A strong current within modern culture (given voice by the ecological movement) greatly regrets the loss

135

of uncitified nature, which is increasingly reserved to national parks and forests. Many work, with only sporadic success, to preserve parklands from the inroads of industrial society and its conflicts. Just as parks have their protected boundaries, their visitors' centers, and their guides, so Monet's art has its museums, its collections, and its interpretations. This book is one of those interpretations (that is all that "history" can be), and it has concentrated on his paintings of Norman resorts and cliffs in order to lead the reader into a distinct historical preserve. Because tourism looms so large in modern culture – it is an industry that has outstripped all others, on a world-wide scale – Monet's subjects have become integrated with images of nature as parkland, that is, as vacationland.

Nowhere can we better see this integration than in Monet's gardens at Giverny, which are as much illusion as reality. The land was first altered by Monet, who diverted a stream for his manufactured water garden and used plantings to screen the railroad that ran through his property. After falling into neglect, Monet's estate was restored with the aid of the visual evidence of his paintings to form the now thriving house-garden-museum. To preserve the original shape of his pond, its edges, which before the restoration were being nibbled away by invasive muskrats, have been completely (and, of course, invisibly) lined with vertical metal pilings. Millions of tourists now go there, using their vacations to steep themselves in the aura of this famous landscapist. During their pilgrimage to this museum they cannot see a single real painting. All they can find there, hung in Monet's old studio and in the gift shop, are large reproductions of his paintings, including those of the gardens and the pastoral surroundings of Giverny. Where is illusion, and where is reality?

Notes

INTRODUCTION

1. Monet's technique of originality has been brilliantly analyzed by Richard Shiff (Shiff 1984, ch. 8, and *passim*). Shiff's book puts paid to any idea that Impressionist paintings were simply objective copies of nature. In particular, his conception of "making" and "finding" (ch. 6, and *passim*) is at the center of a subtle and persuasive study of the interrelationships between the natural world and its renderings in art.
2. "Tourism" came into common usage in Great Britain in the late eighteenth century, stemming initially from the tour (that is, literally a go-around) of the Continent by young upper-class men as a feature of their education. By the time the term became common, it referred also to the travel to historic and picturesque sights in Great Britain and Europe by men and women of means. Eventually – Thomas Cook's mid-century tours are the marking event – tourism spread to a broad spectrum of society.
3. Urry separates the tourist gaze into the "romantic" and the "collective" gaze. The former emphasizes "solitude, privacy and a personal, semi-spiritual relationship with the object of the gaze." The latter "necessitates the presence of large numbers of other people," namely those who share the resort and whose activities and numbers prove the significance of the tourist experience (Urry 1990, p. 45, and *passim*).
4. Particularly Tucker 1982, Tucker 1989, and Spate 1992.

CHAPTER 1

1. See Levine 1976, p. 6.
2. Alain Corbin and Andrew Hemingway show that British artists who painted resorts like Brighton, Hastings, Margate, or Yarmouth at the beginning of the century anticipated some aspects of French artists' later renderings of Channel resorts, including the avoidance of intrusive modernity and the use of Dutch prototypes (Corbin 1988, *passim*, and Hemingway 1992, ch. 8, and *passim*). Jongkind, of course, was himself Dutch, and Boudin, Courbet, Daubigny, Rousseau, and Troyon had drunk at the Dutch well. Because Anglo-Dutch art had entered importantly into the development of French landscape from the 1820s onward, it is difficult to sort out a British component to Monet's paintings. However, since British artists like Turner, Bonington, and Stanfield (see fig. 55) painted the Norman coast and the banks of the Seine, and since British vacationers flooded into Norman resorts from the 1830s onward, we should assume a British connection, no matter how indirect. When he went to London in 1870, and then to Holland (where he returned more than once afterwards), Monet experienced British and Dutch art at first hand. These travels confirmed his preference for the northern tradition in landscape, although precise connections are not easily found.
3. Richard Shiff has analyzed this pair of canvases with great subtlety, showing how their colors, modeling, and compositions constituted Monet's modernity (Shiff 1984, pp. 108–11).
4. Already in 1848 there were 66,000 British residents in France, mostly in the north (a huge number in Le Havre), and Anglican church services were available in twenty-five French towns (Murray 1848, p. xxxviii. See also J.P.T. Bury, "England and Normandy in the XIXth Century, Some Points of Contact," *Annales de Normandie* 8, 2 [May 1958]: 257–72).
5. This aspect of the transformation of villages into resorts is particularly well summarized in Rouillard 1984, p. 97, and dealt with elsewhere in that fine book. Already in 1855 the rising suburbanization of Sainte-Adresse was remarked upon by a leading travel writer: "Sainte-Adresse, which soon will merely be a much frequented part of Le Havre, is a pretty village. One still finds there all the seductions of solitude, silence, and oceanic contemplation, although for several years now little houses, refreshment stands, kiosks, and lodges proliferate in this delicious valley, preparing, one might say, thanks to brick and stone, the hour of its imminent transformation" ("Sainte-Adresse, qui ne sera plus bientôt qu'un quartier très-fréquenté de la ville du Havre, est un joli village; il y règne encore toutes les séductions de la solitude, du silence et de la contemplation océanique, quoique depuis plusieurs années les petites maisons, les vide-bouteilles, les kiosques, les pavillons se multiplient dans sa vallée délicieuse, en préparent en quelque sorte, à force de briques et pierres, l'heure de sa prochaine transformation") (Chapus 1855, pp. 228–30).
6. Adolphe Monet had worked in Le Havre for the Lecadres' business in wholesale foods; he had retired about 1860. For this and all biographical information introduced in the present book I am indebted to the *catalogue raisonné* edited by Daniel Wildenstein (W).
7. Monet knew Manet well by then and had learned a great deal from the older painter. Although Manet had not painted many landscapes, in the 1867 exhibition he had shown three marines done in 1864 at Boulogne: *Battle of the Kearsarge and the Alabama, The Kearsarge at Boulogne* (both in private collections), and *Steamboat, Seascape* (Art Institute of Chicago). The first two are modern history paintings foreign to Monet's way of thinking, but all three display broad brushwork, high horizon lines, and strong surface patterns that would have reinforced his own departures from convention. Several marines that Monet painted at Le Havre or Honfleur in 1867 are closer in their *bravura* to Manet than the big Salon composition, but these are small canvases (two 50 × 61 cm., the other 49 × 64) that he did not exhibit (W 86–8).

8. I discuss resort paintings by Manet, Morisot, Boudin, and Monet in R. Herbert 1988, ch. 7.

9. Hemingway establishes this same distinction for the images of resorts in British art a half-century earlier (Hemingway 1992, ch. 8, and *passim*), when high art was defined by "aesthetic interest" considered by many to be incompatible with topographical and travel prints that readily pictured tourist activity. He shows that artists like Joshua Cristall and William Collins carefully excluded signs of modernity in their resort canvases, that Turner adapted some signs of resort activity by embracing it within the picturesque, and that Constable's recognition of the transformation of Brighton was an element of his modernity, although productive of anxiety and ambivalence.

10. For this, see the brilliant argument laid out in Clark 1985.

11. For the implications of this conception, and for an enlightening discussion of the relation of nature to the subjectivity of art, see Shiff 1984, especially chapters 4 and 6.

12. And yet Adolphe Monet had a mistress, Amande-Célestine Vatine, who had borne his child, Marie (therefore Monet's half sister), in 1860; the elder Monet lived with her after his first wife's death and married her in October 1870, four months after the son had married Camille Doncieux (W I, pp. 12, 37, 55).

13. Monet's ambition, pride, and selfishness cannot be separated from his productivity and should not be politely ignored. His use of Camille, including his deathbed portrait of her (W 543, Musée d'Orsay), gives rise to more than one moral question. Perhaps as dubious was his treatment of his fellow painter Frédéric Bazille; his letters to Bazille (reproduced in W I) include reproaches and petulent recriminations despite his friend's constant monetary support. Monet had the habit of reproaching his friends for his need to beg them for money.

14. Several paintings of fishing boats, sometimes given to Etretat, could as well have been painted at Le Havre, and two inland pictures, including the now famous *Magpie* (W 133, Musée d'Orsay), might date from this winter, but conjecture is not supported by any strong evidence. For this Etretat campaign the Wildenstein catalogue lists three pictures of fishing boats (W 124–6), a rural road (W 128), and *The Magpie*. For a doubtful view, see House 1986, pp. 147, 241 (n. 4), and 245 (n. 3).

15. The picture's apparent spontaneity was, of course, the result of extended periods of work. He presented his huge picture to the Salon jury in 1870, not in 1869, allowing us to assume that he continued to work on it well after leaving Etretat.

16. For Monet's own use of the several terms – *pochade, étude, esquisse* – that can refer to pictures not carried to the "finish" of exhibited works, see House 1986, pp. 157ff.

17. The early history of this picture reveals Monet's miserable fortunes. Although later in 1868 it was accepted for an exhibition in Le Havre of maritime painting, it and his other works in that show were seized for non-payment of debts and sold at auction for derisory sums (W I, p. 168).

18. Although dated 1873 by Wildenstein, there is now wide agreement on stylistic grounds that the picture must instead have been done in 1868 or 1869.

19. House 1986, p. 142.

20. ". . . what I'll do here at least," he wrote that winter, "will have the merit of not resembling anyone, at least I think so, because it will simply be the expression of what I will have felt, I, myself" (". . . ce que je ferai ici a au moins le mérite de ne ressembler à personne, du moins je le crois, parce que ce sera simplement l'expression de ce que j'aurai ressenti, moi personnellement") (W I, letter no. 44 to Bazille, December 1868).

21. See Bermingham 1986. Of course, Constable's spirited brushwork was most evident in his sketches, which were particularly prized by French Romantic painters such as Paul Huet (1803–69).

22. The idea of the representation of spontaneity comes from Shiff 1984, particularly chapter 4.

23. It is possible that natives had initially excavated this pathway to facilitate access to the shore for their purposes, but mid-century travel accounts make no mention of it and warn against the extremely risky descent. In any event, if not made explicitly for visitors, it was widened and railings were added for their convenience. More alterations to the village and its environs will be introduced in later chapters.

24. Trouville and Deauville are discussed in various portions of Rouillard 1984, with particular attention to their villas. I give a brief history of Trouville and Deauville, and an account of Monet's paintings there, in R. Herbert 1988, pp. 265–74, 293–9.

25. Monet was just as immersed in traditional patriarchy as Renoir but has escaped much of the opprobrium that has been heaped upon the latter because of his sensuous nudes. In many ways, Monet seems more thoroughly a middle-class male because he did not paint the nude.

26. Macquoid 1874, p. 317. The Roches Noires is described in the *Guide Annuaire* of 1868 (pp. 75–9) as having been opened in the current summer, but some texts in this guide date from 1866, so it may have been inaugurated then. As for Monet's hotel: In 1868, according to the same guide (p. 80), pension at the Tivoli (on the rue des Bains) was six to seven francs a day, which placed it among the cheapest three of ten recommended (not counting the Roches Noires), yet it was certainly a cut above the unlisted hotels.

27. The roughly similar picture, W 157, was sold at Christie's, New York, 14 November 1988; the remaining boardwalk composition (W 1994) has long been lost from sight.

28. ("Sur la plage allons prendre l'air,/Contemplons l'Océan tranquille./Ah! Si Paris avait la mer,/Ce serait un petit Trouville.") By Alfred Hennequin and Albert Millaud, first performed in 1878.

29. See the carefully worded hints to this effect in W I, p. 46.

30. W I, letter 55.

CHAPTER 2

1. For Monet's work at Argenteuil, see especially Tucker 1982, also Clark 1985, and R. Herbert 1988.

2. For Le Havre, W 259–61, 294–7, and possibly one or two others; for Sainte-Adresse, W 265, 266.

3. A decade later (P. Joanne 1891, pp. 132f), the village is described as "frequented by peaceful families, loving calm and relative simplicity" ("fréquenté par des familles paisibles, aimant le calme et une simplicité relative"), but "The old village has nearly entirely disappeared to make way for large and handsome chalets, magnificent villas, and country houses. The most remarkable *chalets* are those of MM. de Blowitz, *Times* correspondent in Paris, Ernest Daudet and Bardy" ("L'ancien village a presque entièrement disparu pour faire place à de grands et beaux chalets, des villas magnifiques et des maisons de campagne. Les *chalets* les plus remarquables sont ceux de MM. de Blowitz, correspondant du *Times* à Paris, Ernest Daudet et Bardy").

4. Courbet had painted several views of the Mediterranean in 1854, but in these the sea is calm and the viewer is further from the edge of the water.

5. James Herbert discusses this picture in the midst of one of the rare discussions of Monet in the context of tourism (J. Herbert 1992, pp. 100–3). He treats the painting as an

example of the sublime because of its contrast of figures and cliffs, but I do not believe that it evokes the degree of astonishment and awe required for a sublime experience. We agree about the sublime in Monet's works at Etretat (see my ch. 4, p. 86). For a discussion of the sublime, see below, ch. 3, pp. 63–4, and *passim*.

6. W I, letters 210–13.

7. Eighteen of twenty-two paintings sold to Durand-Ruel in May 1881 were of Fécamp and Les Petites Dalles (W I, p. 118).

8. The four paintings (W 647–50) have not previously been identified with the same place at Grainval from which the eastward views were painted (W 653–6). It was only with the help of Jacques Caumont and Jennifer Gough-Cooper that I located this spot, now virtually inaccessible because of thick, bushy growth.

9. Joel Isaacson (1978, p. 213) is the first, to my knowledge, to have compared Degas's angles of vision with Monet's, albeit with an emphasis different from mine.

10. James Buzard construes the tourist's way of viewing as masculine because it retained "the assumptions of gender given to it by its founders, who imagined a male art of seeing that could correct and complete what a feminized landscape held forth" (Buzard 1993, p. 16). Indeed, in the nineteenth century the emulation of that great Romantic traveler Byron "amounted to figuring oneself as a lone male wanderer, unfettered by the familial and female influences of home." (p. 130).

11. W II, letter 730 to Alice Hoschedé, 30 October 1886, writing from and about the shore at Belle-Ile: ". . . mais vous savez ma passion pour la mer, et celle-ci est si belle. . . . Je sens que chaque jour je la comprends mieux, la gueuse, et certes ce nom lui va bien ici, car elle est terrible; elle vous a de ces tons d'un vert glauque et des aspects absolument terribles (je me répète)." "Gueuse" can be translated also as "wench" or "hussy," but Monet's context makes the stronger word more appropriate.

12. More can be said along these lines. In some of Degas's ballet scenes, such as his *Dance School* of 1876 (Vermont, Shelburne Museum), the active forms are placed to one side, forming a tipped-up plane of the center and the other side that assumes the position of Monet's sea in the Grainval marines.

13. Three of the sea viewed from the uplands of Trouville (W 686–8), and one of the eastward end of the bay at Sainte-Adresse (W 689, Copenhagen, Ordrupsgaard Collection).

14. See W II, p. 9, and *passim*. He would presumably have had the added costs of their food, but even so, his gross income would have been perhaps thirty times theirs. He sold his paintings to Durand-Ruel that year for between 500 and 600 francs each, so two of them paid most of the annual salaries of his servants; his annual rent at Vétheuil had been 660 francs a year (W I, p. 118). Yet another indication of his class standing: he did not dare trust a 100 francs note to the "worker" who was taking a letter to Dieppe for him (W II, letter 243).

15. W II, letter 282. Reading Monet's letters is to realize that he thought the world owed him a living, and Durand-Ruel at that time represented the world. On 17 July he thanked Durand-Ruel for the 1,000 francs he had sent, and asked for 1,000 more, as well as direct payment of a color-merchant's bill of 400 to 500 francs; on 27 July he thanked his dealer for 2,200 more francs, and on 16 August asked for another 2,000 (W II, letters 281–4): this is a typical sequence of demands, one nearly always leading to another.

16. W II, letter 236 to Alice Hoschedé, 8 February 1882: ". . . un tas de types de province. . . ."

17. He was probably not the only painter there, for a few years later it was said that in its small casino "were exhibited paintings offered by the artists who form, with actresses, the principal clientele of Pourville" ("où sont exposées des peintures offertes par les artistes qui forment avec les actrices la principale clientèle de Pourville") (P. Joanne 1891, p. 115). Monet painted portraits of Père Paul and his wife: W 744 (Vienna, Neue Galerie in der Stallburg), and W 745 (Harvard University Art Museums).

18. The others are W 754, Upperville, VA, Mr. and Mrs. Paul Mellon; W 780, destroyed by fire; W 781, Washington, D.C., Mr. and Mrs. David Lloyd Kreeger.

19. This cabin appears in nearly twenty paintings of 1882, today bearing confusingly different appellations. Equally confusingly, these pictures are sometimes labeled "Pourville," sometimes "Varengeville." The cabin is perched on the edge of the *valleuse* or dry gorge of the Petit-Ailly that pitches down to the shore between the centers of Varengeville and Pourville.

20. W II, letter 264, 6 April 1882: ". . . la plupart de mes études ont dix et douze séances et plusieurs, vingt."

21. John House has demonstrated (for example, House 1986, p. 185, referring to the present fig. 49, W 758) that Monet often altered portions of his compositions *en route*, that is, he altered "nature" to suit his structures.

22. If a slide of this picture is reversed, the picture is utterly destroyed, because the waves seem to be heading out to sea. Like Degas, Monet knew how to exploit our left-right vision.

23. "Sublime" and "picturesque" are discussed more fully in the next chapter, and again in chapters 4 and 6.

24. The Pourville-Varengeville pictures of 1896 and 1897 are thoroughly dealt with by Paul Tucker (1989, ch. 7). He concludes that their "softer effects engender a sense of introspection" so that "it is tempting to see these pictures as being informed as much by memory as by experience, leading us to believe that we are looking at an aging man reflecting on his past as much as observing and transcribing specific lighting conditions" (p. 208). We might add that in 1897 Monet was fearful that his views eastward from Pourville towards Dieppe would shortly be ruined by entrepreneurs who had rented the uplands for an amusement park. Once again, he wanted to preserve his romantic gaze from the incursions of the collective (W III, letter 1367 to Alice Monet from Pourville, 6 February 1897).

25. W 728. The two variants with paired trees are W 725 (Louisville, J.B. Speed Art Museum) and W 726.

26. *Repoussoir* means an element in the foreground that acts as a foil by which the distance is better measured.

27. The other two views were painted from slightly different spots along the shore, for Monet continued here his practice of reframing a given motif, a way of exploiting the same motif while producing different pictures. W 795 is quite similar, but Monet moved a few yards westward to paint it; for W 796 he was further away and so displays much more of the cliff.

CHAPTER 3

1. W II, p. 9.

2. W II, letter 310, 31 January, 1883.

3. And some towards the end of his life. Paintings of Etretat, freshly worked upon, were sent to his dealers in 1918, 1920, and 1924 (W IV, letters 2269, 2388, 2560).

4. After Monet's time, a tunnel was cut through the Trou à l'homme, giving access to the bay of the Manneporte at low tide. Because of this easier route, the "stairway" up

the cliff has atrophied and is now impassable except to the skilled climber. This change – and others like it at Etretat – is documented by consulting successive editions of guidebooks like Joanne's. However, throughout this book the history of Etretat has been derived principally from Lindon 1963. This acknowledgment frees my text of many footnotes, but doubtless slights the importance of Lindon's useful book.

5. Documented to the eleventh century according to the Abbé Cochet (Cochet 1866, pp. 358ff); the origin of the name is unclear.

6. Ritchie 1834, p. 54. I have chosen to reproduce Stanfield's engraving from a colored postcard on sale in 1990 in Etretat, to demonstrate the longevity of the resort's visual texts.

7. "Picturesque" and "sublime" are rich concepts that can be only hinted at in a crude summary. Among the chief eighteenth-century texts are Burke's *A Philosophical Enquiry into the Origin of Our Ideas of the Sublime and Beautiful* (1757), Kant's *Critique of Judgment* (1789–90), and Uvedale Price's *An Essay on the Picturesque as Compared with the Sublime and the Beautiful* (1794). See Samuel M. Monk, *The Sublime, a Study of Critical Theories in Eighteenth-Century England* (Ann Arbor, 1962), Edward Malins, *English Landscaping and Literature 1660–1840* (London, 1966), Levine 1985, Corbin 1988, and J. Herbert 1992, pp. 100–3. These terms had rough counterparts in the earlier conception of "pastoral" or "rural" vs. "heroic" landscapes traceable to the seminal writings of Roger de Piles, principally his *Cours de peinture par principes* (*The Principles of Painting*) of 1708.

8. Venedey 1838, p. 316.

9. Chapus 1855, pp. 235f: "Depuis longtemps Etretat est noté sur le *diary* des touristes d'élite, de ces hommes qui, par goût, se font voyageurs de profession. . . ."

10. Chapus 1855, p. 245: ". . . est littéralement envahi par la foule les jours de bal, le dimanche et le jeudi, à ce point que nos Parisiennes sont obligées de danser sur les genoux des Fécampoises; les autres jours on y passe le temps assez tristement à jouer au loto ou à la douairière et à faire de la tapisserie."

11. For the social and architectural history of typical resort casinos, see Rouillard 1984, *passim.*

12. These facilities are enumerated in A. Joanne 1867 and P. Joanne 1891.

13. James 1876, p. 206.

14. Karr, in *La pêche* (1860), cited in Lindon 1963, p. 81. Contradictory views of this juxtaposition of locals and visitors can readily be found. Anthony B. North Peat (1868, pp. 1–7) was the quintessential snob who found the locals too primitive, and incapable of understanding croquet; Katherine Macquoid (Macquoid 1874, pp. 138ff) appreciated the rude comforts of Etretat without condescension.

15. See Siegfried Kracauer, *Offenbach and the Paris of his Time* (London, 1937), pp. 155, 197, 225, 279, 307f, 313, and *passim,* as well as Lindon 1963, pp. 85f, 131.

16. Michelet 1861, pp. 405–7, and *passim.* Michelet's fame as a leading historian gave weight to his advice. Despite his regret at changes brought about by bathers, he so valued sea bathing for city dwellers that he elevated it to "a science of emigration" ("une science de l'émigration"), and entitled one chapter "Bathing – Renaissance of beauty" ("Bains – Renaissance de la beauté"). Alain Corbin has shown (1988, pp. 72–113) that the medicinal benefits of seaside hydrotherapy had been well established by the late eighteenth century.

17. Lindon 1967. Lindon remarks that the picture is probably an assemblage of portraits and not an accurate record of bathing.

18. Arsène Houssaye (Parisian journalist and fine arts inspector), in his *La plage d'Etretat* of 1868, cited in Lindon 1963, p. 119: "Le bain Mathurin-Lemonnier est le plus recherché, le plus nombreux. C'est là que vont les artistes, les hommes de lettres, les élégantes. . . . Les baigneurs préférés des dames sont Louis Mathurin, Maillart et le gros Aimé. Ils sont polis, gais, robustes, prudents. . . . "

19. "No barrier separates the two sexes, and one enjoys on this particular beach an always respectable freedom; it also affords advantages and an animation that one looks vainly for elsewhere . . . " ("Aucune barrière n'y sépare les deux sexes et l'on jouit sur cette plage particulière d'une liberté toujours convenable; aussi présente-t-elle une animation et des avantages qu'on chercheraient vainement ailleurs . . . ") (A. Joanne 1867, p. 59).

20. James 1876, p. 199.

21. *Le Marais en vendée,* painted from 1837 to 1844, now in the Cincinnati Art Museum. See Hélène Toussaint, *Théodore Rousseau* (Musée du Louvre, 1967–8), no. 17.

22. For example, Macquoid 1874.

23. See Lindon 1967. For an account of artists' and others villas, see Lindon 1963 and Thomas 1985; the latter reproduces many of these villas.

24. For Delacroix, see Alfred Robaut, *L'Oeuvre complet de Eugène Delacroix* (Paris, 1885), nos. 612, 615, and 1684, dated by Robaut 1835. It is not known when Monet acquired his watercolor of the Porte d'Aval by Delacroix (Robaut 1684), now in the Musée Marmottan. For Jongkind, see Victorine Hefting, *Jongkind, sa vie, son oeuvre, son époque* (Paris, 1975), *passim.* Corot's works are dated 1872 by Robaut, *L'Oeuvre de Corot* (Paris, 4 vols., 1905), nos. 2054–60, 2073. Lindon (1963, p. 100) disputes the date of 1872 because the old mill pictured by Corot had been destroyed before that year.

CHAPTER 4

1. W II, letter 312, 1 February 1883: "Je compte faire une grande toile de la falaise d'Etretat, bien que ce soit terriblement audacieux de ma part de faire cela après Courbet qui l'a faite admirablement, mais je tâcherai de la faire autrement. . . . " For other information gleaned from Monet's letters, not separately footnoted here, see W II, letters 310–30, mostly to Alice Hoschedé, a few to Durand-Ruel.

2. He was in Paris in May, during Courbet's exhibition, although he does not mention attending it (W II, letter 273 to Durand-Ruel, 24 May 1882).

3. Courbet to his family, undated letter, probably late August or early September 1869 (Letter 69-7, in Petra ten-Doeschate Chu, ed., *Letters of Gustave Courbet* [Chicago, 1992]). Otherwise, all information here about Courbet and his pictures comes from the catalogue *Gustave Courbet* (Paris and London, 1977–8), biography by Marie-Thérèse de Forges, entries by Hélène Toussaint, and from Fernier 1978. Fernier attributes about sixty pictures to Etretat, although most of these are pure seascapes with no internal signs that indicate Etretat.

4. Including entries by Toussaint, *loc. cit.,* and in Fernier 1978. Another Courbet (Fernier, no. 521) shows the laundresses somewhat closer to the foreground, although still not in large scale. It is the picture that has been called "Seaweed Gatherers" and "Marée montante" in the Clark Art Institute, Williamstown, MA, but should be retitled *Laundresses at Low Tide, Etretat.*

5. The sight of the women at work was one treasured by vacationers and tourists, who compared them with urban laundresses, in the self-serving dialogue of city and resort: "On washing-day you may see some dozens of women kneeling on the beach, delving amongst the shingle till they each make a circular basin-shaped hole amongst the stones. If you watch for a few minutes, this hole is speedily filled by fresh water, in which your shirts and collars are submerged and acquire a far better colour than under the *eau de javelle* process, so extensively practised by your Parisian *blanchisseuse*. . . . I can assert that my shirts were remarkably well washed" (North Peat 1868, p. 6).

6. W II, letter 318 to Alice Hoschedé, 7 February 1883: "une grande chose." In other letters that month he uses the phrase "une grande toile."

7. W II, letters 310, 311 to Alice Hoschedé and to Durand-Ruel, 31 January 1883: "moins nouveau" and "peut-être pas si varié."

8. W II, letter 315, 4 February 1883: ". . . je n'ai qu'une crainte, c'est que ces nouvelles choses ne soient pas aussi différentes de mes autres choses que ce que je devais faire au Havre. C'est là ma grande préoccupation, mais je ne puis ne pas me laisser séduire par ces admirables falaises. . . ."

9. W II, letter 330 to Alice Hoschedé, 16 February 1883: "deux ou trois bêtes de motifs à falaises."

10. Monet's window views had their ancestry in paintings done early in the century, particularly in Germany, but these earlier pictures usually represented a portion or all of the window frame. See Levine 1979 and, for the Romantic era, Lorenz Eitner, "The Open Window and the Storm-Tossed Boat: An Essay in the Iconography of Romanticism," *Art Bulletin* 37 (December 1955): 281–90. Levine's stimulating essay concerns the represented window and therefore is only marginally related to the paintings of Monet with which I am dealing.

11. W II, letter 324 to Alice Hoschedé, 13 February 1883: ". . . depuis que je travaille de ma fenêtre, j'ai fait une grande pochade qui est très bien, je crois, comme pochade, mais impossible à terminer ni même à exposer. Vous verrez cela, c'est une chose à faire une grande toile." The canvas in question has not been identified. It could have been discarded, or could lie underneath a known painting. For a discussion of "pochade," see House 1986, pp. 157ff.

12. From his letters of 1883 we know that Monet painted from the hotel's "annexe," which was surely on the Aval side of the main building, but which is not otherwise described. His letters of 1885 (e.g., W II, letter 590) make it clear that he was allowed to paint from many of the hotel's windows, and this liberty was apparently available already in 1883. (The hotel and adjacent buildings were leveled by the German occupation forces during World War II in order to provide clear lines of fire out to sea.)

13. For the very short visit in 1884, see below, p. 97.

14. W II, letter 328 to Alice Hoschedé, 15 February 1883: ". . . Il faut encore que le soleil ou le temps gris coïncide avec la marée qu'il me faut basse ou haute selon mes motifs."

15. Because titles cannot always be correlated with specific pictures, only eight of the eleven sold to Durand-Ruel have been documented in the Wildenstein catalogue. In July, out of five with Etretat titles, W 826 and W 832; in November, W 817 and W 831; in December, W 818, W 821, W 823, and W 828. Wildenstein lists W 816, a "finished" picture, and W 829, more sketchy, as among those probably sold in July. However, W 830, a "finished" picture, seems as good a candidate as W 829, and if this is so, then none but completed pictures were sent to Durand-Ruel in 1883. Monet probably took other pictures begun in 1883 with him to work on when he returned to Etretat in subsequent years; some, we know, were touched up in the studio before selling them decades later.

CHAPTER 5

1. W II, letters 388 and 397, 12 and 28 January 1884.

2. W II, letter 436 to Alice Hoschedé, 3 March 1884: ". . . un peu beaucoup mon élément."

3. W II, letter 415, 11 February 1884: ". . . les grands motifs d'ensemble y sont rares. C'est touffu, et ce sont toujours des morceaux avec beaucoup de détails, des fouillis terribles à rendre, et moi, justement, suis l'homme des arbres isolés et des grands espaces."

4. W II, letter 401 to Alice Hoschedé, 1 February 1884: ". . . maintenant ce que je fais est beaucoup mieux; je vois les motifs où je ne les voyais pas les premiers jours; enfin, ça marche plus facilement; aussi je trouve mes premières études très mauvaises; elles ont été péniblement faites, mais elles m'ont aussi appris à voir."

5. W II, letter 395 to Alice Hoschedé, 27 January 1884: ". . . les paysans doivent être heureux, mais, moi, je suis navré de ne pouvoir travailler."

6. W II, letters 410 and 412, 7 and 9 February 1884. In the first he refers to "photographs," in the second, to "views" ("quelques vues de Bordighera"). Some of them are preserved in the Monet archives in the Musée Marmottan; one is reproduced in Alphant 1993, p. 393.

7. House 1986, pp. 24–5.

8. And published twice before that: see Rodolphe Walter, "Charles Garnier et Claude Monet à Bordighera," *L'Oeil* 258–9 (January–February 1977): 22–7. See also W II, p. 23, for a capsule history of Bordighera.

9. W II, letter 414 to Alice Hoschedé, 10 February 1884.

10. W II, letter 488, 23 April 1884: "J'ai besoin de voir tout cela tranquillement dans de bonnes conditions. J'ai travaillé pendant trois mois, me donnant bien du mal, et n'étant jamais satisfait, sur nature, et c'est seulement ici depuis quelques jours que je vois le parti que je peux tirer d'un certain nombre de toiles."

CHAPTER 6

1. I drew attention several years ago to the fact that the known date of Monet's picture should probably redate Sargent's to 1885 (it is usually dated 1887).

2. Monet said that he had brought paintings with him to Etretat in August 1884, but that he had accomplished nothing at all because of the bad weather (W II, letter 518 to Durand-Ruel, 6 September 1884). Only two paintings were dated 1884 by Monet, *Etretat, the Beach and the Porte d'Aval* (fig. 94), and *The Porte d'Aval and the Needle* (Basle, Kunstmuseum, W 908). The latter, however, was sold by Monet only in 1923, and he wrongly remembered the date, for the picture unquestionably matches up with two others done in 1885, W 1046 (Moscow, Pushkin Museum) and W 1047 (Musée de Dijon).

3. "Merle leaves this morning. Good riddance!" ("Merle parti de ce matin. Quelle débarras!") (W II, letter 594 to Alice Hoschedé, 21 October, 1885).

4. Maupassant 1886, translated in Stuckey 1985, pp. 121–4. When visiting Monet's hotel room, Maupassant was much taken by *Etretat, Rainy Weather* (fig. 124), and later, we can assume, he invented his charming story to suit the picture.

5. For a masterpiece of self-interested ingratitude, see the letter to Durand-Ruel from Etretat, 10 December 1885 (W II, letter 638).

6. "I began quite a few things yesterday, duplicates, in the hopes of being able to work every day. . . . It is true that with a few good sessions all these canvases can quickly take on real form . . ." ("J'ai commencé bien des choses hier, des répétitions, dans l'espoir de pouvoir travailler chaque jour. . . . Il est vrai qu'avec quelques bonnes séances toutes ces toiles peuvent vite prendre tournure . . .") (W II, letter 597 to Alice Hoschedé, 24 October 1985).

7. W II, letters 620, 624, 627, all to Alice Hoschedé.

8. W II, letter 606 to Alice Hoschedé, 2 November 1885: "J'étais furieux, car ils m'ont fait perdre mon temps."

9. W II, letter 634 to Alice Hoschedé, 29 November 1885: "Je ne puis passer mon temps à toujours faire la même chose de ma fenêtre, d'autant plus que les bateaux ne sortent pas et cela manque d'intérêt."

10. Fifty catalogued in W II and W V with dates of 1885 or 1886, plus W 908, which should be redated 1885 (see above, note 2).

11. Although he and Alice had been living together for years, Monet felt that their relationship was threatened by Ernest Hoschedé's communications with his wife. The situation was finally resolved by Hoschedé's death in 1891, followed the next year by Monet's marriage with his widow.

12. W 1009, 1020, and 1039 in December 1885; two more were delivered with them, probably W 1035 and 1037. In 1886, Monet sold W 1018, 1044, and 1053, and probably also 1032.

13. North Peat 1868, p. 7.

14. "Finish" and "sketchiness" are always relative terms for Monet and the Impressionists. This picture is far from an improvisation. The water is a complicated play of underlying verticals (formed by dragging rather dry pigment sideways so that the vertical canvas threads pick it up), swooping surface strokes, smaller irregular dabs, and, near the shoreline, a reduction to the gray underpainting. The foreshortened wall of the cliff is even more complicated, with many fine touches of dark red, stronger red, pink, off-whites, green-blue, and pale blue, sometimes three or more of these lying on top of one seemingly spontaneous stroke that was first applied to give a texture of fake immediacy. For the relationship between Impressionism and Fauvism's subjects and techniques, see J. Herbert 1992.

15. North Peat 1868, p. 6.

16. Levine 1985, p. 392. Levine's essay, concentrating on Monet's pictures of the wild coast of Belle-Ile (autumn 1886), shows the wisdom of treating them as heirs of the "oceanic sublime" whose early exemplar was Joseph Vernet (1714–89). Although Levine does not touch upon any issues related to tourism or to Etretat, his synopsis of the sublime and his subtle analysis of Monet's Belle-Ile compositions have given me valuable lessons.

17. The dark silhouette atop the cliff in Boudin's picture is that of the "Fort de Fréfossé." It was a rather ludicrous but charming tower-cum-gateway in pseudo-medieval style built athwart the pathway to the promontory of the Aval by Ernest Dubosc, a local landowner. Visitors were charged a fee to pass through it, and they could also buy a modest collation there. Constructed on the foundations of an ancient building, it was the kind of tourist trap that gave form to old legends, and it was a favorite image in turn-of-century postcards (fig. 142). It was destroyed in 1911, perhaps because good taste won out over cupidity ("Etretat, à la dynamite," *Journal de Fécamp*, 29 October 1911); from atop the cliff, pieces of it can be seen beneath the water. Because Boudin's picture is dated 1887, one

wonders if it were already there in 1885? If yes, then Monet deliberately omitted it in all of his paintings of the Aval, and such an editorial action would be revealing. Alas! It has so far proved impossible to date the construction of the little building, and therefore we do not know if Monet saw it. Dubosc's successor-notary today retains no document about the building that ante-dates 1890. My warmest thanks to Jacques Caumont and Jennifer Gough-Cooper for locating the notary, and for their efforts at dating the "Fort."

18. Monet's use of the term "impression," and the scale of his work from the sketchiest to the most finished are the subject of a succinct discussion in House 1986, p. 162. "Impression" was a rough equivalent of the previous generation's "study after nature" ("étude d'après nature"), so that pictures so labeled would not be judged by the same standards as finished compositions. To the same end, he called other pictures "Essay of . . ." and, more commonly, "Effect of . . ." (W 1011, W 1112) ("essai de," "effet de"), perpetuating the mid-century terminology often used by Courbet and Rousseau. He told Durand-Ruel (W II, letter 650, 22 January 1886), when looking over canvases brought back from Etretat, that "some things are undoubtedly interesting, but too incomplete for the collector" (". . . il y a sans doute des choses intéressantes mais trop incomplètes pour l'amateur").

19. W II, letter 603 to Alice Hoschedé, 30 October 1885: "I just saw all the large boats head out for fishing, all at the same time; it is admirable, and I count on offering myself a *pochade* of that every day" ("je viens de voir le départ de tous les gros bateaux pour la pêche, tous à la fois; c'est admirable et je compte bien me payer chaque jour une pochade de cela"). About a dozen letters witness his eagerness to paint the fleet's departures, and his frustration at the delays he encountered. He made another picture of the departing fleet from this same spot, at sunset (Moscow, Pushkin Museum, W 1046), but may have painted its boats from memory.

20. The fourth (W 1036) is certainly a *pochade*, but admired as such by his friend John Singer Sargent, who acquired it in 1887. In its very sketchiness it is more like Sargent's work than the other three.

21. That Monet admired Japanese prints is certain, although we do not know when he began to collect them. And it is equally certain that there are valid comparisons with them. (Monet's relationship to Japanese prints is most convincingly dealt with in House 1986, pp. 57–8, and *passim*.) In my view, however, the supposed influence of Japanese woodcuts has been greatly exaggerated. It is instructive to see how often Monet's pictures are "explained" in terms of Japanese prints, without significant reference to their sites or their effects on viewers. Furthermore, despite the analogies that can be found, a Japanese woodcut was printed in flat inks, on a small piece of paper, whereas Monet worked in multi-layered oils, on a large canvas. The supposed transfer from one medium to the other seems more logical to a historian steeped in reproductions than to a painter who works in oily pigments.

22. For example, the rock arch on the shore at Corona Del Mar, California, usually glossed as "ancient" in tourist postcards, is attached to mariners' legends.

23. W II, letters 631 and 632 to Alice Hoschedé, 27 and 28 November 1885. In the first of these he tells her that the accident occurred at the spot "where you came with me" ("où vous êtes venue avec moi"). Since it is highly unlikely that she climbed up and down the steep cliff, they must have hired a boat. Monet regularly employed a boat to transport his painting gear (he mentions such boats in

several letters), just as vacationers hired them for transport to the favored views near the village.

24. House 1986, pp. 125, 150, 184.

25. Michelet 1861, p. 22: ". . . les assises superposées où se lit l'histoire du globe, en gigantesques registres où les siècles accumulés offrent tout ouvert le livre du temps. Chaque année en mange une page. C'est un monde en démolition, que la mer mord toujours en bas, mais que les pluies, les gelées, attaquent encore bien plus d'en haut." Had Monet read Michelet he would undoubtedly have appreciated the historian's praise (p. 25) of Jacob van Ruysdael's rendering of the northern sea in which he saw "not at all the cold of the North Sea but, on the contrary, the fermentation, the flood of life" (". . . je ne sens aucunement le froid de la mer du Nord, au contraire, la fermentation, le flot de la vie"). Steven Levine does not refer to Michelet, but deals with time as a Kantian feature of the sublime: "On the one hand [in Monet's paintings], nature's ineluctable might is apprehended; on the other hand, it is the acknowledgement of infinite extension, succession, and duration in time and space that gives rise to the characteristc sensation of the mind's sublimity" (Levine 1985, p. 391). James Herbert treats Monet's *Manneporte* in terms of the sublime, with a rather different set of references (J. Herbert 1992, pp. 101–2). He presciently contrasts Monet's conception of the sublime, formed in the northern tradition, with the later outlook of Matisse and Derain, whose Mediterranean canvases share in a southern vision that excludes the sublime.

26. Venedey 1838, p. 316.

27. "This morning I went below the Manneporte to try to do this very beautiful motif of green water; I would like to succeed, because it is really beautiful, but I think it is very difficult" ("Ce matin je suis allé sous la Manneporte essayer de faire ce si beau motif d'eau verte; je voudrais le réussir, car c'est vraiment beau, mais je crois très difficile") (W II, letter 623 to Alice Hoschedé, 18 November 1885).

CONCLUSION

1. *Nouveau guide du voyageur au Havre et dans ses environs* (Le Havre, 1853), cited in Rouillard 1984, pp. 53f.

2. Macquoid 1874, p. 142.

3. Recounted by Siegfried Kracauer, *Offenbach and the Paris of his Time* (London, 1937), p. 279. It is Dean MacCannell who pointed out so clearly that the tourist site is often a staged performance (MacCannell 1976).

4. Buzard 1993, p. 207. See also pp. 8f, 81, and *passim*. Alain Corbin (1988) reminds us that in the late eighteenth century the application of the "picturesque" to nature was a process of selection, and therefore much had to be excluded.

5. For this "Fort," see above, ch. 6, note 17. Town fathers probably acquiesced in its construction because it added a few francs in taxes to the local coffers.

6. Once again, it is Rouillard who has so perceptively documented a vital feature of the seaside experience. On the construction of "views," see Rouillard 1984, pp. 310ff, 315ff, 338, and *passim*.

7. In his study of British landscape of the early nineteenth century, Andrew Hemingway (1992) shows why landscape painting should be understood as a phenomenon of the culture of cities, where the pictures are shown, marketed, and written about.

8. They were rather mocking and disdainful, whereas Michelet was more impassioned: "This mixing with Paris, with fashionable Paris, although it brings in money, is a plague for the place" ("Ce mélange avec Paris, le Paris mondain, quelque cher que celui-ci paye, est un fléau pour le pays") (Michelet 1861, p. 407).

9. W II, letter 313 to Alice Hoschedé, 2 February 1883: "j'apporterai des masses de documents pour faire de grandes choses à la maison."

10. For example, W II, letter 636 to Alice Hoschedé, 8 December 1885.

11. The late Nicholas Green (1987) has shown that the rise of the market for Impressionism meant the identification of the artistic individual with the art, the marketing of a "Monet" as much as of a painting. Green's essay is the most insightful study of the relationships among artists, dealers, and clients of the Impressionist era, and his bibliography is excellent.

12. Eugène Chapus wrote that looking out from the heights of Ingouville, above Le Havre, was like viewing a painting, with its ocean, its promontories, its vessels, "and its perspectives, its horizons, and its backgrounds." One might then turn to left or right, after "your gaze like that of a poet, artist or passionate tourist has been saturated in the ecstasy born of the magic of this viewpoint . . ." ("et ses perspectives, et ses horizons, et ses arrière-plans! Après que vos regards de poëte, d'artiste ou de touriste passionné se sont noyés dans l'extase qu'enfante la magie de ce point de vue . . .") (Chapus 1855, p. 233).

13. ". . . le désordre qui ressort de cette fantaisie romanesque qui, malgré le talent de l'artiste, n'est plus en accord avec notre époque" (letter to Lucien Pissaro, 10 January 1887, *Correspondance de Camille Pissarro*, vol. 2: *1886–1890*, ed. Janine Bailly-Herzberg [Paris, 1986], no. 375).

14. Monet's later paintings of Rouen cathedral, exhibited in 1895, are further proof of his neo-romanticism, since they perpetuated the Gothic Revival. Who could imagine Monet painting the classical façade of a bank or government building?

15. Maupassant 1886, translated in Stuckey 1985, pp. 121–4. Maupassant tied technique to subject when he exclaimed over the suitability of Monet's passionate brushwork to the dramatic setting of Etretat. The artist himself wrote of painting alongside a lark-hunter (and his pleasure at being given six larks for his lunch) (W II, letter 606 to Alice Hoschedé, 2 November 1885). His frequent dining companions were hunters who came to Etretat for guillemots. Rouillard 1984, pp. 45ff, is especially good on the writer and painter as pioneer.

16. Buzard 1993, p. 9, and *passim*.

17. It is MacCannell who first dealt thoroughly with the Janus-faced tourist experience of authenticity and inauthenticity (MacCannell 1976, *passim*).

18. Buzard 1993, p. 153.

19. *Social Formation and Symbolic Landscape* (London, 1984), p. 262, cited by Urry 1990, pp. 97f.

20. Virginia Spate has expressed this well: "The desire to heal life and, in particular, to recuperate those things lost in modern urban society by means of paintings which in both subject and technique suggest a realized vision of free, pleasurable work and of the unconstrained joys of the body in a nature liberated from servitude by modern technology, may be a profound one. If expressed in ways which invite participation in its meanings, it may be productive of social thought and action" (Spate 1992, p. 72).

Bibliography

The following list of references consists of publications that are immediately relevant to this book, therefore publications about Monet's art after 1886 and about twentieth-century tourism are not included unless they shed particular light on the nineteenth century. Recent publications are favored; the early works included are limited to those that still have currency.

MONET

Detailed work on Monet must begin with the *catalogue raisonné* edited by Daniel Wildenstein (1974 *et seq.*), whose five volumes include a serial biography, the artist's letters, and other documents. Gustave Geffroy's two little volumes (1924) remain the best of the accounts by the artist's friends. Steven Levine's dissertation (1976) is essential for the critical reaction to Monet's exhibited pictures, and his article on Monet's seascapes at Belle-Ile (1985) is one of the few devoted to a single campaign of painting. Paul Tucker's volume on Monet at Argenteuil (1982) is an ideal model for a book on one site, and I am beholden to him for many lessons in methodology and in sensitive readings of individual pictures. His catalogue of Monet's series of the 1890s (1989), although it concerns the period after the one I deal with, is rich in all manner of helpful observations about the imagery of landscape and Monet's concern for his market. John House's study (1986) is invaluable for its detailed examinations of Monet's procedures and techniques across his whole career, with many prescient analyses of the relation of technique to natural imagery. Virginia Spate's sensitive and commonsensical monograph (1992) deals briefly with Monet's seacoast campaigns in terms of tourism. The most recent monograph, Marianne Alphant's (1993), has the convenience of a detailed biography (not a study of paintings), but it relies upon the Wildenstein catalogue without adding substantially to it.

RELEVANT STUDIES IN THE HISTORY OF ART

The pioneering work on Monet in the context of Impressionism is that of the late John Rewald (4th ed., 1973). Richard Shiff's book (1984) is the most insightful interpretation of Impressionist technique in relation to theories of naturalism, with acute analyses of such terms as "originality," "impression," and "sensation." T.J. Clark's social history (1985) pays little attention to Monet, but estab-lishes Impressionism as a phenomenon of Parisian culture. My own book on Impressionist leisure (1988) talks of Monet in the suburbs of Paris and on the seacoast, as does the exhibition catalogue edited by Richard Brettell *et al.* (1984). The latter was preceded by the enterprising exhibition organized by Bonnie Grad and Timothy Riggs (1982). Another major exhibition was devoted to the eight exhibitions of the Impressionists (Moffett *et al.*, 1986) and includes extensive documentation. Art historians devoted to British painting have been particularly attentive to the social iconography of landscape, and there are abundant lessons in the work of John Barrell, Ann Bermingham, Denis Cosgrove, and David Solkin. Unusually rich in ideas are recent books by the late Nicholas Green (1990) and by Andrew Hemingway (1992) which place landscape firmly at the center of cultural discourse, including discussions of naturalism as part of the complex ideology of the urban bourgeoisie.

TOURISM

The origins and early history of tourism are not featured in this bibliography, but mention must be made of the stimulating book by Alain Corbin (1988) who analyzes the profound role the seashore had in early modern culture. Otherwise, the early stages of tourism are examined (with helpful bibliographies) in the major studies of tourism mentioned in the next paragraph. Most books on tourism deal with the twentieth century, principally from the vantage point of commerce and sociology. However, several modern books on tourism, although they do little at all with the visual arts, have insights into literature and social history that are of first importance. Louis Turner's and John Ash's book (1974) is a history that emphasizes the development of the tourist industry and its ramifications from the mid-nineteenth century onward. James Walvin wrote another substantial history (1978), paying more attention to working-class culture than most authors. Thomas Cook's tours, which constitute both major subject and symptom, are well presented by Edmund Swinglehurst's popular history (1982).

Three books have put the social and theoretical analysis of tourism on a firm footing. Dean MacCannell's semiotical investigation (1976) provides a theoretical basis for the study of tourism that all subsequent writers must deal with. John Urry (1990) incorporates much of MacCannell while subjecting the tourist experience to close analysis.

His formulation of "the romantic gaze" and "the collective gaze" is especially fruitful. For the present book, James Buzard (1993) has been the most useful because, although the visual arts take no role, his work on travel literature (principally Henry James and E.M. Forster) has many lessons that can be applied to painting. The first half of his book is the most percipient discussion of tourism that I know of, although his "anti-tourist" is too rigorously separated from the ordinary tourist.

NORMANDY AND ETRETAT

The only study of Norman tourist resorts that pays attention to the visual arts is the book by Dominique Rouillard (1984), who combines semiotics and social history with brilliant results. He is principally concerned with town planning and architecture, but includes topographical prints and some paintings. For Normandy, given my focus on tourism, I relied on successive editions of the guide-books edited by Eugène Chapus (1855), Adolphe and Paul Joanne (1867 *et seq.*), and John Murray (1844 *et seq.*), and the anonymous *Guide annuaire* (1866, 1868) and *Album-guide* (1881). Among travel accounts, the most interesting include those of Jacob Venedey (1841) and Katherine Macquoid (1874). For the history of Etretat, see Raymond Lindon (1963) and the Abbé Cochet (1862 and 1866).

LIST OF REFERENCES

(Exhibition catalogues appear under the names of their authors/editors.)

Anon. *Album-guide illustré des voyages circulaires, Côtes de Normandie.* Paris 1881.

Anon. *Guide annuaire à Trouville-Deauville, Villers-sur-Mer et Cabourg.* Paris 1866, 1868. Some texts signed Henri Letang.

Alphant, Marianne. *Claude Monet, une vie dans le paysage.* Paris 1993.

Audin, J.M.V. [pseud. "Richard"]. *Guide classique du voyageur en France.* Paris 1855.

Baedeker, Karl. *Northern France from Belgium and the English Channel to the Loire.* Leipzig 1889 *et seq.*

Bermingham, Ann. *Landscape and Ideology: The English Rustic Tradition, 1740–1860.* Berkeley 1986.

Blanquet, Albert. *Les Bains de mer des côtes normandes, guide pittoresque.* Paris 1859.

Brettell, Richard, *et al. A Day in the Country: Impressionism and the French Landscape.* Exhibition catalogue. Los Angeles County Museum of Art, 1984.

Buzard, James. *The Beaten Track: European Tourism, Literature, and the Ways to Culture 1800–1918.* Oxford 1993.

Chapus, Eugène. *De Paris au Havre.* Paris 1855.

Clark, Timothy J. *The Painting of Modern Life: Paris in the Art of Manet and his Followers.* New York 1985.

Cochet, J.B.D. *Etretat, son passé, son présent, son avenir.* Dieppe 1862.

——. *La Seine Inférieure, historique et archéologique.* Paris, 2d ed., 1866.

Corbin, Alain. *Le Territoire du vide, l'Occident et le désir du rivage 1750–1840.* Paris 1988.

Cosgrove, Denis. *Social Formation and Symbolic Landscape.* London 1984.

Cosgrove, Denis, and Stephen Daniels, eds. *The Iconography of Landscape.* Cambridge 1988.

Désert, Gabriel. *La Vie quotidienne sur les plages normandes du Second Empire aux années folles.* Paris 1983.

Fernier, Robert. *La Vie et l'oeuvre de Gustave Courbet, catalogue raisonné.* 2 vols. Lausanne 1978.

Frascina, Francis, *et al. Modernity and Modernism, French Painting in the Nineteenth Century.* New Haven and London 1993.

Geffroy, Gustave. *Claude Monet: sa vie, son temps, son oeuvre.* 2 vols. Paris 1924.

Gordon, Robert, and Andrew Forge. *Monet.* New York 1983.

Grad, Bonnie, and Timothy Riggs. *Visions of City and Country, Prints and Photographs of 19th Century France.* Exhibition catalogue. Worcester Art Museum, 1982.

Gratrix, Dawson. *The Holiday Beaches of Northern France.* London 1958.

Green, Nicholas. "Dealing in Temperaments: Economic Transformation of the Artistic Field in France during the Second Half of the Nineteenth Century," *Art History* 10 (March 1987): 59–78.

——. *The Spectacle of Nature: Landscape and Bourgeois Culture in Nineteenth-Century France.* Manchester 1990.

Guillaud, Jacqueline and Maurice, eds. *Claude Monet, au temps de Giverny.* Exhibition catalogue. Paris, Centre Culturel du Marais, 1983.

Hamilton, Vivian. *Boudin at Trouville.* Exhibition catalogue. Glasgow, Burrell Collection, and London, Courtauld Institute Galleries, 1992–3.

Hemingway, Andrew. *Landscape Imagery and Urban Culture in Early Nineteenth-Century Britain.* Cambridge 1992.

Herbert, James D. *Fauve Painting, the Making of Cultural Politics.* New Haven and London 1992.

Herbert, Robert L. "Method and Meaning in Monet," *Art in America* 67, 5 (September 1979): 90–108.

——. "Impressionism, Originality and Laissez-Faire," *Radical History Review* 38 (Spring 1987): 7–15.

——. *Impressionism: Art, Leisure, and Parisian Society.* New Haven and London 1988.

House, John. *Monet: Nature into Art.* New Haven and London 1986.

Isaacson, Joel. *Claude Monet: Observation and Reflection.* Oxford 1978.

——, ed. *The Crisis of Impressionism, 1878–1882.* Exhibition catalogue. Ann Arbor, MI 1979–80.

James, Henry. *Parisian Sketches: Letters to the "New York Tribune."* Ed. Leon Adel and Ilse Dusoir Linde. London 1958 [orig. 1875–6].

Jean-Aubry, Georges. *Eugène Boudin.* Paris 1967 [orig. 1932].

Joanne, Adolphe. *La Normandie.* Paris 1867, 1873.

Joanne, Paul. *Itinéraire général de la France, Normandie*, vol. I: *Du Havre au Tréport*. Paris 1891.

Levine, Steven Z. *Monet and his Critics*. New York 1976 [Ph.D. dissertation].

——. "The Window Metaphor and Monet's Windows," *Arts Magazine* 54, 3 (November 1979): 98–104.

——. "Seascapes of the Sublime: Vernet, Monet, and the Oceanic Feeling," *New Literary History* 16, 2 (Winter 1985): 377–400.

Lindon, Raymond. *Etretat, son histoire, ses légendes*. Paris 1963.

——. "Eugène Le Poittevin et ses "Bains de mer à Etretat'," *Gazette des beaux-arts* 6, 70 (December 1967): 349–57.

MacCannell, Dean. *The Tourist: A New Theory of the Leisure Class*. New York 1976.

Macquoid, Katherine S. *Through Normandy*. London 1895 [orig. 1874].

Maupassant, Guy de. "La Vie d'un paysagiste," *Gil Blas* (28 September 1886), in Stuckey 1985, pp. 121–4 (trans. Catherine J. Richards).

Michelet, Jules. *La Mer*. Paris 1861.

Moffett, Charles S., *et al. The New Painting: Impressionism 1874–1886*. Exhibition catalogue. San Francisco Fine Arts Museums, 1986.

Murray, John. *A Handbook for Travellers in France*. London 1844, 1848, 1856, 1864, 1867, 1873.

North Peat, Anthony B. *Paris sous le second Empire*. Paris 1911 [written 1868].

Rewald, John. *The History of Impressionism*. 4th ed., revised. New York 1973.

Rewald, John, and Frances Weitzenhoffer, eds. *Aspects of Monet, a Symposium on the Artist's Life and Times*. New York 1984.

Ritchie, Leitch. *Travelling Sketches on the Sea-coasts of France*. London 1834.

Rouillard, Dominique. *Le Site balnéaire*. Brussels 1984.

Shiff, Richard. *Cézanne and the End of Impressionism*. Chicago 1984.

Solkin, David. *Painting for Money*. New Haven and London 1993.

Spate, Virginia. *The Colour of Time: Claude Monet*. London 1992.

Stuckey, Charles, ed. *Monet: A Retrospective*. New York 1985.

Swinglehurst, Edmund. *Cook's Tours*. Poole 1982.

Thomas, Jean-Pierre. *Etretat autour des années 1900*. Fécamp 1985.

Tippetts, Marie-Antoinette. *Les Marines des peintres vues par les littérateurs de Diderot aux Goncourt*. Paris 1966.

Tours, Constant de. *Du Havre à Cherbourg*. Paris n.d. [*c*.1890].

Tucker, Paul Hayes. *Monet at Argenteuil*. New Haven and London 1982.

——. *Monet in the Nineties*. Exhibition catalogue. Boston, Museum of fine Arts, Art Institute of Chicago, and London, Royal Academy, 1989–90.

Turner, Louis, and John Ash. *The Golden Hordes: International Tourism and the Pleasure Periphery*. London 1975.

Urry, John. *The Tourist Gaze: Leisure and Travel in Contemporary Societies*. London 1990.

Venedey, Jacob. *Excursions in Normandy*. 2 vols. London 1841 [orig. *Reise und Rasttage in der Normandie*, Leipzig 1838].

Venturi, Lionello. *Les Archives de l'impressionnisme*. 2 vols. Paris 1939.

Walvin, James. *Leisure and Society 1830–1950*. London 1978.

Wildenstein, Daniel. *Claude Monet, biographie et catalogue raisonné*. 5 vols. Lausanne 1974–91.

Williams, Raymond. *The Country and the City*. Oxford 1973.

Index

Abstract Expressionism 134
Algeria 91, 93
Amsterdam 37
Antibes 4, 6, 95
Arcachon 15, 19
Argenteuil 35, 37, 93

Baden-Baden 66
Barbizon 67
bathers, bathing 2, 6, 26, 64–6, 97, 101, 129,
 131, 134; *see also* swimmers, swimming
Baudry, Paul (1828–86) 95
Belle-Ile 4, 6
Bellio, Georges de 95
Bischoffsheim, Baron Raphaël 93
Bisson, Romain 64–5
Bonington, Richard Parkes (1802–28) 63
Bordighera 4, Chap. 5, 97–9, 116
Boudin, Eugène (1824–98) 6, 9, 14, 23, 30,
 34–5, 103
 Approaching Storm fig. 21; 14, 18
 Beach at Trouville fig. 37; 34
 Etretat, the Porte d'Amont fig. 111; 103, 111
Bougival 26
Boulogne 14
Brandard, R.
 Rocks of Etretat (engraving after W. Clarkson
 Stanfield, *qv*) fig. 72
British painting 9, 25, 57–9, 63, 64
Buzard, James 4, 129, 134

Caillebotte, Gustave (1848–94) 98
caloges 21, 73, 76, 79, 81, 83, 89, 103, 107
Capelle, Jan van de (1624–79) 10
casinos 2, 26, 39, 44, 63, 65–7, 95, 97, 101,
 130–1
Cézanne, Paul (1839–1906) 6, 85
Chapus, Eugène
 De Paris au Havre 65–6
Cherbourg 41
Chicago 4
Choiseul, duc de 30
churches, chapels 56–7, 59, 93, 101, 130
Coignet, J.-L.P. (1789–1860)
 Cours complet du paysage 69
Constable, John (1776–1837) 25
Corot, Camille (1796–1875) 6, 68–9
 Port de la Rochelle fig. 119; 108
Cosgrove, Denis 135
Courbet, Gustave (1819–77) 6, 9–10, 14, 21, 30,
 34, 37, 39, 68–9, 71–3, 79, 81, 86–7, 89, 131

Beach at Etretat, Sunset fig. 140; 127
Cliff at Etretat fig. 95; 83
Cliff at Etretat after a Storm figs. 79, 80; 71,
 74–6, 84, 89
Podoscaphe 14
The Shore at Palavas 14
The Wave fig. 78; 71–4, 76, 89
Cubism 85

Daubigny, Charles (1817–78) 6, 9–10, 14, 65,
 131
Davanne, Maurice
 *Eugène Le Poittevin's Studio-House "La
 Chaufferette" at Etretat* fig. 75; 68, 71
 Etretat from the "Chambre des demoiselles" fig. 70;
 62
 Fishermen's Workshop fig. 76; 69
dealers 15, 43–4, 71, 98, 131; *see also* Durand-Ruel,
 Paul
Deauville 26, 30
Degas, Edgar (1834–1917) 42, 85
 Landscape fig. 47; 43
 The Tub fig. 46; 43
Delacroix, Eugène (1799–1863) 6, 69, 91
Dieppe 43–4, 130
Doche, Eugénie 66
Doncieux, Camille (1st wife of Monet) 4, 19, 21,
 26, 28, 30, 34–5, 37
Durand-Ruel, Paul 38, 43–4, 61, 71–2, 76,
 79–80, 86, 89, 91, 95, 98, 100–1, 131
Dutch painting 9, 10, 14, 15

England 11, 35, 37, 39
Etaples 15, 19
Etretat 1–2, 6–7, 19–26, 30, 37–9, 59, Chap. 3,
 Chap. 4, 91, 95, Chap. 6, 129–31, 133–4
exhibitions 72–3, 98, 130–1
 Impressionist exhibitions 43, 87, 98
 Salon 15, 23, 68, 71, 87, 89
 (1865) 9
 (1866) 66
 (1867) 10
 (1868) 14
 (1870) 21, 71
 (1878) 135

Fau, Fernand
 Gathering Mussels at the Roches Noires (engraving
 by Rougeron Vigneret) fig. 52; 46
Faure, J.-B. 95, 97, 131, 133
Fauvism 101, 103, 134

Fécamp 6, 15, 19, 37–40, 43–4, 51, 61, 63, 65
Fénéon, Félix 131
Fingal's Cave 120
"Fort de Fréfossé" fig. 142; 130, 142n17

Garneray, Louis (1783–1857)
 Ports de France 68
Garnier, Charles (1825–98) 93, 95
Gauchard, J.
 View from Grainval towards Tréport fig. 43;
 39–40
Giverny 6, 37, 61, 72, 92, 95, 97, 100, 132–4,
 136
Goncourt, Edmond and Jules de
 Manette Salomon 30
Grainval 38–43, 46, 51, 82, 86, 111
guidebooks, travel guides 2, 39, 46, 56, 61–7,
 72, 83, 86, 92, 95, 111, 114–15, 120,
 129–31

Haviland, Charles 95
Le Havre 4, 9–10, 13–14, 19, 23, 37, 61, 65,
 72–3
Hecht brothers (Albert and Henri) 95
Hemingway, Andrew 4
Herbert, James 4
Holland 35, 37, 39
Honfleur 9–10, 19
Hoschedé, Alice (2nd wife of Monet) 4, 37,
 44–5, 61, 97–8, 100
 Monet's letters to 53, 61, 71, 92, 95
Hoschedé, Blanche 45
Hoschedé, Ernest 37, 43
hotels 1–2, 6, 12, 26, 28–9, 39, 44, 64–5, 67,
 97, 101, 129–30, 134–5
 Hôtel Blanquet 26, 61, 64, 67–8, 73–4, 79,
 97, 100, 103, 106, 130–1, 134
 Hôtel des Roches Noires 28
House, John 24, 92, 116

Les Ifs 65
Ingouville 9
Inness, George (1825–94)
 Etretat fig. 122; 110–11
Isabey, Eugène (1803–86) 6, 39, 56, 67–8, 131
 The Beach at Granville fig. 92; 81
Isle of Wight 15, 19

James, Henry 66–7, 115, 129–30
Japanese prints 114, 142n21
Jeufosse 133

Joanne, Adolphe
 Géographie du Département de la Seine-Inférieure
 39
Johannot, Tony (1803–52)
 Two Women on the Edge of a Cliff fig. 44; 41–2
Jongkind, J.B. (1819–91) 6, 9–10, 14, 23, 69
 Shore at Sainte-Adresse fig. 22; 14

Kaemmerer, Frederik H. (1839–1902) 16, 18
 The Beach at Scheveningen, Holland fig. 23; 15, 134
Kandinsky, Wassily (1866–1944) 134
Karr, Alphonse 64–5, 67–8, 130

Lancelot, D.
 The Porte d'Aval and the Needle of Etretat
 (engraved by August Trichon) fig. 73; 65
Landelle, Charles (1821–1908) 68
Lecadre, Jeanne-Marguerite (cousin of Monet) 13
Lecadre, Marie-Jeanne (aunt of Monet) 4, 9,
 13–14
Le Poittevin, Eugène (1806–70) 6, 98
 Bathing at Etretat fig. 74; 66–8, 71, 74, 130
Levine, Steven 4, 110
Lindon, Raymond 66
London 4, 6, 35, 39
Lorrain [i.e., Gelée], Claude (1600–82) 9, 57
 Landscape with Perseus, or The Origins of Coral
 fig. 132; 115

MacCannell, Dean 4, 134
McCormick, Stanley R. 95
Macquoid, Katherine 28, 129
Manet, Edouard (1832–83) 14–16, 19, 21, 26,
 66, 85, 100
Marseilles 14, 91–2
Massenet, Jules 66
Matisse, Henri (1869–1954) 101
Maupassant, Guy de 66, 98, 112, 130, 134
May, Ernest 95
Meissonier, Ernest (1815–91) 95
Menton 91–2, 95
Merle, Hugues (1823–81) 68, 93, 130
Michel, Marius 97
Michelet, Jules 66, 116, 118, 131
Millet, Jean-François (1814–75) 9
 The Cliffs at Gréville fig. 45; 41–2
Miramont, P.-M. de 66
Monet, Adolphe (father of Monet) 13–14, 19
Monet, Alice, *see* Hoschedé, Alice
Monet, Camille, *see* Doncieux, Camille
Monet, Claude (1841–1926)
 Banks of the Seine at Jeufosse, Autumn fig. 143;
 132
 The Beach and the Porte d'Amont fig. 109; 101
 The Beach at Etretat fig. 90, 91; 80–1, 101
 The Beach at Sainte-Adresse fig. 13; 10–11
 The Beach at Trouville fig. 31; 26
 The Boardwalk at Trouville figs. 33, 35; 29
 Boats in Winter Quarters fig. 115; 103, 106–8
 Camille on the Beach at Trouville fig. 32; 26, 28
 The Church of Varengeville, Effect of Morning
 figs. 63, 64; 59
 The Church of Varengeville, Setting Sun fig. 62;
 56–7, 59
 The Cliff and the Porte d'Aval fig. 83; 76

Cliff at Etretat fig. 95; 83
The Cliff at Grainval, near Fécamp fig. 42;
 39–40, 51, 111
The Cliff of the Porte d'Aval fig. 121; 108, 111
Cliff Walk at Pourville fig. 49; 45–6, 135
The Cliffs at Pourville fig. 51; 46
Cliffs at Varengeville fig. 59; 48, 51, 54, 111
Cliffs of Les Petites Dalles figs. 38, 39; 37–8
The Coastguard's Cottage at Pourville fig. 57; 48,
 54
The Departure of the Fleet fig. 116; 103, 107, 114
Entrance to the Port of Trouville 26
Etretat, the Beach and the Porte d'Amont fig. 108;
 101
Etretat, the Beach and the Porte d'Aval fig. 94; 83
Etretat, Rainy Weather fig. 124; 112, 135
Etretat, Rough Sea fig. 82; 21, 73–4, 76, 79, 82
Etretat, Setting Sun fig. 86; 76
The Estuary of the Seine at Honfleur 9
Fishing Boats (W823) fig. 89; 79
Fishing Boats (W1028) fig. 112; 103
Fishing Boats and the Porte d'Aval fig. 87; 21, 76,
 79
Fishing Boats Leaving the Port fig. 126; 112, 114
Garden of the Princess fig. 19; 13, 73
Gorge of the Petit Ailly, Varengeville figs. 60, 61;
 54–6
The Jetty at Le Havre fig. 27; 14, 23
Hôtel des Roches Noires figs. 30, 34; 28
Luncheon fig. 24; 21, 26
The Manneporte at High Tide fig. 130; 120, 135
The Manneporte, Etretat (W832) figs. 96, 97; 86,
 120
The Manneporte, Etretat (W1052) fig. 129;
 115–16
The Manneporte, Etretat (W1053) fig. 134; 120
The Manneporte Viewed from the West fig. 128;
 115
Meadow with Haystacks near Giverny fig. 106; 97,
 132
The Moreno Garden at Bordighera fig. 101; 93
The Needle and the Porte d'Aval figs. 104, 127;
 114–15
The Needle at Etretat, Low Tide fig. 98; 86, 114
Needle Seen through the Porte d'Amont (W1040)
 fig. 135; 120, 125
Needle Seen through the Porte d'Amont (W1050)
 figs. 137, 138; 120, 125, 135
The Pointe de l'Ailly fig. 48; 44–5
Port of Honfleur fig. 11; 10
The Porte d'Amont, Etretat figs. 28, 136; 21, 24,
 26, 83, 85–6, 120
Pourville, Flood Tide fig. 54; 46, 51, 54
Regatta at Sainte-Adresse fig. 14; 11, 13, 15,
 134
Rocks at Pourville, Low Tide fig. 50; 46
Rough Weather at Etretat fig. 93; 82
Sainte-Adresse, Fishing Boats on the Shore figs. 9,
 16; 10–11
Sainte-Adresse, la Pointe de la Hève at Low Tide
 fig. 10; 9
The Sea Viewed from the Cliffs at Grainval
 fig. 41; 39, 111
Ships Careened in the Harbor of Fécamp fig. 40;
 39

Stormy Sea at Etretat figs. 25, 26; 21, 23–6, 73,
 82
Terrace at Sainte-Adresse fig. 17; 11–12, 28, 34,
 73, 108
Under the Poplars, Sunlight Effect fig. 144; 132–3
Villas at Bordighera fig. 102; 93, 95, 97
Wintry Landscape, Etretat fig. 107; 100
Monet, Jean (son of Monet) 4, 19, 21, 26, 35
Monet, Léon (brother of Monet) 4, 37–8
Monte Carlo 91–2, 95
Moreau-Nélaton, Etienne 23
Moreno, Francesco 92–5
Morisot, Berthe (1841–95) 19, 23, 95
 Harbor at Lorient 14
Morlent, J. 129
Mozin, Charles (1806–62) 6, 69

Napoleon Bonaparte, Louis (Napoleon III) 34
neo-romanticism 86, 106, 108, 110, 131–2, 134
Noël, Alexandre-Jean (1752–1834)
 Etretat fig. 71; 62, 83, 129
Noël, Jules Achilles (1815–81) 39

Offenbach, Jacques 66, 129
Outin, Pierre (1840–99)
 The Look-Out Point fig. 145; 134–5

Paris 2, 4, 6, 7, 13, 14, 19, 26, 34, 37, 38, 43, 44,
 64, 66, 71, 91, 95, 97, 98, 130, 132, 133, 134
Paris Commune 35
Peat, Anthony North 100, 115, 130
Pennell, Joseph (1857–1926)
 Falaise d'Amont, Etretat fig. 110; 103
Petit, Georges 98, 112, 131
Les Petites Dalles 4, 6, Chap. 2, 97
Picturesque 54, 63, 68, 69, 74, 79, 81, 110, 120,
 129, 133
Pissarro, Camille (1830–1903) 98, 131–3
Pissarro, Lucien (1863–1944) 132
Poissy 37, 61
Pont-Aven 67
Pope, Alfred A. 95
Pourville 4, 6, Chap. 2, 61, 72, 82, 111
Poussin, Nicolas (1594–1665) 9
Prussian war 34–5

railways, railroads 65, 93, 97, 130, 136
Renoir, Auguste (1841–1919) 26, 91, 100
 Field of Bananas fig. 100; 93
restaurants 1–2, 44, 64–5, 67, 97, 101, 134
Ritchie, Leitch
 Travelling Sketches on the Sea-coasts of France 63–4
Romanticism, Romantic 9, 18, 39, 41–2, 54, 63,
 69, 73, 81, 83, 86, 91, 106, 108, 110–11, 116,
 132, 134–5
Rouen 37, 130
Rouillard, Dominique 131
Rousseau, Théodore (1812–67) 68
 Jetty at Granville fig. 118; 106–7

Sainte-Adresse 4, 6, Chap. 1, 37, 43, 61, 108
Salon, *see* exhibitions, Salon
Sargent, John Singer (1856–1925) 95, 98
 Claude Monet Painting at the Edge of a Wood
 fig. 105; 97

Seurat, Georges (1859–91) 131–2
Signac, Paul (1863–1935) 132
Spate, Virginia 4
Stanfield, W. Clarkson (1793–1867)
 Rocks of Etretat (engraved by R. Brandard)
 fig. 72; 63–4, 73–6, 111
Sublime 42, 54, 63–4, 68, 69, 73, 86, 110–11,
 115, 116, 118–20, 132, 134
Sutton, James F. 95
swimmers, swimming 28, 44, 66–7, 135; *see also*
 bathers, bathing
Swinburne, Augustus 66

Third Republic 34–5
travel guides, *see* guidebooks
Trichon, August
 The Porte d'Aval and the Needle of Etretat
 (engraving after D. Lancelot) fig. 73; 65

Trouville 4, 6, 26–35, 37, 43, 61, 65, 108
Tucker, Paul 4
Turner, J.M.W. (1775–1851) 59, 63
 Lake Avernus: Aeneas and the Cumaean Sibyl
 fig. 65; 57, 59

Urry, John 4, 11, 134

Varengeville 6, 37, 56–9, 61, 72, 92
Velde, Adriaen van de (1636–72)
 Beach at Scheveningen fig. 15; 10–11
Velde, Willem van de, the Younger (1633–1707)
 Sea with Bathers fig. 12; 10
Venedey, Jacob 63–4, 108, 112, 118, 120,
 130–1, 134
Venice 4, 6
Vernet, Claude Joseph (1714–89)
 Seashore fig. 20; 13

Vétheuil 37, 93
Vichy 66
Vigneret, Rougeron
 Gathering Mussels at the Roches Noires (engraving
 after Fernand Fau) fig. 52; 46
Villemessant, Henri de 67

windows, window views 1, 29, 61, 73–4, 76, 79,
 82, 100, 103, 108, 114, 130
Wright, Joseph (1734–97)
 Grotto at Salerno fig. 133; 120

Yport 140

Zola, Emile 18